Historic Tales

of

ALAMO

CALIFORNIA

To Wendy and Mike,

Sharon Burke

Beverly Lane

BEVERLY LANE
with Sharon Burke

THE
History
PRESS

Published by The History Press
Charleston, SC
www.historypress.com

Copyright © 2021 by Beverly Lane with Sharon Burke
All rights reserved

Picnic at Hemme Park, circa 1895. *Courtesy of the Museum of the San Ramon Valley.*

First published 2021

Manufactured in the United States

ISBN 9781467148108

Library of Congress Control Number: 2021934138

CONTENTS

CONTENTS

ACKNOWLEDGEMENTS

*T*his book began because of some conversations with native-born Alamo residents Betty Humburg Dunlap and Carlo Borlandelli. I was curious about what Alamo was like when they grew up beginning in the 1930s. We created some "memory maps" and shared some good times along the way. Exactly where did the original Stone Valley Road meet the old highway? How accurate were Virgie Jones's books? Who built that roller-skating rink? Where was Portuguese Gulch? What all happened at the historic Henry Hotel?

In 2019, the Alamo Hay and Grain Store closed. The building had been an Alamo fixture for seventy-five years, and editor Alisa Corstorphine wrote about its history in the *Alamo Today Danville Today News* monthly newspaper. Next, an Alamo walking tour from the Museum of the San Ramon Valley began; it was focused on the intersection of Danville Boulevard and Alamo Square Drive (formerly Stone Valley Road). Three Alamo history buffs began leading and improving these tours: Sharon Burke, Anne Struthers and Alisa Corstorphine.

Long story short, this book on Alamo's history was the result, facilitated, of course, by the various COVID-19 cautionary stay-at-home directives. In fact, it could probably be called a pandemic project. Fortunately, Sharon Burke joined me in creating this history. She improved it immeasurably with her dedicated research, all fueled by her love of Alamo.

Many thanks to the people who helped with the stories, who wrote about Alamo in the past and who care deeply about this community. Betty, Carlo,

Sharon and Alisa generously shared their knowledge from the start. Claudia Mauzy Nemir, Maxine Matthews Soto and Vicki Koc contributed their extensive memories. Mark Harrigan and Jeff Mason helped with images, for which we are extremely grateful.

Historical writings by Mary Ann Jones, Flora May Stone Jones, Virgie V. Jones, Carola Kuss Cordell, Roy Bloss, Barbara Hall Langlois, Inez Butz, James Dale Smith, Irma Dotson, Veda Wayne, Vicki Koc, Don Wood and Fred and Ida Hall informed the book at every turn. Helping as well were Dublin historian Steve Minniear, Grange historian Ross Smith, Supervisor Candace Andersen, Cameron Collins, Ann and Larry Kaye, Lillian Burns, Susan Rock, Arthur Anderson, Claudia Waldron, Ed and Linda Best, Tom Hanson, Steve Mick, Mike McDonald and Mike Gibson.

For nineteenth-century Alamo history, Professor James D. Smith was an important observer. He was a bright, observant schoolboy in the 1850s and became the headmaster of Livermore College. In the mid-1920s, he wrote about Alamo's beginnings in a series of *Daily Gazette* newspaper columns, which were titled "Looking Back to the Days When the Gringo First Came." Virgie V. Jones deserves special recognition for all her work writing the first books on Alamo and San Ramon Valley history in the 1970s. Finally, we stand on the shoulders of Irma M. Dotson, whose research and writings on the railroad, electric railway, San Ramon Valley and August Hemme were extraordinary.

Alisa Corstorphine, Betty Dunlap, Vicki Koc, Steve Minniear, Vivienne Wong, Ann Pfass-Doss, Ross Smith and Alice Chambliss read draft chapters, for which we are thankful. Needless to say, any errors are our own.

INTRODUCTION

*A*lamo's past reflects the history of California, as do the histories of many other communities that began soon after the Gold Rush. Here's a weather example:

An enormous rainfall and megaflood covered California in December 1861 and January 1862, dropping over forty inches of rain in Contra Costa County and filling the Central Valley. The *Contra Costa Gazette* reported on the event:

> *The entire population of Alamo, at the foot of Mt. Diablo, 50 miles east of San Francisco, was forced to flee rising floodwaters. People abandoned their homes in the middle of the night. Some found refuge, others drowned. The San Ramon Valley was one sheet of water from hill to hill as far as the eye could see. The destructive force of the floods was awesome: houses, otherwise intact and complete with their contents, were carried away in the rapids; horses, cattle, and barns were swept downstream for miles.*

Newspaper articles throughout the state reported similar flooding, which was followed by a drought that marked California's agricultural transition from grazing to grains in the following decades.

While these weather events were memorable, Alamo residents regularly cite their satisfaction with the area's moderate Mediterranean climate. Tales of the Native peoples who lived here for eons, the Spanish invasion,

Mexican ranchos and Gold Rush settlers are similar to the experiences of all Californians. Also shared in this book is Alamo's century-long history of agriculture, racial tensions, migrations, post–World War II growth and the challenges of governance.

1

ALAMO'S SETTING

Mount Diablo was the grandest object in the landscape.... The San Ramon Valley, west of Mount Diablo, lay at our feet, the richest and most lovely I have yet seen in the state. It is all held in farms, where wheat is grown, and crops of over sixty bushels per acre are expected.
—William H. Brewer, surveyor 1861

California's Mount Diablo rises as a solitary, elegant mountain, sometimes set in a silvery cloud of fog. Alamo lies between this mountain and the undulating hills of Las Trampas, at the northern end of the San Ramon Valley. These hills provide boundaries for people living in the valley today, just as they once marked the territories of prehistoric Indian tribes and Mexican ranchos.

Alamo's creeks stretch across the valley, often carrying people's names, beginning with an Ohlone Indian called Ramon, for whom the valley was named. The San Ramon Creek flows north through Danville and Alamo and joins Las Trampas Creek as a headwater for the Walnut Creek Watershed. Three other Alamo-area waterways that flow to San Ramon Creek—Miranda, Stone Valley and Rutherford—were named after early residents. Las Trampas, "the traps" in Spanish, refers to the canyons into which deer were driven and trapped by Native peoples. Alamo is a Spanish name that means "poplar" or "cottonwood," trees that grew abundantly along San Ramon Creek.

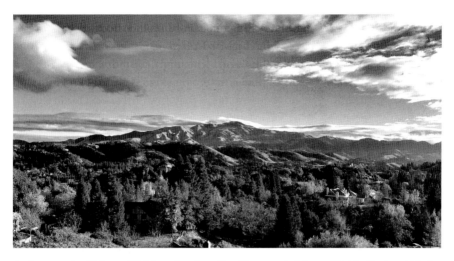

A photograph of Mount Diablo, taken from Las Trampas to Mount Diablo Regional Trail in 2020. *Photographer, Mark Harrigan. Courtesy of the Museum of the San Ramon Valley.*

During the nineteenth century, San Ramon Creek had wetlands on each side and was not as incised as it is today. James Smith recalled that the creek was a fine stream of water with many trout and an abundance of willow trees in different sections. In the 1860s, during the drier parts of the year when funerals were held at the Cumberland Presbyterian Church, he wrote that caskets could be walked across the waterway, directly to the Alamo Cemetery.

GEOLOGY

Las Trampas Hills, Mount Diablo and the San Ramon Valley have existed for only a brief moment relative to the tremendous age of the earth. Over billions of years, continents and seas have come and gone, and mountains have thrust upward, then melted away. The rocks that make up the valley formed slowly in a shallow sea as sand and clay layered into deposits thousands of feet thick. Today, fossilized marine oyster, scallop and snail shells from the Miocene era are found both in the valley and on the hills.

Mount Diablo came into being many millions of years ago, when an enormous segment of oceanic crust separated and slid into a deep trench on the ocean floor. As the oceanic plate continued its descent under the continent, a wedge was interjected at depth and slowly raised the mountain

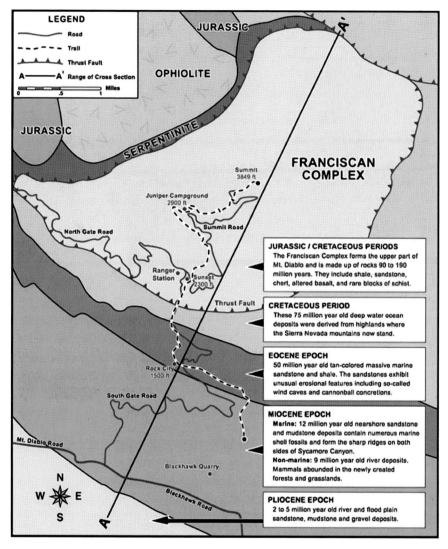

A drawing showing Mount Diablo's complex geology and its Trail Through Time. *Courtesy of Mount Diablo State Park.*

to its present position. According to geologist Ron Crane, the mass of the East Bay Hills has been squeezed into folds and faults, with rocks moving upward and outward in every direction, whichever way gave relief to the relentless pressure. The land shifted like a wedge pushing into a deck of cards—the free edge bending upward, with each surface sliding over the adjacent one.

The San Ramon Valley is still young, geologically speaking, and has small earthquakes regularly. One hundred thousand years ago, it was much wider than it is today. A lowland stretched a few miles to the west, southward to the rising Diablo Range, eastward to the growing low hills near Altamont Pass, northeastward to a gradually rising Mount Diablo and far to the north through Suisun Bay, toward the Central Valley. The East Bay Hills moved eastward as the Mount Diablo mass moved westward and upward, narrowing the valley to its present, slimmed form. It continues to slowly narrow, and one day, the valley will totally disappear.

Thought erroneously to be a volcano by many, Mount Diablo is much more complex than that. The core of the twin-peaked mountain consists of an uplifted jumble of rocks of the Franciscan formation, which are now exposed by the erosion of the once-overlying Cretaceous and Miocene formations. A "Trail through Time" in the state park may be followed, which shows how different layers folded over one another, allowing geologists to trace the various surface rocks. At 3,849 feet tall, the isolated mountain can be seen from hundreds of miles away.

EARTHQUAKES

Earthquakes are a fact of life in the valley, including occasional cluster quakes. Tear faults travel southwest from Mount Diablo, through Green Valley, north of Boon Hill and across Diablo Road to San Ramon Creek. West of the valley, the Calaveras Fault slices beneath the earth. It is covered by ancient landslides around Danville and near Las Trampas Ridge. This ridge forms the high hills to the west of Danville and Alamo and is a thrust-faulted anticlinal structure underlain by a series of natural springs.

Written records describe several large earthquakes in the San Ramon Valley. On July 4, 1861, the Calaveras gave a hefty jolt, which San Ramon's Samuel Russell said daylighted a good-sized spring on his ranch and damaged all the adobe buildings in Dublin, as reported by William Brewer.

On October 21, 1868, the Hayward quake shook the entire East Bay. In the Sycamore Valley, Cynthia Wood recalled that "the branches of the old oak swept the earth with its force…and chimneys were turned halfway around." The *Daily Alta California* reported, "At Alamo in Contra Costa County, the only brick house in the place is now a pile of bricks." At the time of the quake, Albert Stone was preparing to build a new house made

of brick, which he then decided against. The adobe home where the family was living at the time had nary a crack.

The large, long-lasting Loma Prieta earthquake of 1989 was felt throughout the valley, tumbling dishes from cupboards and collapsing chimneys, including one at the historic Danville depot building. Eager to help, Alamo's Don and Trudi Copland with daughter Kelly and others, traveled to the Santa Cruz mountains (near the epicenter of the 6.9 quake) and cooked a meal for three hundred homeless people at one campsite.

In 1990, Josephine Jones was living alone in the seventy-year-old Rancho Romero house when a series of earthquake swarms occurred over forty-two days. Centered on the Mount Diablo Thrust Fault, there were 350 earthquakes reported, with the largest measuring 4.4 on the Richter scale. They knocked food off store shelves and frayed nerves. For her, the quakes seemed to go on forever, and this was just six months after the Loma Prieta earthquake. So, at age eighty-two, she decided it was time to move.

The Alamo-Danville area has had seven similar quake swarms, ranging from two to forty-two days, since 1970. A swarm in 2018 included sixty small quakes, the largest measuring 3.6.

MINERALS

The mountain and environs in the Alamo-Danville area contain deposits of several minerals, including cinnabar (mercury ore), coal sand and rock. Cinnabar was used by the Natives as body paint during ceremonies and dances. In 1852, coal was discovered on the northeastern slopes of Mount Diablo. For several decades, the Mount Diablo coalfields were the main coal producers in the state and were surrounded by the largest towns in the county. After coal was no longer mined, sand was extracted for glass making during the twentieth century.

Mercury was discovered in 1863–64, and commercial amounts were extracted on and off for one hundred years. This has produced pollution downstream in Marsh Creek and its reservoir. During that decade, brothers Myron and Benjamin Hall from Alamo mined

Pioneer Myron Hall came to Alamo in 1853 and became the father of the walnut industry in the East Bay. *Courtesy of the Museum of the San Ramon Valley.*

on the mountain after copper ore with traces of gold was discovered on the slopes of Eagle Peak.

In 1925 when he wrote his memoirs, James Smith recalled this copper mine and the involvement of his father, John "Scotch" Smith. The Smiths lived near the Halls in Green Valley.

> *In 1864, Mr. Myron Hall, who had cattle that, at times, ranged upon the mountain, had frequent calls to travel on the west side of the mountain. On one of these trips, he discovered what was evidence of copper deposit and filed a mineral claim known as the "Hall claim." My father, being an experienced mining man…was engaged to sink a shaft on the prospect very near the top of the mountain. They had progressed until more assistance was required to go to a greater depth. They came from the mine July 3rd, 1864.*

This enterprise was not a successful one.

Crushed stone quarrying on the north side of the mountain at the Hanson Aggregates Clayton Quarry and Cemex's Clayton Quarry are now the only active mining activities on Mount Diablo. The material mined is diabase, a hard and durable rock used in the construction of roads, buildings, dams and levees.

Paleontology

Discoveries near Mount Diablo on the former Blackhawk Ranch revealed plants and wildlife, now fossilized, that existed here millions of years ago. A mastodon tusk was found in 1923 during a road-widening project in Danville. In 1937, the fossilized femur of a Miocene camel was discovered by University of California, Berkeley graduate student Nestor John Sander while he examined the southern reaches of Mount Diablo. A systematic study of what became the Blackhawk Ranch Fossil Quarry site has been carried out periodically by the University of California's Museum of Paleontology (UCMP) staff.

According to UCMP Museum scientist Mark Goodwin, the quarry is an excellent window into life in the Pacific region nine to ten million years ago, when this area looked like a rolling series of hills sweeping down to the ancient San Pablo Bay.

While the site is small, it is quite rich and diverse. Paleontologist Dr. Michael Greenwald said it includes animal and fish bones, plant fossils and

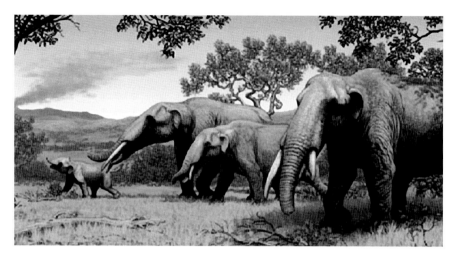

A drawing of the area's prehistoric savanna and the *Gomphotheriums* (a predecessor of the mastodon), which once lived in the valley. *Artist, Carl Buell. Courtesy of the Museum of the San Ramon Valley.*

remnants of ancient fauna and flora. Scientists think this concentration occurred because river waters picked up the bones and deposited them in a pool, or perhaps a bog existed in which the animals became mired.

Some of the animals that have been discovered include the medium-sized precursor of a mastodon (*Gomphotherium simpsoni*), saber-toothed cat (*Smilodon*), bone-crushing dog (*Epicyon diabloensis*) and one-toed horse (*Dinohippus*). The fossils include skulls, long bones, teeth, tusks, ribs and foot bones of a great variety of animals, including mammals, reptiles and fish. Plants recovered include leaves of poplar, willow, oak, elm, sycamore, mahogany and sumac plants.

By the late 1990s, over 3,400 museum-numbered specimens had been unearthed and removed from the Blackhawk Quarry. Most of these fossils were collected by Works Progress Administration crews in the late 1930s, but classes and field groups from the University of California and other institutions continue to examine the quarry during the summer months.

MOUNT DIABLO NAMES

The mountain was sacred to the ancient peoples, some of whom included Miwok, Ohlone and Yokuts language speakers. Indians met for fall

gatherings, where they traded, danced, worshipped, feasted and visited with relatives and neighbors. The upper reaches of the mountain were reserved for shamans or other individuals with special spiritual powers. Today, bedrock mortars reveal that people lived on the foothills of the mountain for extended periods of time.

Tribes had unique names for the mountain. Here are a few that are known:

- *Tuyshtak* (Ohlone/Costanoan)
- *Oj-ompil-e* (Northern Miwok)
- *Supemenenu* (Southern Miwok)
- *Sukku Jaman* (Nisenan)

Spanish navigators noted Mount Diablo as an early landmark when they first entered the Bay by sea in 1770. An early Spanish name for the peak was *Cerro Alto de los Bolbones*, or "High Point of the Volvon Indians," since most of the mountain lay within the Bay Miwok Volvon homeland. In 1805, when a group of Bay Miwok Chupcan Natives silently and successfully escaped from a thicket in north Concord, the pursuing Spanish soldiers named the area *monte de diablo*, or "thicket of the devil" in old Spanish. Gradually, this name was fixed to the prominent mountain not far to the south.

Explorers such as Edward Belcher in 1837 recorded that the "high range of the Montes Diavolo," as well as the "range of the Sierra Bolbones... (were) visible equally from the sea." In 1844, Eugene Duflot de Mofras wrote, "Mount Diablo, the highest peak in the California range, actual height is 1,149 meters. The end of this chain is designated locally as Sierra de los Bolbones. The location of Mount Diablo is important to navigators; being visible from afar, it marks the entrance to San Francisco Harbor." A Fremont map from 1848 called the mountain Monte Diabolo.

Americans, eager to have accurate boundaries drawn after California's 1850 statehood, sent crews to measure Mount Diablo early and produce maps keyed to the summit. No more watershed area boundaries accepted by different Native tribes. No more Mexican rancho grants, which used trees or rocks as boundary points, accepted by neighbors.

On July 18, 1851, Colonel Leander Ransom established the mountain as the reference point for United States land surveys in most of central California and all of Nevada. The base and meridian lines crossed at an initial point, which passed through the mountain's summit. Land survey maps of the Bay Area all use this same reference point, enabling the land to be divided into grids of 640 acres.

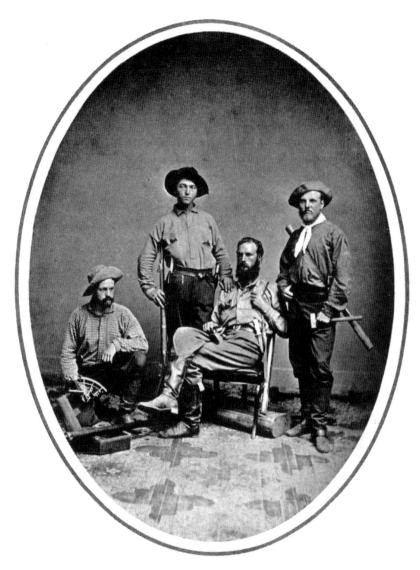

A field party for the California State Geological Survey in 1864. *Left to right*: James T. Gardiner, Richard D. Cotter, William H. Brewer and Clarence King. From William Brewer's *Up and Down California in 1860–1864.*

The U.S. Coast and Geodetic Survey and the Whitney Geological Survey used the same initial point to mark latitude and longitude and reference the area's geology. William H. Brewer kept notes for the Whitney Geological Survey, which included recording Diablo's flora and fauna. In particular, he noted tarantula spiders "of a size that must be seen to be

appreciated…their bodies as large as a half-grown mouse, their hairy legs of proportionate size, their fangs as large as those of the moderate sized rattlesnake. Pleasant companions!"

With its oak-dotted hills, burnished gold in the summer and soft green during rainy winters, Alamo has an exceptional setting. When residents wake to see clouds bouncing around the iconic Mount Diablo or watch Las Trampas fend off the Bay fogs, they know that the beauty of the place will stay etched in their memories forever.

THE FIRST PEOPLE

*A Northern Miwok, Too'-le-loo, stole fire from the valley people by putting them
to sleep with music from his elderberry flute, then placed some fire in the flute.
When he had done this, he ran out with it and climbed up to the top of the high
mountain called Oo'-yum-bel'-le* [Mount Diablo] *and made a great fire, which
lighted up all the country 'till even the blue mountains far away in the east* [the
Sierra Nevada Range] *could be seen. Before this, all the world was dark.*
—*C. Harte Merriam, historian*

*A*lamo's first people and their descendants lived in the area
for thousands of years. Their culture changed very little from
generation to generation, as they built villages by the creeks
and worshipped at sacred places in the valley and on the mountain. The
Bay Miwok-speaking Tatcan people lived in Alamo.

There are contemporary theories that trace human emigration from Asia,
but Indians know they have been here from the beginning of time. Native
creation accounts, as related in long narratives during campfire-lit winter
evenings, describe how people were made. Some tell about the heroic acts of
"First People," supernatural beings with both human and animal attributes.
This account was recorded in 1859 by H.B.D. in the *Hesperian Magazine*:

*At that time, the entire face of the country was covered with water, except
two islands, one of which was Mount Diablo, the other, Reeds' Peak.
There was a coyote on the peak, the only living thing there. One day, the*

coyote saw a feather floating on the water and, as it reached the island, suddenly turned into an eagle, which spread its broad pinions and flew upon the mountain. Coyote was much pleased with his new companion, and they lived in great harmony together, making occasional excursions to the other island, coyote swimming while eagle flew. After some length of time, they counseled together and concluded to make Indians; they did so, and as the Indians increased, the waters decreased, until where the lake had been became dry land.

In a Bay Miwok Julpun Indian world-making tale:

Molluk [Condor] *lived on Mount Diablo, where his son, Wekwek (Falcon) was born. Wekwek flew east to buy a branch of the elderberry tree from the Star Women. Wekwek and his grandfather Olette* [Coyote] *planted elderberry trees to provide music, food, and medicine for the people they were going to make.*

To create people, Wekwek and Olette captured three bird beings and plucked their feathers. They traveled to places where they wanted villages and stuck three feathers in the ground. The feathers came to life and became people. Olette turned himself into a coyote, and Wekwek changed into a falcon.

The Natives' lives revolved around the rhythms of the natural world, which provided a dependable and diverse diet, including seeds, acorns, fish, birds, insects, animals and root plants. In certain seasons, such as autumnal acorn-gathering, people worked from dawn to dusk; at other times of the year, life took a more measured pace. Using regular burning and pruning, they shaped the grasses and plants of their landscape. They traded for desirable items that were unavailable locally, including obsidian rock for arrow and spear points, which came from the Napa Valley.

Indians moved from permanent settlements to seasonal camps during the year. They knew their own territory intimately, with boundaries accepted by neighboring tribes. To reach Mount Diablo for the autumn festivals, permission to travel through the Tatcan territory would have been needed. At least seasonally and for these gatherings, people lived on the Mount Diablo Foothills, as evidenced by today's bedrock mortars, cupule petroglyphs and rock chip areas where chert was quarried.

Special ceremonies on Mount Diablo were only one part of what Theodora Kroeber has called the "gossamer curtain of religion," which hung over all Native activities. Ethnohistorian Randall Milliken provided this description:

The earth and sky and all objects in between had life and consciousness.... Individuals and groups could...increase their chances for good health and wealth by following traditional ethical proscriptions in every aspect of life. They showed respect to unseen forces through prayerful thoughts and offerings as shrines and by repeating traditional religious dances at proper seasons on a yearly cycle.

Ethnohistorians think the Bay Area has been populated for about thirteen thousand years. Information about the first people was recorded in Spanish writings beginning in the 1770s. This information can also be found in mission records and surveys, accounts of European expeditions, interviews with descendants by ethnohistorians and archeological discoveries. In Alamo, three sites were investigated by archaeologists in the 1960s, with one site dating a human presence of at least five thousand years.

Milliken wrote that the first Spanish-named people who lived in Alamo and the western reaches of Mount Diablo were the Tatcan (Tascan), part of the Bay Miwok language group of Contra Costa. He estimated that their territory—the San Ramon Creek Watershed—was about eighty square miles, with a population of 220 to 240 Tatcan people at the time of Spanish contact including half of them under the age of fifteen.

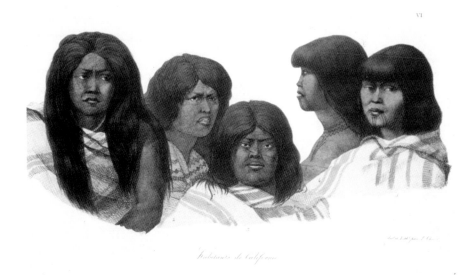

A drawing of Bay Area Natives in 1816. The figures on the right provide two views of a Bay Miwok Saclan woman. *Artist, Louis Choris. Courtesy of the Bancroft Library.*

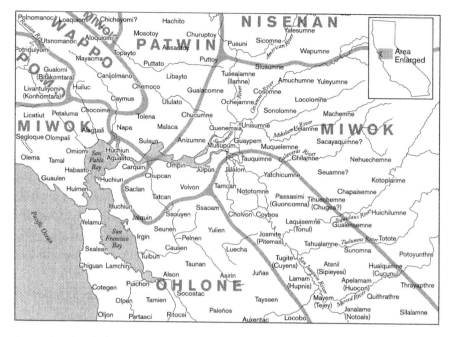

A map showing the language groups and tribes that lived in West Central California. From Randall Milliken's *Native Americans at Mission San Jose*.

Other Bay Miwok speakers included the Saclan, who lived north of Alamo in Lafayette and points west; the Chupcan in Concord; the Volvon (Bolbon) north of Mount Diablo; the Ompin at the northeastern edge of the county; and the Julpun east of the mountain. Ohlone (Costanoan) tribes, called Seunen and Ssouyen, lived south of the Bay Miwok territory in the Alameda Creek Watershed, which includes San Ramon and Dublin today.

The Tatcan intermarried with members of other tribes from as far away as Altamont Pass (Brushy Peak), the Amador-Livermore Valley and the Diablo Valley. Usually, they stayed in their own territory and traded for goods that were unavailable locally, although the men may have gone as far as Napa for large festivals. Some of them would have traveled as far west as the Hayward area and known about the ocean. Our knowledge of their living patterns, material culture and spiritual beliefs touches only the surface.

The Spanish Invasion

In March and April 1772, an *escolta* led by Capitan Pedro Fages and accompanied by Franciscan Padre Juan Crespi traced the northern part of Contra Costa County and the delta and then trekked south from Walnut Creek through the San Ramon Valley.

Padre Crespi's diary described the Alamo area and the Natives' reactions:

> *March 31: At six in the morning, we set out.... We came to three villages with some little grass houses. As soon as the heathen caught sight of us, they ran away, shouting and panic-stricken.... This valley seemed to me to be a charming site for a settlement with all the advantages that are required.*

> *April 1: We set out at six, following the same valley in a southerly direction, the excellence of the road continuing, with many trees. This day, we covered ten leagues, all by the same valley, all level land, covered with grass and trees, with many and good creeks, and with numerous villages of very gentle and peaceful heathen. It is a very suitable place for a good mission, having good lands, much water, firewood and many heathen.*

The Indians may have heard about men on horses who had traveled on the east shore of the Bay in 1770, but the reality was something else altogether. Nevertheless, after the initial shock, Natives along the Fages and later Spanish expedition routes responded to the strangers as they normally did—by formal greetings and by trading goods and food. Soon, missionaries tried to entice the Natives into the new mission settlements, focusing especially on young people.

In 1794, twenty years after the first Spanish incursion, the acorn crop failed in the Bay Area, and 1,200 people joined the missions of San Francisco and Santa Clara. Almost all of the Saclan and eight Tatcan went to San Francisco. When Indians joined a mission, some instruction was usually attempted and the recruits were baptized, which meant the Padres considered them to be their wards. Thereafter, these "neophytes" could not leave the mission without permission.

Shortly after the East Bay Indians came to Mission Dolores in San Francisco, a disease struck (probably typhus) that sickened and killed many of them. A large group of the newly baptized Bay Miwok Natives left the

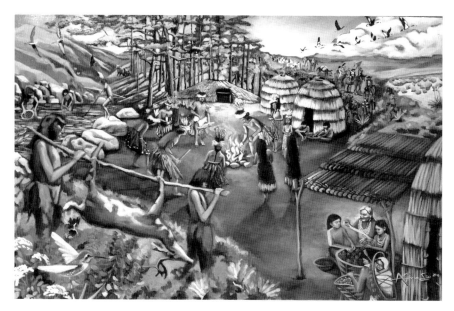

First Contact, a drawing by artists Alicia Maria Siu, Antonio Moreno, Vicente Moreno and Vicente T. Moreno. *Courtesy of the California Indian Heritage Center Foundation.*

mission. They returned to their homelands in today's Lafayette and, when fourteen mission Indians were sent to get the escapees, seven of them were killed in the ensuing battle.

There were not enough soldiers to punish the Natives for these deaths, and a significant Indian defiance persisted for nearly a decade. The Saclan and others threatened to kill Indians who helped build the proposed mission at San Jose. Probably allies, cousins and friends of the Tatcan were involved in this resistance.

In 1797, Mission San Jose was founded close to Santa Clara. A logical location for the mission would have been farther inland in the Amador or Diablo Valleys, but the Native tribes' hostility prevented it. Sargento Pedro Amador wrote that the Spanish needed to end the resistance because the Indians "have the idea we fear them" and should be set straight. On July 15, 1797, Amador led twenty armed Spanish troops and attacked the Saclan village of Jussent. The soldiers killed seven and took thirty captive, charging eight of the Saclan men with the killings in 1794.

TRADITIONAL CULTURE ENDS

By 1803, the East Bay area was stripped of Indian tribes, as their village economies and trade systems had collapsed. The people were having debates about whether or not to go to the missions. Perhaps the Spanish spirits were simply more powerful than the mountain spirits. Chief warriors lost credibility when they were defeated by the powerful Spanish weapons. Cattle grazing was destroying the Indians' clover, herb, seed and lupine fields and creating food shortages. Spanish food was interesting and had become more reliable as crops were planted. But babies died early at the missions, unusual diseases abounded and the old ways were not respected.

In 1803–4, 150 Tatcan people went to Mission Dolores. At that point, the missionaries were deciding which mission Natives should enter and were probably splitting up tribes that lived near the resistance centers. A devastating measles epidemic killed many Tatcan at Dolores in 1806.

The San Ramon Valley was named for a baptized Indian, Ramon Nonato, whose Native name was Usacsc of the Ssouyen (Ohlone) tribe, located in San Ramon. In an 1855 land case, Jose Maria Amador testified that a mission Indian named Ramon had tended sheep in the area and that the creek and valley were named for him. The preface "San" was added later.

Ranchos were granted to former soldiers on mission lands after the successful Mexican Revolution in 1821, so Natives dispersed from the missions, and many worked on ranchos. Some came from Mission San Jose and set up camps on Mount Diablo's foothills, raiding ranchos for cattle and horses. The Indians threatened the first Alamo/Danville rancho owners, Mariano Castro and Bartolome Pacheco, who received permission to live in Santa Clara and Pueblo San Jose instead of at their rancho. Corrals were built near today's Crow Canyon Road, away from the mountain.

TWENTIETH-CENTURY DISCOVERIES

A Smithsonian reference book edited by Robert F. Heizer, *The Handbook of North American Indians, California*, provides general information about the Bay Area's first people. One page shows drawings of artifacts that were found in a Danville burial mound, CCo-229 (the site's specific number), not far from Alamo, during the 1950s. Beads, abalone ornaments, charmstones, spear

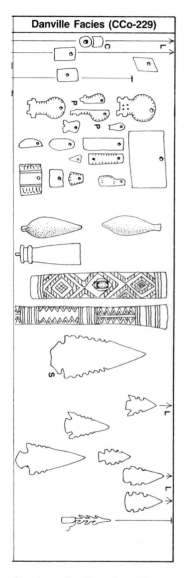

Danville Facies (CCo-229)

Drawings of artifacts found in a Danville mound, CCo-229. From the Smithsonian Institution, *Handbook of North American Indians*, vol. 8, *California*, 44.

and arrow points, deer bone awls, pestles, mortars and bone whistles are among the items shown.

In contemporary times, several Indian village or burial sites have been unearthed. In 1962, when the state realigned San Ramon Creek to construct the I-680 freeway off-ramp and a new Stone Valley Road, a significant Indian site was unearthed. The leader of the archaeological excavation, Dr. David Fredrickson, was one of the first California archaeologists to reach out to Native descendants and confer with them about the remains found at such sites. At site CCo-308, he and his team uncovered three distinct levels of occupation. The site's lowest strata revealed artifacts and remains that were over five thousand years old. At the time, this excavation and its findings represented one of the oldest and most important in the Bay Area.

Since the freeway construction schedule limited the time allowed for study, Fredrickson noted that there would have been more to learn deeper in the site. He said that from what was found, the most recent tribes appeared to have been fairly wealthy. The investigation was financed by the Archeological Salvage Program of the State of California Division of Highways.

Other sites in Alamo where Native remains have been unearthed include one south of the village (CCo-30), which was also investigated in 1962. In addition, the "knoll," which is often referenced in histories of Alamo's first post office, turned out to be an Indian burial mound, number CCo-311. When the knoll was leveled in 1967, over fifty burials were found. The artifacts discovered there included Olivella beads, abalone pendants and seventeen large stone

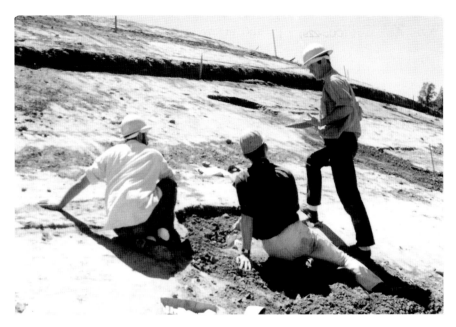

Archaeologists at site CCo-308 on the San Ramon Creek in Alamo, circa 1962. *Photographer, Betty Humburg Dunlap. Courtesy of the Museum of the San Ramon Valley.*

ceremonial blades. Described as a "salvage site," a limited amount of time was provided for study because of commercial project deadlines. An *Oakland Tribune* article on September 15, 1967, reported, "The site has now been leveled because of the hordes of sightseers and amateur 'pot-hunters' who flocked to the scene."

Currently, descendants of California Natives are working to preserve sacred sites and revive past customs, ceremonies, dances and languages. Scholars are mining the interviews that J.P. Harrington recorded in the East Bay, and there are efforts being made by Vincent Medina and others to revive the Chochenyo Ohlone language. A magazine called *News from Native Californians* offers extensive information about descendants' contemporary activities. The annual Ohlone Gathering in Fremont at Coyote Hills Regional Park provides opportunities to learn more about the California Indians who first lived here.

THE HISPANIC ERA IN ALAMO

At six in the morning, we set out....We came to three villages with some little grass houses....This valley seemed to me to be a charming site for a settlement with all the advantages that are required.
—Padre Juan Crespi, March 31, 1772

When planners examine topographical maps of the San Ramon Valley, the phrase "Rancho San Ramon" appears—a reminder of the Mexican ranchos that preceded Alamo's American settlement in the 1850s.

MISSIONS

The first Spanish expedition to travel through Alamo arrived on March 31, 1772. Capitan Pedro Fages, along with a few soldiers and Padre Juan Crespi, had been sent from Monterey to discover if there was a land crossing over the San Francisco Bay from the southern shore to the north side. They found only expanses of water and an enormous, impassable delta full of spring runoff.

While Crespi wrote that the valley was "a very suitable place for a good mission," and commented on the many Natives, ample vegetation and clear water, no mission was founded in the inner valleys. Two missions, one in San Francisco (1777) and one in San Jose (1797), had the greatest impact on the East Bay Native peoples prior to the rancho era.

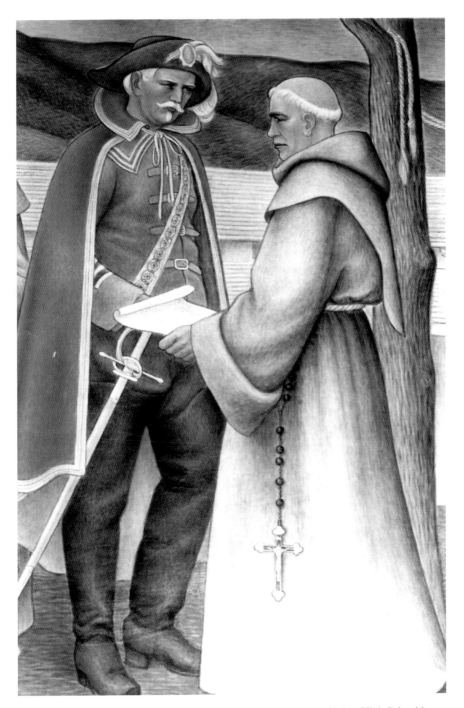

A mural showing a Spanish soldier and Franciscan missionary at Mission High School in San Francisco. *Artist, Edith Hamel. Courtesy of the Museum of the San Ramon Valley.*

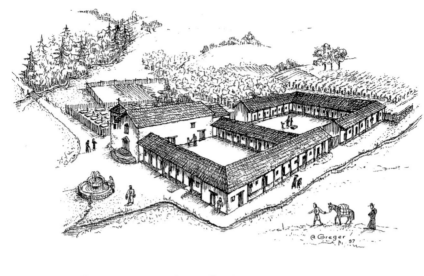

Conceptional View of Mission San Jose – ca. 1830

A conceptual view of Mission San Jose in 1830. *Artist, Al Greger. Courtesy of the Museum of the San Ramon Valley.*

When the Spanish first invaded Alta California in 1769, missions were their main colonizing institutions, with twenty-one Franciscan missions established from San Diego to Sonoma. The missionaries recruited Native peoples as laborers, baptizing them, teaching them to carry out new tasks and expecting them to change their life patterns. The Natives sustained the missions and learned agricultural skills, such as garden, orchard and livestock management, but at a devastating cost.

Ethnohistorian Randall Milliken wrote:

> [At the missions], *people were subjected to paternalistic controls on their work schedules, on their sexual practices, their eating habits, their religious expression, all in ways contrary to their indigenous values. Daily operations were maintained by threats of punishment in this life and an eternal afterlife. And the missions were breeding grounds for disease.*

Many Bay Miwok peoples, led by the Saclan and supported by the Tatcan, resisted the Spanish for years. Hubert Howe Bancroft in his *California History* wrote this about the resistance:

The natives…caused more trouble in the region of San Francisco than in any other part of California, the troublesome gentiles [unbaptized Indians] *being chiefly those inhabiting what is now known as Alameda and Contra Costa Counties, acting in conjunction with deserters from San Francisco mission, but threatening more seriously Mission San Jose.*

After Mission San Jose was founded in 1797, Alamo and Contra Costa County became part of the mission's Indian recruitment area, and traditional village life gradually disintegrated. The valley became mission grazing land for sheep and cattle tended by Indian vaqueros. In dry years, the livestock spread north into today's Diablo Valley.

Padre Narciso Duran, a longtime missionary at Mission San Jose, taught Natives the new skills and religious expectations. He developed a Native choir and orchestra of some renown. Nevertheless, as with all of the missions, at Mission San Jose, many Natives who were confined there died of various diseases (typhus, measles and syphilis). At one point, the Natives were characterized by Duran as being "fragile as glass." In one letter, Duran worried that giving Natives access to horses might be shortsighted because he saw their potential to be as fierce as the Apaches.

THE RANCHO ERA

New Spain supported the missions' land holdings and gave fewer than thirty land grants to individuals. One such Spanish grant was given to Luis Maria Peralta in 1820. His enormous Rancho San Antonio included today's Oakland, Berkeley, Emeryville and Albany and extended to Las Trampas Hills on early maps. One of Peralta's sons, Domingo, later testified in a land case that, as a boy, he had hunted in the inland valleys—including Alamo—and knew the area well.

After the Mexican Revolution in 1821, the new government took a different approach to settlement. They ended the mission system and opened mission lands for private ownership—a process called secularization. Throughout Alta California, newly granted Mexican ranchos became the centers of power, replacing missions. Over eight hundred ranchos were granted with elaborate procedures that had been set up to verify ownership, even though the Mexican government was not particularly stable. A grantee had to file a petition with the governor for a specific tract

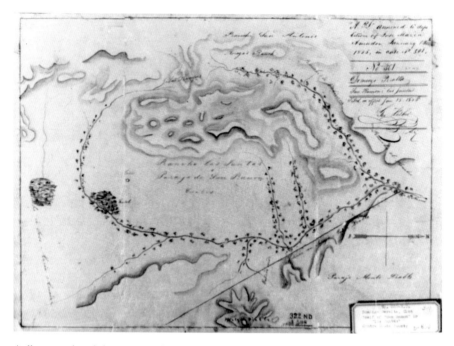

A diseno, or hand-drawn map, showing the Rancho San Ramon, two square leagues owned by Mariano Castro and Bartolome Pacheco. The drawing shows a truncated image of their valley property, with Las Trampas (west) across the top and San Ramon and Las Trampas Creeks joining to the right (north). The two creeks merged to create Walnut Creek. *Courtesy of the Bancroft Library.*

of land, prove Mexican citizenship, present reasons why the land should go to them and provide a sketch-map (*diseno*) of the land.

Then the grantee had to mark the land's boundaries, erect a permanent building or fence and either make a survey or have the local magistrate define the boundaries by an act of judicial possession. An initial decree was then issued, followed by a final one. Often, the boundaries were made without surveying instruments, since there were few trained surveyors in Alta California. The disenos regularly referred to a leaning tree, huge rock or turn in a creek to mark their limits. Other times, the boundaries were simply mutually agreed on by adjacent owners.

Frequently, Mexicans would apply for the land and, since the title confirmation process took so long, they would settle on the rancho before the final decree was issued. Many of the Californios (native-born Californians) neglected one or more of the required steps, especially the boundary-marking, which damaged their cases in American court land title hearings after 1851.

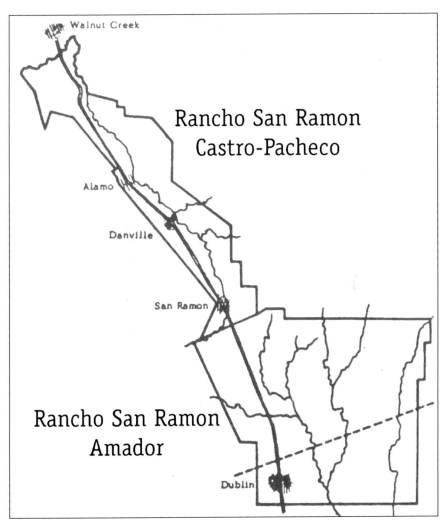

A map showing both San Ramon Valley ranchos granted by Mexico in the 1830s, as approved by the Land Commission. The dotted line indicates the Contra Costa–Alameda County line; the solid line is I-680. The San Ramon Creek and Alameda Creek Watersheds are outlined, showing that the Castro/Pacheco Rancho waters flowed north to Suisun Bay, and the Amador Rancho waters went south and west to San Francisco Bay. *Courtesy of the Museum of the San Ramon Valley.*

It was not until the mid-1830s that former soldiers received grants in the San Ramon Valley. In 1833, Mariano Castro and his uncle Bartolome Pacheco were the first to receive a grant. It included the San Ramon Creek Watershed in Alamo, Danville and north San Ramon and covered two leagues, or about nine thousand acres. Castro owned the northern half, and Pacheco owned the southern. In 1834 and later, Jose Maria Amador received over twenty thousand acres for his Rancho San Ramon, which included Dublin and San Ramon in the Alameda Creek Watershed.

Most mission Indians went to work in the newly established ranchos. Some joined existing villages in the Central Valley; some from Mission San Jose created a village at Alisal in Pleasanton; and others combined in multitribal bands and attacked ranchos. One such group was located in the foothills of Mount Diablo, where the Indians threatened rancho owners and took cattle and horses at will. North of Alamo, Felipe Briones was killed by the Natives in January 1840, when he was helping Ygnacio Martinez recover livestock that had been taken from Rancho Pinole. The Soto brothers lived briefly in Danville, but after all of their horses had been stolen by Natives, they moved back to a safer area.

Neither Castro nor Pacheco settled on their rancho because the Indians around Mount Diablo were no longer Crespi's "gentle and peaceful heathen." The Mexicans feared them, according to repeated testimony in 1850s land cases. Castro and Pacheco constructed a building and corrals at the south end of their Rancho San Ramon, away from the mountain and near Amador's boundary. They went to their rancho for periodic cattle branding and slaughtering. Precise boundaries for both the Amador and Castro/Pacheco grants were delineated later by American courts.

RANCHO EL SOBRANTE DE SAN RAMON

In 1843, brothers Inocencio and Jose Romero talked with rancho owners in Walnut Creek (William Welch's Arroyo de las Nueces y Bolbones), Moraga (Joaquin Moraga's Laguna de los Palos Colorados) and Alamo (Castro) about receiving a five-league grant in Alamo, Tice Valley and part of Las Trampas Hills. It was viewed as a leftover area, or a *sobrante*. In later land case testimony, their fellow Californios testified that they welcomed the Romeros and were pleased to have them as neighbors.

Cattle brands for Mariano Castro (top), Domingo Peralta (middle) and Inocencio Romero (bottom). *Courtesy of the Museum of the San Ramon Valley.*

The *Contra Costa Gazette* from August 27, 1864, stated: "It was mutually agreed that the Romeros should occupy the land north of a certain creek, which ran across the [Pacheco/Castro] ranch." In land case testimony (LC 322), Victor Castro said the creek was three-fourths of a mile south of the "Town of Alamo." It was referred to as a dry creek and was probably the creek that is located just south of today's La Serena Avenue, which flows under the highway to San Ramon Creek.

The rancho's complete name was Rancho El Sobrante de San Ramon, and it covered about twenty thousand acres. In 1844, the San Jose alcalde and Governor Manuel Micheltorena reviewed the grant application, which included a diseno. In Land Case 304, Micheltorena stated, "Let the judge of the proper district take measurement of the unoccupied land that is claimed." The Romeros could not afford to have the measurement made, since there were few surveyors available and their wealth was tied up in livestock. Their neighbors accepted the rancho's approximate boundaries. After all, there was plenty of land, and the cattle grazed unrestricted by fences. Cattle ownership was established by regular round ups where calves were marked with the mother cow's brand.

Other than the measurement, the Romeros did what rancho owners were required to do. They moved to the property (in today's Tice Valley), built an adobe house, constructed a corral, cultivated vegetable and grain crops and ran cattle and horses.

Next, the Romeros appeared before John Burton, the alcalde of San Jose, in January 1847, ready to sell the eastern one-half of their rancho for sixty dollars to Francisco and Jose Miguel Garcia, their brothers-in-law. The sale was to be subject to the final result "if the government grant it in ownership." Both parties agreed that if the grant was not finally made, "then Garcia should lose equally with Romero." Mexican and post–Gold Rush settlers assumed that the Romero brothers owned the land and had legally sold the Alamo area to the Garcias.

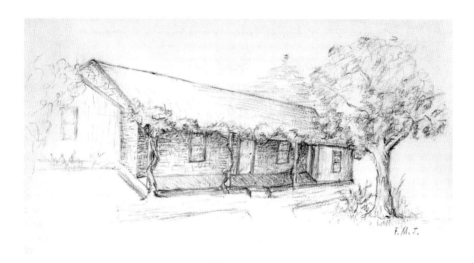

A drawing of the Jose and Rafaela Garcia adobe, which was built in 1848. Albert and Martha Stone and their family lived there until they built a large Victorian house around 1870. *Artist, Flora May Stone Jones. Courtesy of the Museum of the San Ramon Valley.*

Two adobes were built in the Alamo area by the Garcia brothers around 1849. Francisco and Maria Garcia's large adobe was built on a mound (or knoll) in the future village of Alamo. The other adobe was built by Jose Miguel and Rafaela Miranda de Garcia east of San Ramon Creek. Evidently, several Spanish families lived in this vicinity.

TITLE PROBLEMS FOR ALAMO

After California statehood, a Federal Land Commission was set up to address land claims in 1851. The commission had three types of title classes to address: clearly valid claims with title papers, claims with unclear titles and claims that were obviously fraudulent. The commission chose to question all titles, which led to lengthy court battles, during which the Spanish-speaking (and sometimes illiterate) Californios were greatly disadvantaged.

When the Romero brothers petitioned for a confirmation of their claim to the "Romero Sobrante" before the U.S. Board of Land Commissioners in 1853, many witnesses testified to their ownership in multiple pages of the Northern District Land Case 304. In the hearings, Jose Maria Amador supported the Romeros' claim to the grant. He stated: "[In] 1844, the Romeros went upon the land and built a wooden house and put on it

about 100 head of cattle" and fifteen to twenty horses and cultivated a portion. Then they built corrals, enclosed land and "made improvements on the said wooden house with adobe." A relative of Rafaela Soto de Pacheco, Francisco Soto, claimed some of the Sobrante property in 1836, a transaction that never was concluded.

The Romeros produced documents to establish their claim but not the title papers. They stated that the title papers had been used in an 1850 suit and had been taken to Georgia by a lawyer, Fred H. Sanford, never to be seen again. In 1857, the judge wrote that their case was a hard one, "For there seems no reason to suppose that the grant would have been refused, if the measurement had been made....But no grant, either perfect or inchoate, was made, nor any promise given that one should be made." The Romero claim for five leagues of land was rejected by the board and appealed to the U.S. District Court and U.S. Supreme Court, where it finally lost in 1864.

Imagine the effect of this tangled web of landownership in the San Ramon Valley. The Romeros (and, therefore, the Garcias) did not own the land in Alamo. Americans who had bought land from Romero or Garcia lost their claims and were often labeled "squatters." This happened with other parts of the Castro/Pacheco Rancho as well. Domingo Peralta testified he had sought to buy the Castro league of the original San Ramon Rancho property in 1843 from his brother-in-law Mariano Castro, but a dispute between Castro and Lorenzo Pacheco (Bartolome Pacheco's heir) prevented the purchase. Evidently, Peralta successfully acquired part of the property in 1852.

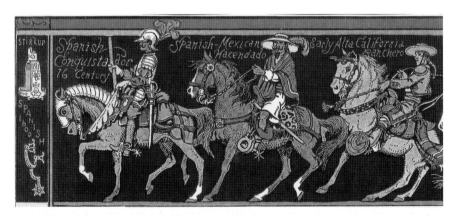

Horsemen of the Hispanic era: a Spanish conquistador, a Spanish Mexican hacendado and an early Alta California ranchero. *Artist, Jo Mora. Courtesy of the Museum of the San Ramon Valley.*

Historian Josiah Royce described the Mexicans' problems. "The poor Californians, no businessmen to begin with, [had to] gamble for their own property, under the rules of an alien game, which they found largely unintelligible." The Mexican rancheros were often behind in taxes and ended up paying attorneys in land. Very few came out possessing even part of their land grants.

Ultimately, the notorious American attorney Horace Carpentier managed to obtain both the Romero Sobrante and the Castro/Pacheco Ranchos. Fluent in Spanish, Carpentier—who had begun his accumulation of rancho land with some of the Peraltas' Rancho San Antonio property—shifted his attention to several ranchos in Contra Costa County. Lorenzo Pacheco's widow, Rafaela, hired Carpentier to help with her title confirmation, with land as payment. He acquired this rancho (and others) by paying delinquent taxes and debts, and he threatened litigation to have his way. As Hubert Bancroft wrote in *History of California*, "This Carpentier seems to have been a shrewd land fiend interested in many of the crooked cases."

Throughout California, if a Mexican ranchero was able to keep five hundred acres and a house out of an average ten-thousand-acre rancho, that was a successful result. Ultimately, post–Gold Rush settlers in Alamo and Danville had to negotiate with Carpentier to obtain secure titles. A complicated and sad tale, indeed.

4

PIONEER DAUGHTERS NARRATE ALAMO HISTORY

On every side, the valley and surrounding hills were covered with thick, velvety clover, and with wild oats standing waist high, waving and rippling in the summer breeze like the bosom of a lake.
—Flora May Stone Jones, historian

Memories from longtime residents are always a treasure. In 1914, the following essay by Friederiche Humburg appeared in the first San Ramon Valley Union High School yearbook, *The Valley Kernel*, when she was a sophomore. She wrote this with her aunt Flora May Stone Jones, so it should be viewed as a joint effort. Jones had graduated from the Mills Seminary in Oakland and was a diligent historian.

An Historical Sketch of San Ramon Valley

And what is so rare as a day in June?
Then, if ever, come perfect days;
Then Heaven tries the earth if it be in tune,
And over it softly her warm ear lays.

It was on such a perfect day, in June 1847, that a canvas-covered wagon, drawn by oxen, slowly wound its way through a beautiful valley. This "prairie schooner" carried a little family of home seekers, and as the oxen moved laboriously along,

A portrait of Friederiche Humburg when she was a high school student. *Courtesy of the Museum of the San Ramon Valley.*

the scene which greeted the eye at every turn of the winding path called forth exclamations of admiration from the occupants of the wagon.

At length, the travelers halted the oxen that they might better gaze and admire the picture of beauty and serenity that was spread before them. On every side, the valley and surrounding hills were covered with thick, velvety clover and wild oats standing waist high and waving and rippling in the summer breeze like the bosom of a lake. The western hills were clumped with oaks, maples and shrubs, willows and mottled trunked sycamores fringed the little stream at their left; while the mountain, which formed the eastern wall of the valley, seemed ever at their side as they journeyed southward.

Cattle grazing on the luxuriant grasses, the chirp and twitter of birds and the drowsy hum of insects completed a picture of beauty, peace, and contentment. Save for the bridle path, which was the only guide of our travelers, and for a tule thatched hut near the stream (used as a rude shelter by Spanish vaqueros when night overtook them in this region), there was nothing to show the hand of man.

This was San Ramon Valley as it looked when first viewed by Americans, when they stopped their ox team on that June day so long ago, just north of the spot where the village of Alamo now stands. No wonder that the head of that little family bared his brow, as he stood amid the wild oats and exclaimed, half in prophecy, half in determination, "Some time, we will have a home in this valley." This was before the discovery of gold in California, and this little family were home seekers, not gold hunters. But because of the Mexican war, which was raging at that time, they sought a settlement for protection, and Pueblo (now San Jose) was their destination.

Four years later, the year 1851 found our homemakers back in the San Ramon Valley accompanied by another family. These two families, along with two others who joined them later, purchased four leagues of land in the Romero Grant, paying for it four thousand dollars.

Is not our pride in our valley justifiable when one considers that these people who had journeyed by wagon and ox team over half a continent, and who had the whole state of California to choose from, chose for their home the heart of the San Ramon?

Some changes marked the valley during the four years that had passed, notably the building of adobe houses, which were the homes of Spanish families. Viewed through the lapse of years, we associate the adobe with the romantic and the picturesque. Built of adobe bricks, dried in the sun, their thick walls, deeply framed doorways and windows afforded warmth in winter and coolness in summer. Every adobe house was surrounded by a 'portico' about whose rude pillars clambered vines of the mission grape, and in every door yard bloomed the fragrant Castilian rose of old Spain.

The adobes call to mind tales of the gay, carefree life of the Spanish days in California. We think of the fandango, the soft music of the guitar and the horsemen with their wide sombreros, their bright colored serapes, their jingling spurs and their horses no less gaily bedecked in silver mounted bridles and saddles with monstrous *tapaderas*.

But one may ask why, in our valley today, we find no descendants of these gay, pleasure-loving people. That question may be answered in two words: the "manana" of the ease-loving Spaniard and the "today" of the hustling, progressive American.

Farms were improved with houses, barns and granaries, a few fruit trees were set out, and gardens planted. The fertile land, little of which had ever known a plowshare, under American thrift, was cultivated and made to produce abundantly.

In the midst of this prosperity, a heavy blow fell upon the residents. The Spanish grants under which title the people had bought their land, became the cause of years of litigation, and many residents were forced to pay for their land a second time.

In those days, all were neighbors in the fullest sense of the word; helping one another by an exchange of work; all joining together in their few social affairs; and ready to aid when sickness or death entered a home. Doctors were far away, and trained nurses were unknown, but it was nothing unusual for a pioneer mother to ride miles on horseback, often with a baby in her arms, to care for a sick neighbor.

The first post office in San Ramon Valley was established in 1852 and named "Alamo"—a Spanish word meaning poplar tree. The post office was given quarters at the home of John M. Jones, who lived in an adobe house that

A portrait of Flora May Stone before she married James Cass Jones, circa 1895. *Courtesy of the Museum of the San Ramon Valley.*

crowned the knoll of the J.O. Reis home site just north of Alamo. Mr. Jones was the first postmaster, and his wife, Mrs. Mary A. Jones, was his deputy. For many years, Alamo was the only post office between Martinez and Mission San Jose. The mail was carried between those two points by a man with a horse and cart who made a round trip twice each week.

Alamo is the second oldest town in the county, Martinez being the oldest. The first house in the town of Alamo was built by a man named George Engelmeyer. He at first had a shoe shop, but he soon enlarged his shop to a general merchandise store and did such a thriving business that in a short time, he had to employ a clerk. Other shops soon followed—blacksmith, harness and butcher shops and a hotel.

In 1858, the frame building, still standing under the maples and walnuts on the west side of the street, was built. The lower floor of this building was used as the general merchandise store of Lomax and Smart, while the upper floor was the Masonic lodge room. Alamo Lodge No. 122 F. & A.M., which now holds its meetings at Walnut Creek, was organized in Alamo in 1858, and this old building was its first home. In 1860, a two-story brick structure was erected on the west side of the street, on the property that is now owned by Mrs. George Smith. Wolfe and Cohen were the owners of the general merchandise store that occupied the lower story, while the Masonic lodge moved from its first location into the more commodious quarters of the upper story of the new brick building.

The bricks from which this building was constructed were made by G.W. Webster, who lived in what is now the Van Gorden place. The brick kiln was situated on the Rancho El Rio, just across the creek from the Van Gorden pear orchard. In the great earthquake of 1868, the building mentioned was badly damaged and was soon afterward torn down.

The ruin known as the Foster house is of historic interest. It was erected in 1857 by James Foster of Maine, and the staunch timbers of which it is constructed were made from trees that grew in the Maine woods. The lumber for the house was sawed, shaped and fitted, all ready to put together, then shipped around the horn to its destined home.

Mr. Foster was a wheelwright, and wagons, carriages, furniture and even coffins, when occasion required, were turned out from his shop with a neatness and finish that would do credit to the present day.

In 1854, the first school in San Ramon Valley opened its doors in a little house that stood in the northern part of what is now the Kendall property, near the cemetery. Richard Webster was the first teacher. Soon after, a church (Cumberland Presbyterian) was built near the schoolhouse on the lot that is now a drive way leading to the cemetery.

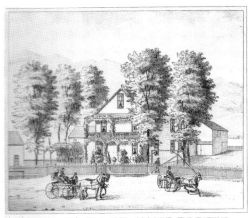

RESIDENCE OF JAMES FOSTER,
ALAMO, CONTRA COSTA CO. CAL.

The James and Nancy Foster house on a county road. From *Illustrations of Contra Costa Co. California with Historical Sketch*, 1879.

For a while, a school was conducted in a little house that stood on a bedrock knoll, a short distance north of the point where the Southern Pacific Railroad crosses the county road between Alamo and Walnut Creek. This was known as the "Wall" schoolhouse, being near the home of Captain Wall, at that time the owner of the Foulds Ranch.

In 1859, leading residents organized the Contra Costa Educational Association and erected the Union Academy, a boarding and day school. The Academy opened for instruction in June 1860, with Rev. David McClure as its first principal, while Silas Stone, John M. Jones and Robert Love comprised its first Board of Trustees. The Union Academy was a large three-story structure, centrally located between Alamo and Danville, on the west side of the county road, on land that is now a prune orchard belonging to E.B. Anderson. The fine locusts that grace the roadway at that spot were planted in the days of the academy, to adorn the entrance to its grounds.

John H. Braly, who was, in later years, the principal of the San Jose Normal School, succeeded Dr. McClure as principal. Mr. Braly's successor was Rev. Robert King, and in 1868, during his principalship, the Academy was destroyed by fire and was never rebuilt. The church building almost directly opposite the academy site afforded temporary school accommodations. In the meantime, other towns had sprung up—Danville (so named for Daniel Inman, its first resident), Limerick (now San Ramon) and Walnut Creek, situated at the junction of Walnut and San Ramon Creeks. District schools were established in Alamo and in these younger towns.

In 1910, by popular vote of the Danville, San Ramon, Alamo, Green Valley, and Sycamore districts, a high school was established in Danville and named

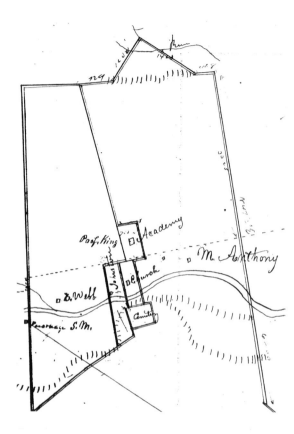

Left: A county survey map from 1866, showing the border between Alamo and Danville, including the Union Academy, Cumberland Presbyterian Church, San Ramon Creek and Alamo Cemetery. *Courtesy of the Contra Costa County Historical Society.*

Below: The Oakland, Antioch and Eastern electric train in Danville, circa 1920. *Courtesy of the Museum of the San Ramon Valley.*

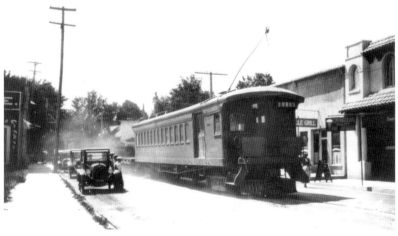

the San Ramon Valley Union High School. Although still in its infancy it gives promise of becoming a power in the land.

In nothing does history show progress in a greater degree than it does in modes of transportation. Beginning with that ox team that "gee-hawed" its way through our valley in 1847, we may trace the means of travel next by the saddle horse, then by carriages drawn by horses. Next came the steam railroad with the advent of the Southern Pacific in 1891; in more recent years, by scores of automobiles; and now in 1914, the Oakland, Antioch and Eastern Electric Railroad lands us in the metropolis in less than two hours.

Since the coming of our first American settlers in 1851, the years have brought many changes besides those of transportation. Many of the big ranches have been divided into smaller holdings. With the increase of population and more intensive farming, land has steadily increased in value, and instead of being sold by the "league," it is measured to the hundredth of an acre. Instead of the scattering farmhouses of the 1850s, the valley and foothills are dotted with comfortable and attractive homes.

Better facilities for handling perishable products have changed many grain fields into orchards, and fruit from San Ramon Valley now commands the highest prices in the markets of eastern cities.

We, of the San Ramon Valley, have much for which to be thankful—thankful for nature's gifts of ideal climate and fertile soil; for a varied and beautiful landscape; for educational and commercial facilities of modern times; for the touch of romance that has come to us from olden days; for musical names—relics of the sons of Spain; but above all, are we glad and thankful that we are descendants of men and women who, thrilled by the tales of the "Pathfinder," braved the dangers and hard ships of the long journey across the plains, bringing with them little of material riches but a wealth of courage, fortitude, energy, industry and integrity. As inheritors of this wealth, may we of the present day live up to the high standard set by our forefathers—the pioneers of San Ramon Valley.

—Friederiche Humburg

5

ALAMO'S AMERICAN BEGINNINGS

1850s and 1860s

For healthfulness of climate, beauty and diversity of scenery, fruitfulness of soil and variety and general excellence of its production, Contra Costa is unexcelled by any county in the state.
—James Foster, pioneer, 1879

lamo has the distinction of being one of Contra Costa County's earliest American settlements, since it was established soon after the county seat of Martinez. The name Alamo means "poplar" or "cottonwood" in Spanish. In 1848, the California Gold Rush drew thousands of people, including most of Alamo's first settlers. Soon, in 1849, leaders proposed a state constitution, and Californians avoided the usual territorial period, becoming a state on September 9, 1850.

Mary Ann and John M. Jones came to California in late 1846, after an arduous trek across the country from Missouri. Their daughter Josephine was born on Chiles Ranch in Napa in January 1847. Mary Ann wrote a complete account of their life, including this account of John's first impression of Alamo, as they traveled south to Pueblo San Jose. He said, "Mary, look! Did you ever see anything so beautiful?" She recalled:

There was nothing in sight but Nature…except a little mud-and-stick hut (close to where the Alamo bridge now is), where men stayed to look after

John M. Jones, Alamo's first postmaster, circa 1865. With his wife, Mary Ann, he was a leader in Alamo during the early years of American settlement. *Courtesy of the Museum of the San Ramon Valley.*

the cattle and horses running on the plain. After we had looked and talked about it for a while, my husband said, "If I live and can get a home here, I am going to have it." And he never forgot it!

They heard about the gold discoveries early in 1848 and spent time mining in the Sierras. Mary Ann did some panning herself and earned enough to buy furnishings for their San Jose house. When the state legislators decided to move the capital from San Jose to Vallejo, John was disgusted. He decided to take the family back to the lovely spot he had admired.

On their return in late 1850, they brought with them their good friends Bill and Polly Mitchell. The Joneses purchased a large adobe home on a prominent knoll and the land surrounding it from Francisco and Maria Garcia. Soon after arriving, they hosted a camp meeting and founded the pioneer Cumberland Presbyterian Church in April 1851. John became the first postmaster in 1852, and Mary Ann started a school to serve their growing family and others in Alamo. Two other families they knew, headed by Reverend Cornelius Yager and James M. Thompson, joined them and acquired land nearby.

Jones was the County Assessor (1853–55), Superintendent of Schools (1856-57) and secretary of the new Contra Costa Agricultural Society in 1859. With Robert Love and Silas Stone, he established the Union Academy, a boarding and day high school south of the village, which served students from 1860 to 1868. Mary Ann's remembrances help bring this early period of Alamo to life, as have the writings of Hall family members, J.P. Munro-Fraser in an 1882 county history and Professor James Smith.

FOUNDING FAMILIES

Alamo had its own stew of immigrants from the start. The Garcias were part of a Spanish settlement east of town, according to James Smith, who reached the area with his Scottish parents in 1848. Others came from the east, traveling over the prairies and mountains or on ships that crossed at Panama or Guatemala. Several emigrated from Germany. Mack Jasper, a Black man, arrived as a slave, was freed, cooked for the Alamo camp meetings and set up a shoe repair shop in the village. George Sam, a Chinese immigrant, settled in town. Portuguese families from the Azores had so many ranches near Mount Diablo in the Miranda Creek Headwaters that the area was called "Portuguese Gulch." The 1860 census stated that there were eight Natives, one Black person and 4 Mulattos in the Alamo area. The Olsson family moved from Sweden to San Ramon in the nineteenth century. Astrid Olsson taught at Alamo School in the twentieth century. In later years Japanese workers and families lived on the Hemme Ranch.

David and Eliza Glass emigrated from Iowa, heeding the siren call of the Gold Rush in 1850. The rough environment of the camps repelled Eliza, and David was ill, so they stayed in the Sierras for only a few months. They settled between Walnut Creek and Alamo in 1851, purchasing one hundred acres near Alamo late that year and planting the area's first apple orchard. David opened a trading post north of Alamo which was the only store in the county outside of Martinez.

Stone family members, led by Albert Ward Stone, came to Alamo after traveling overland from Iowa in 1853. Albert's parents, Silas and Susanna Stone, soon settled in the valley east of San Ramon Creek. Silas was older than most of the immigrants and, after being elected justice of the peace in 1854, he was called *alcalde* (a Spanish mayor or judge) and addressed as Squire Stone. Albert, his wife, Martha, and their family lived in Colusa before coming to Alamo in 1858; there, they purchased the ten-year-old Juan Miguel and Rafaela Garcia adobe. Stone family members eventually owned 1,200 fertile acres that later became Stone Valley.

In 1853, Myron Hall reached Alamo with his Stone cousins and did some gold mining and farming. In 1859, he returned to Pennsylvania, married Lucy Dorman and brought her to Alamo, where they moved into a rustic canyon in Green Valley. The Sunday after they arrived, their Stone relatives visited, unannounced. The family story says that Myron told Lucy, "Stir your stumps, Lucy, get some dinner going!" It was an incident the young wife evidently never forgot.

Silas and Susanna Stone settled in Alamo in 1853. Their classic two-story house, built around 1860, survived for one hundred years near Stone Valley Road. *Courtesy of the Museum of the San Ramon Valley.*

Myron's business partner was Austin Dorman (Lucy's brother). They raised stock and dairy cattle, farmed crops and did some copper mining on Mount Diablo. In 1870, Myron and Lucy bought 103 acres just north of Alamo from John Chrisman and moved in with their growing family. The property covered both sides of the county road and was dubbed "The Farm."

German-born August Hemme and Frederick Humburg arrived in California in 1849 and 1858, respectively. Hemme had immigrated to New York in 1846 at the age of thirteen. He then traveled to California in 1849, mined in the Feather River area and made his stake by selling cattle to the miners. In 1852, he came to Alamo, became a successful rancher and married Minerva Ish, the daughter of a neighbor, in 1856. They had eight children who lived to adulthood. In 1863, after acquiring several hundred acres and ranching for eleven years, the couple sold the property and moved to the greener pastures of San Francisco. There, Hemme worked as an assayer and entrepreneur and did very well. He became known for his generous philanthropies, especially to the Presbyterian church. The family returned to Alamo in the 1880s, built a large home and owned two thousand acres in Alamo and Danville.

Frederick Humburg mined in the Sierras for five years. He then moved to Alamo and plied his trade as a skilled harness maker. When Maria Kornmann came from Germany to visit her sister (merchant Henry Hoffman's wife), their acquaintance led to marriage in 1863 and produced two children, August and Frederick. The family moved back to Germany briefly from 1876 to 1879. Returning to Alamo, the Humburgs bought a 116-acre farm east of San Ramon Creek and stayed for good. In the twentieth century, August bought property along the county road, which included the original post office location on the knoll.

James Foster traveled from Maine to California in 1856 and to Alamo in 1857, where his wife, Nancy, and two children joined him. He purchased Alamo land at that time. A wheelwright and active community leader, he served as Alamo's postmaster from 1866 to 1879, justice of the peace in the 1860s and county assessor from 1869 to 1879. Foster later became a respected Walnut Creek lawyer and, as sole referee, helped settle some disputed Martinez land titles to the satisfaction of all involved.

Another large landowner along the county road was Joshua Bollinger. He moved to California from Missouri twice, once in 1850 and again in 1855, and he purchased canyon property in San Ramon, which bears his name today. In 1866, he bought 283 acres in south Alamo from Bill Mitchell and J.M. Thompson, along the county road. He and Catharine Looney were married on March 24, 1854, in Bollinger County, Missouri, and they raised seven children in California.

James Smith wrote about the small Spanish community east of San Ramon Creek, which included the "Garcia, Mesa, Miranda, Otoyo and Chorene families grouped together, adjacent to some springs of water." He said, "I never knew a Spanish family in the early days to have a well—they preferred running water….Mr. (Santos) Miranda was a skilled mechanic, made spurs and Spanish bridle bits inlaid with gold and silver…and rawhide ropes."

Smith scribed several remembrances as an older man; in them, he noted the way families helped one another out. When his mother, Elizabeth, was ill, he said the Hall family helped take care of her at their home for a considerable time. He wrote, "Neighbors were neighbors in those early times." Smith recalled two swimming holes in Alamo:

> [One] *much patronized by the schoolboys, being near the school, was located midway between Danville and Alamo, just west of the Alamo Cemetery. It was the best, fully 100 yards long with varying depths from 2 to 10 or more feet….The second swimming hole was north of Alamo,*

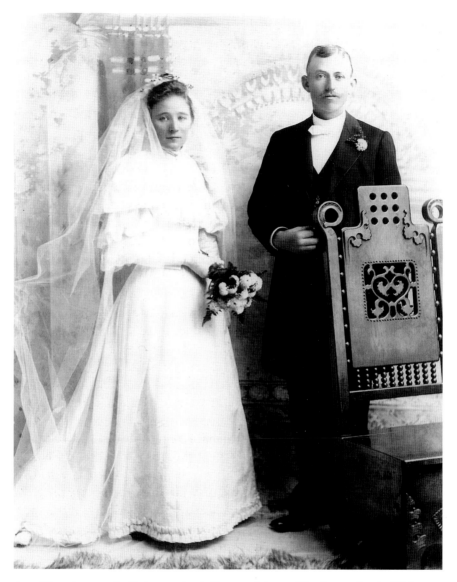

A wedding photograph of pioneers Annie Stone and August Humburg, taken in 1893. *Courtesy of the Museum of the San Ramon Valley.*

about two miles. It was wider and longer but not so deep, and the water did not flow so rapidly, and the depth was more gradual. It was to this second swimming hole that the converts from the yearly camp meetings were brought to be baptized, washed of their sins.

THE FIRST VILLAGE

With farms and ranches getting settled, businesses were needed to support them. The village of Alamo was formed when Henry Hoffman purchased merchandise for a store from Glass in 1853. He constructed a hotel in 1854 at the intersection of the county road and Diablo Road (later renamed Stone Valley Road). The first stores were built around this early intersection, with Hoffman's San Ramon Hotel (later called the Henry Hotel) on the southeastern corner.

James Smith described the Hotel: "This hotel provided a commodious hall on the second floor to accommodate dancing parties and travelling shows, barroom, dining room and sleeping rooms; also a good sized parlor and, at that date, was as up to the time and serviceable as any in the county." Fred Hall added there was a "saloon which was an indispensable part of all

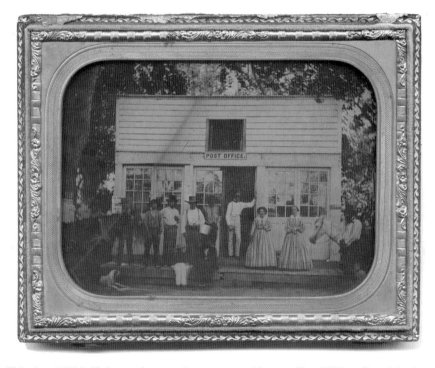

This circa 1860 half-plate ambrotype shows a store with post office. William Carmichael and Simon Wolf were postmasters from 1861 to 1863. Two small signs are attached to the store, which say: "Dr. Howard" and "J.C. Howard/Ambrotype." The John and Jane Howard family lived in Alamo from 1857 to 1862. *Photographer, Jane C. Howard. Courtesy of Sean William Nolan.*

hotels....There were reports of card games for high stakes held there in early days....However, Henry kept a very quiet place, and dances and Christmas trees were usually held in the hall over the saloon." Other general stores were built, owned by Simon Wolf and Company, George Engelmeyer, and Lomax and Smart.

The town's other early businesses included Foster's wheelwright store (1857), Humburg's harness and saddlery shop and Daniel Seely's blacksmith shop. South of the village, on the east side of the creek, G.W. Webster produced bricks in a kiln, which meant bricks were available for the large Union Academy foundation in 1859. Webster's Alamo Brick Store lasted until 1865. An impressive two-story brick building was constructed on the west side of the road, with the Wolf store located on the first floor.

An early Masonic lodge, No. 122 F. and A.M., opened in 1858, meeting in the upper floor of the Lomax and Smart store, which drew many members. They moved to the new brick building just before the 1868 earthquake, when the building collapsed. Eventually, the lodge moved to Walnut Creek.

George Washington Sam, a Chinese man who cut his queue (long braid) and chose to stay in California, opened a small store, which Fred Hall remembered for the candy he sold. Sam was a barber on the side, providing shaves and haircuts, before later becoming a cook.

The Alamo community was set in a lovely valley, and its location added to its advantages. It was on the main road from Martinez to Pueblo San Jose, where an early stagecoach route facilitated travel. James Smith wrote: "Another reason for Alamo's growth was the fact that a road from the redwoods, west of Moraga valley, passing over the divide, brought one direct to Alamo." Another road trailed east through Green Valley, which led to Mount Diablo.

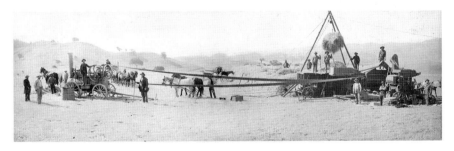

Joshua Bollinger stands in front of workers harvesting wheat on his Alamo ranch property, circa 1880. A straw-fired steam engine powers the stationary threshing machine with a grain cleaner alongside it. Horses were used to bring water for the engine and other functions. *Courtesy of the Museum of the San Ramon Valley.*

Alamo did stay small, however, since Jones and Bollinger saw no reason to lose ranch land to businesses. Fred Hall wrote about this:

All the land up to the town was owned by John M. Jones, a western farmer with a large family, mostly girls and Uncle Josh Bollinger, a sturdy though unlettered farmer from Pike County, Missouri. Both of these were farmers and not land speculators, and neither wanted to be bothered with a town of any size on the edge of their grain fields, and as neither would subdivide or sell lots adjacent…so the tide of town builders went to Danville and Walnut Creek.

TITLE UNCERTAINTIES DISRUPT ALAMO'S LIFE

In these early years, nothing was more contentious than the issue of land titles. The treaty of Guadalupe-Hidalgo, which settled the Mexican-American War in February 1848, guaranteed that Mexicans who were legal landowners in California could keep their property. But many of their ranchos had serious questions of legality, and most had never fulfilled all of the ownership requirements, such as boundary measurement. The land had been lightly settled; cattle and sheep grazed without fences, and regular roundups for branding marked livestock ownership.

By 1850, there were about 100,000 people in the state—ten times the non-Indian number of Californios who lived there in the pre–Gold Rush era. An overwhelming influx of Americans viewed the land as public, and many simply squatted, built homes and considered the land theirs by right of possession. Farther south, Jose Maria Amador's large Rancho San Ramon was full of squatters who resisted removal. After James Dougherty purchased ten thousand acres of the rancho, he organized his own posse to remove the settlers, something Amador had been unable to accomplish.

While some of the Alamo settlers probably squatted, most made an effort to purchase the lands they farmed. James Foster, for one, acknowledged that he had obtained possession of his property but not the formal title. In 1851, precise metes and bounds were made possible by American surveyors, who placed base and meridian lines at an initial point on the summit of Mount Diablo.

A Federal Land Commission was set up to rule on the existing Mexican titles—inevitably to their detriment. The rapacious attorney Horace

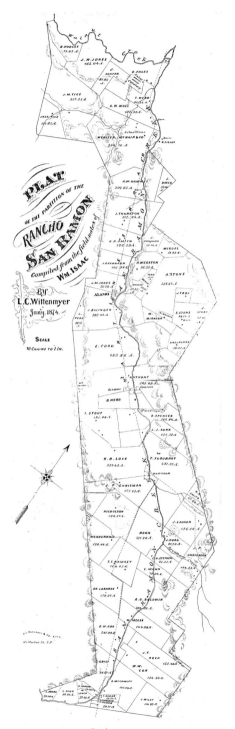

Carpentier managed to acquire the original Castro/Pacheco Rancho grant, which covered all of Alamo and Danville. As historian Mae Fisher Purcell wrote, "They, like other American settlers, were forced to repurchase their properties to retain possession when the early land trader, H.W. Carpentier, acquired title through his real estate manipulations."

Long story short, Alamo titles were not secured until 1865, following extensive and acrimonious litigation, after which sixty-five settlers ended up paying Carpentier $90,000 in gold coin over a period of four years, with interest set at 1 percent a month. Some of the Alamo litigants were John Jones, Joshua Bollinger, Albert Stone, Manuel Miranda, Mark Anthony and Erastus Ford.

After years of insecurity and debate, with this agreement, Alamo's pioneers were at last able to develop their land, free from fear of eviction.

A map showing the Rancho San Ramon confirmed titles in Alamo, Danville and San Ramon in the northern and central parts of the San Ramon Valley, circa January 1874. *Courtesy of the Museum of the San Ramon Valley.*

AGRICULTURE SUPPORTED ALAMO FOR A CENTURY

Un condado da Contra Costa e u logar que da melhor erva verde em todo u mundo. Portuguese for "Contra Costa has the world's best grass country that lays outdoors."
—*Joseph Muir, cattleman*

*A*lamo is situated in a lovely valley with a mild Mediterranean climate and fertile land—ideal for farms and ranches. Initially, American settlers continued the cattle grazing that was already in place. They soon realized that California's rainfall patterns required new approaches to farming, which were different from their farms back east. No rain in the summer meant that dry-farming techniques were needed on land that was extremely productive.

While the Mexican rancheros had focused exclusively on cattle-raising, with cow hides and tallow as trade products, beef itself became valuable, as a burgeoning population moved into California during and after the Gold Rush. Alamo and its environs had excellent forage for livestock; some declared it to be the best in the west.

The immigrants brought new breeds of cattle to improve the stock, and they raised dairy herds for milk, butter and cheese. James Smith touted his mother's cheese, which was made in cheese boxes they received from Scotland. Myron Hall and his brothers drove cattle and dairy cows across the plains on their trips to California. The enterprising August Hemme obtained cattle and drove them to the Sierras, selling beef to the gold miners. Later in the century, Hemme bred Durham shorthorns, pasturing droves of cattle during the summer months in the Livermore Mountains.

Cattle brands registered to Alamo ranchers. Left column, from top to bottom: August Humburg, James Foster, John M. Jones, August Hemme, Albert W. Stone. Right column, top to bottom: Myron Hall and Austin Dorman, Hap Magee, Henry Hoffman, Erastus Ford and David Glass. *Courtesy of the Museum of the San Ramon Valley.*

In 1958, Richard Rutherford wrote this in the *Valley Pioneer*:

> *By 1860, there were various prominent American cattle growers in the valley with established brands. The partial list included: M.B. Mitchell, A. Ford, August Hemme, B. Hall, S.A. Carpenter, James Foster, S. Stone, F.A. Bonnard, Austin Hammitt, V. Huntington, Albert W. Stone, W.C. Chapman, D.P. Smith, E.H. Cox, W. Hays, S. Wolff and Company, David Glass, Joel Harlan, J.M. Jones and Gold Field, all of Alamo.*

MEGASTORMS AND DROUGHT

Early in this era, some weather disasters impacted them all. In 1861–62, there were megastorms throughout the state. The Sierras had snow levels between ten and fifteen feet deep, which were followed by warm rainfall, sending water into rivers in unprecedented amounts. The water rose to thirty feet in some areas, covering the new telegraph poles that stretched

from Sacramento to New York. All of Sacramento was under ten feet of brown water that January.

A *Contra Costa Gazette* article in 1862 stated:

> [In Alamo], *it came suddenly and without any warning at about three in the morning. Many of the people fled as fast as possible and took refuge in the Academy and Wolfe's brick store. The barn and stable of Hoffman and White washed off with 15 tons of hay* [and] *a fine buggy....The horses were saved....August Hemme lost a large barn, a fine carriage and some outbuildings and fences. And George Engelmeyer had 1,500 sacks of wheat destroyed.*

William Brewer, who was surveying California that year, wrote in January 1862, "Thousands of farms are entirely underwater—cattle starving and drowning....All the roads in the middle of the state are impassable; so all mails are cut off." One-quarter of the state's eight hundred thousand cattle drowned in the flood.

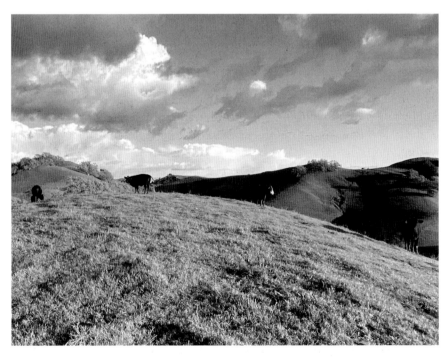

Cattle grazing in the Mount Diablo Foothills, near Alamo in the twenty-first century. *Photographer, Jeff Mason. Courtesy of the Museum of the San Ramon Valley.*

A drought in 1864 nearly finished the settlers off. A publication titled *The Hall Book* states that business partners Myron Hall and Austin Dorman were raising cattle in Green Valley. The 1864 drought devastated their cattle flock, allowing them to sell only seventy-five head out of several hundred. Once farmers recovered from losing so many cattle, they focused on cultivating grain and hay in addition to grazing livestock.

DIVERSIFIED CROPS

Between 1870 and 1900, California farmers became leaders in grain production for the entire nation. The county's wheat and hay production was tremendous, and it was primarily shipped out of Martinez and Port Costa to Great Britain. According to writer Gerald Nash, "California produced a hard, dry and unusually white wheat that became particularly popular on the Liverpool Corn Exchange." The *California Farmer* proclaimed in 1869: "California is now the esteemed granary of the world."

By the 1880s, Contra Costa County's Port Costa was the busiest wheat shipping port in California. In 1891, the county was planted in 44,000 acres of wheat, 28,400 acres of barley and 22,000 acres of corn. These crops depleted the soil, since little fertilizer was applied, and crop rotation was not usually practiced. Eventually, farmers learned to rotate crops and experimented with new crops, with advice from the Grange.

There was a regular market for local hay in San Francisco, as it was used by livery and draft horses and the Presidio Cavalry. Hay from valley ranches was grown primarily on the hills. Each year, about a ton of hay per horse was needed, so large hay barns appeared on ranches of any size. According to agricultural historian Don Wood:

> *Thousands of tons of hay and grain were hauled to Martinez by freight wagons—some with trailers—pulled by four, six, or eight horses carrying four to eight tons per trip….The horses' hooves and steel wagon tires pounded the dirt road into a thick layer of extremely fine dust, which flowed like water and drifted in the air almost like smoke when disturbed.*

All of this agricultural success required hard work and applied expertise. New ways to be productive were shared at Danville Grange meetings after it was founded in 1873. Ground squirrels were serious pests for grain ranchers, since the rodents could destroy entire crops. Either ranchers had

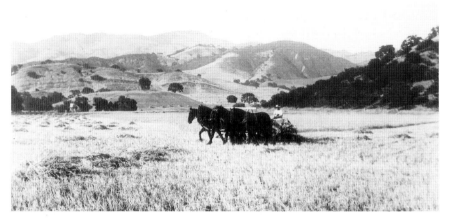

Around 1916, this binder was pulled by a five-horse team. It cut and bundled grain on the Donahue Ranch, which is now the location of Whitegate Homes. Other wagons would collect the grain bundles and carry them to a stationary threshing machine. *Courtesy of the Museum of the San Ramon Valley.*

to control the squirrels themselves, or a county squirrel inspector could visit and perform the service at a fee. In Alamo, the squirrel eradication district followed the Alamo school district lines. County inspectors included Myron Hall in the 1870s and Lorenz Humburg in the late 1920s and 1930s. There was also a goat dairy in Alamo for a time, according to Don Wood.

PAEAN TO ALAMO AGRICULTURE—AND HEMME

In the *Contra Costa Gazette*, on May 7, 1892, William Cook wrote about a trip on the new railroad from Avon to San Ramon and could barely contain himself as he reached Alamo.

> *Orchards! And such orchards!…What stems, what limbs, what fruit, what cultivation, what enterprise, what sight! So near to San Francisco and Oakland that two hours time will cover the journey, and not one person in 500 are aware of its location or existence.*
>
> *Water of the purest quality and unlimited quantity. An atmosphere where fogs are as scarce as water on a desert; where the cheeks grow rosy and the appetite needs no coaxing; where the nightingale whistles in the stillness of the night, and the lark bids you welcome in the morning; where the nights are cool and refreshing and the air of the mornings is laden dew.*

Minerva Hemme began buying Alamo property in 1871 and, eventually, the Hemmes owned most of the land between Alamo and Danville, around two thousand acres. They built their elegant mansion in 1876, and the entire family moved back to Alamo by 1883. August Hemme's agricultural innovations were renowned. For example, seven miles of tubing were used on the farm to pipe water from springs to the crops and buildings. He was the first to ship refrigerated fruit from Martinez to England in 1889, even before the new railroad opened.

An 1879 county history recorded:

August Hemme has, by far, the finest farm in Contra Costa County, situated in the heart of the San Ramon Valley, extending from hill to hill and comprising about 2,000 acres. The neatest and most substantial board fences line the highway, which passes through the center of the valley and farm. Shade trees have been planted along the roadside and are growing with the rapidity peculiar to our soil and climate and stand in marked contrast to the sturdy oaks, which here and there occupy the interior of the fields.

There are four orchards on this place, producing fine crops of choice apples, pears, plums and other fruits. Wheat is the chief production, of

A peach orchard in spring bloom on the valley floor. *Courtesy of the Contra Costa Historical Society.*

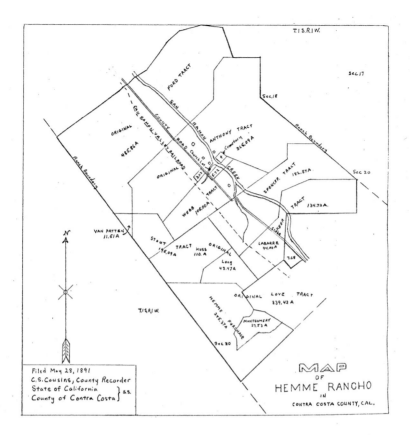

A map of the extensive Hemme Ranch holdings covering south Alamo and north Danville in 1891. Note the cemetery located along San Ramon Creek. *Courtesy of the Museum of the San Ramon Valley.*

which large crops are raised; this land and valley is noted for its superior wheat. On the place are about 175 head of choice breeds of cattle, 20 extra-large mules and other stock required on such a farm.

Another article on the Hemme Ranch listed 110 acres of pears, 275 acres of cherry trees, 275 acres of apples and 1,000 acres of quince tree.

Since water was essential to agriculture and rain was scarce from April to October, water tanks, cisterns and windmills were important. Albert Stone hired Chinese workers to build an enormous brick-lined cistern with a two-hundred-thousand-gallon capacity on his property to provide reliable water. Still in place today, it measures about fifty feet across.

WALNUT COUNTRY

Walnuts became Alamo's signature crop. According to Barbara Hall Langlois in 1990:

> *In 1873, William Meek, a horticulturalist of Hayward (and husband of one of Myron Hall's Stone cousins) brought from the east a scion (shoot containing buds) of a soft shell walnut called the Persian walnut, which Meek had received from Europe. As an experiment, Hall grafted this scion on to the native black walnuts on the farm. The combination of the strong root structure of the native tree with the fine flavor of the Persian soft-shelled walnut made the experiment a great success.*

Hall became known as the father of the walnut industry, as he generously shared his scions. The nuts were flavorful, and unlike native walnuts, they had shells that were easy to crack. That first tree came to be called the "Mother Tree" and lived for over a century north of today's Jackson Way, producing tons of excellent nuts. Langlois wrote, "The whole family helped process the nuts, and walnut-stained hands in the fall were an affliction for all of the Halls."

A picture from a Diamond Brand brochure. Most walnuts in Alamo qualified for the premier designation as Diamond Walnuts. *Courtesy of the Museum of the San Ramon Valley.*

He grafted many other walnut trees on their property, setting the grafts high along the highway so as not to "interfere with road traffic." Hall's trees lined the road between today's Jackson Way and Ridgewood and made a pretty picture. Later, they planted prune and pear trees as well.

In 1912, the California Walnut Growers Cooperative was founded with this goal: "Equitable recompense for the grower and the production of a dependable uniform product for the consumer." They created the Diamond Brand, which guaranteed top-quality walnuts. In Walnut Creek, a processing plant (nicknamed the "nut house") was built, which took nuts from members of the cooperative; today's Lesher Theatre is located there.

Walnut ranchers used agile climbers to knock ripe walnuts off the tree or workers standing on the ground would knock nuts down with long

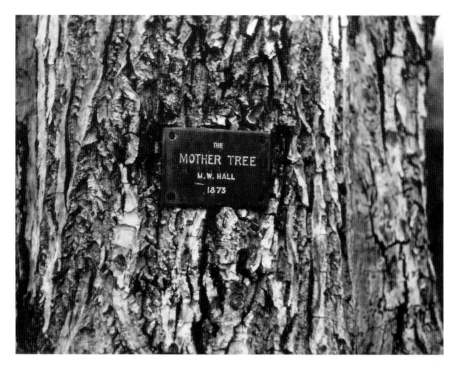

The Mother Tree with a plaque pictured in 1973. Myron Hall grafted a Persian walnut scion to this native walnut tree and began the area's walnut industry. This "first tree" produced profuse flavorful walnuts for over one hundred years. *Courtesy of the Museum of the San Ramon Valley.*

branches. The nuts were picked up and put in five-gallon buckets, three buckets making a sack. One knocking method was invented by Travis Boone of San Ramon in which he set a tower on a tractor with two or three positions for men to loosen nuts with poles. Power shakers soon followed. The nuts were either hulled by hand or in processing machines. Boone, Joseph Bolla and others did custom harvesting for others, providing commercial hulling and drying services. Tending the walnuts included spraying for blight with a nicotine dust; an engine-driven air-blast sprayer provided the best coverage.

Transient families during the 1930s harvested walnuts and prunes. Josephine Jones recalled:

> *They made the rounds of the county and would take their children out of school. During the prune season, the children would work for six weeks picking the prunes. Prunes would be shaken off the trees just like the*

walnuts, then dried on trays. The children did the bending over to pick them up.…I remember the prunes were sold to the Oppenheimer Co.

Virgie V. Jones wrote that the Jones Ranch had housing for Filipino workers and a Filipino gardener who ruled the roost in the 1940s.

VINEYARDS EVERYWHERE

Vineyards thrived in Alamo as well. B.W. Stone wrote that vineyards would do well, advising that vines should be planted on the hillsides in soil that was "unusually mellow and loose." He reported averaging over one hundred dollars per acre with his vines. In Green Valley, Judge W.W. Cope grew almonds and grapes, and one ranch had a three-thousand-acre vineyard. The Howard brothers had a small vineyard, and its "table grapes [were] pronounced to be among the finest flavor in the market," according to the April 16, 1887 edition of the *Contra Costa Gazette.*

After 1866, the Jones ranch extended from the highway to Las Trampas Hills. "From the house down to Danville Boulevard, it was all in vineyards, grapes were taken to a winery in Pleasanton. I remember we'd get back two

The Jones family's Rancho Romero was planted to grapes for many years. This photograph shows their field west of the county road, with Mount Diablo in the background. *Courtesy of the Museum of the San Ramon Valley.*

kegs for our own use," reported Josephine Jones. In the 1930s, phylloxera attacked the vine roots, and the Joneses decided to expand the orchards and give up on vines. Josephine said, "The vineyard gave way to walnut trees, pears, a few prunes, a few cows to milk and a few horses to look pretty on the hills."

In the Livorna Road area, east of Miranda Creek, an Italian immigrant named James Marengo purchased land in 1883, planted a ten-acre vineyard and built a fifty-seven-foot-deep wine cellar into a hill by their house. Unhappily for him, Prohibition in the 1920s ended his wine making. His grandson Carlo Borlandelli shared this family story: federal agents swept in, took all the wine barrels from Marengo's cellar, broke them up and sent the wine down Miranda Creek. It was heartbreaking for the old man, who passed away in 1924.

FRUIT ORCHARDS

As the twentieth century progressed, vast orchards of walnut and pear trees came to dominate the valley's floor, since these products did well with dry-farming techniques. During the 1930s, new state and federal dams brought water for irrigation to Central Valley ranches, which meant some local valley crops, like prunes, could not compete. Bishop Ranch to the south did have sizeable aquifers and was able to irrigate extensively, which Alamo and Danville could not do.

During the 1920s in Alamo, there was a fruit packing plant called the Tracy-Waldron Company, which regularly shipped railroad carloads of pears to markets. Since they ripened for a week or two off the tree, pears traveled well. In 1928, Ralph Harrison's orchard produced Carmen peaches, which, according to the *Byron Times*, were "some of the most beautifully colored and finest flavored Carmen peaches produced in California." He also grew cherry trees, Royal Anne cherries, pears and almonds.

At the Treasure Island World's Fair in 1939–40, during the two Contra Costa Days (September 17, 1939, and September 22, 1940), agricultural samples were handed out to visitors, including grape juice, almonds, walnuts, celery, cider, various fruits and onions.

Because hay, fruits and nuts had a predictable season, itinerant workers were needed for short and intense periods of time. The census of 1880 counted fifty-seven Chinese cooks and laborers in Green Valley, probably working on

a hay harvest. Chinese, Japanese, Filipino and Mexican farmworkers picked crops and pruned trees over the years. Little Betty Humburg was told to stay completely away from the gypsy pickers, as they had a reputation for kidnapping children, true or not.

In the twentieth century, a number of Japanese workers lived on large ranches and provided labor. Their children appear in many Alamo School photographs. A Japanese school in Danville provided language and cultural instruction on weekends. The parents were Japanese nationals and ineligible for citizenship; they wanted the next generation to appreciate their heritage. Viola Root recalled a large camp of Japanese families in the Camille Avenue area: "The Japanese took care of most of the harvesting of the fruit, trimming the trees and so forth."

Cattle and sheep grazing continued on the hills. The Humburg Ranch (east on Livorna Road) had sheep; the Magee Ranch to the south ran cattle and horses. In the 1970s, Hap Magee hosted jackpot steer roping events that I-680 drivers could see. He raised longhorn steers, created a "Working Cowboys" traveling exhibit and had a world-class collection of branding irons. He said, "I don't want an iron just to have it. It isn't worth anything to me unless there is a story to go with it!" And he was quite the storyteller.

Although motorized vehicles eventually replaced work horses in the valley, Alamo remained horse country. Large properties had room for horse setups, and many families rode horses for pleasure and in competitions. The Sherman, Rogers and Lacey Ranches raised and bred Arabian and other blooded horses. John Rogers imported Serafix, a famous purebred Arabian stallion, to his Alamo ranch from England in 1954. Serafix was a chestnut with a blaze, two white socks and a near half-sock; he was noted for his bold demeanor, charismatic behavior, excellent movement and many successful offspring.

The state policy of assessing land for its highest and best use in the 1950s meant large ranch properties were reassessed as potential housing. Ranchers saw their taxes increased tenfold from one year to the next. Agriculture gave way to suburban development, as retail stores expanded Alamo's downtown and new homes were built, many with a few walnut or fruit trees in their yards.

New residents enjoyed the open space and orchards but disliked the crop dusters that provided aerial pest control and the noisy ground rigs that applied chemicals during early mornings when the air was still. Responding to complaints, according to Don Wood, farmers began "to

A photograph of the famous Arabian stallion Serafix, a grand champion show horse. Serafix was the sire of 129 champion horses and 41 national winners. *Photographer, Johnny Johnston.*

abandon parts, or all, of orchards and fields near houses. This practice left a stock of pests to reinfest the crop and contributed to the willingness of farmers to sell their property for other uses."

Ward Hall wrote in a tribute to his father, Myron:

> *The valley has changed—from rolling land with wild mustard to great fields of grain, taller than a man, walnut and fruit orchards, spacious farms, home subdivisions and, now, condominiums and townhouses. This is progress, but it is wonderful to have memories of less crowded times.*

7

CIVIC ENGAGEMENT

Into the routine life of the farmer and his family, the Grange brought social contacts, news of the outside world and the pleasure of laughing, talking and eating with new and old friends and neighbors. Programs were an established item in the order of business, and people who had never spoken, sung or debated before an audience could now have that opportunity.
—Inez Butz, historian

For many decades, Alamo was a small farming community of a few hundred people. Neighbors got together to chat at the post office, have tea, join a fraternal order, attend church and celebrate May Day at the schoolhouse. Some early organizations included the Masons (founded in 1858), grammar school district boards and county agricultural societies. In 1873, the Danville Grange No. 85 brought women and men together to address farm practices.

Clubs such as the Alamo Community Club, Alamona Chapter 211 of the Eastern Star, Women of Woodcraft, Neighbors of Woodcraft, Woodmen of the World, the Farm Bureau and Farm Bureau Women all encouraged civic activity. There were other organizations that people joined over the years: the International Order of Odd Fellows (IOOF), the United Portuguese of California (UPEC), temperance groups and the Japanese Association. And there were many improvement clubs, merchant associations, an Alamo Dads' Club and, in 1955, the Alamo Improvement Association.

THE POST OFFICE

Alamo's post office was the first permanent post office in the San Ramon Valley, and it was the second in the county. It was an important community gathering place from the beginning. On May 18, 1852, John M. Jones became the first Alamo postmaster, with his wife, Mary Ann, assisting.

According to historian Roy Bloss, who spoke at the September 15, 1985 dedication of the San Ramon Valley Historical Society's post office plaque, it is likely that the enterprising Jones pressed for the appointment. "For he was the get-up-and-go type who would have been seeking some economic use for his recently-acquired two-story adobe. A post office atop the low knoll, where letters could be picked up and mailed, was a suitable use with which he could share their new home."

In those days, people picked up their mail and stayed to visit. During the early 1860s, there were probably some Civil War debates, since residents had differing opinions on secession and the Union. Mary's autobiography gives readers a sense of her liveliness, as she described post office visitors:

> When his [John's] *business called him away from home, I took care of the office. Many times, men would come and get their mail and sit and read and talk until I felt like saying, "Do go, I have to work." We had no stamps then, nor envelopes. We wrote our letters, folded and sealed them with sealing wax and then paid ten cents for delivery. We had mail twice a week.*

A young man who used the post office in 1856 became a famous western writer: Bret Harte. His letters to his sister were mailed from Alamo, leading some people to believe he lived there. As an eighteen-year old, he tutored four boys on a ranch near Alamo Creek in the Tassajara Valley. Harte's famous tale "A Legend of Monte Diablo" and other writings were inspired by his time in the area.

Alamo had a close brush with postal fame in 1860. The legendary Pony Express delivered mail in an astonishing ten days from St. Joseph, Missouri, to Sacramento; from there, the mail traveled to San Francisco on a steamer. Several times, Pony Express riders missed the steamer, came overland and used the ferry at Benicia-Martinez. They then dashed down the county road through Walnut Creek House (an early hotel), rode west through Lafayette and Orinda via today's Fish Ranch Road and Claremont Canyon and took the Oakland ferry to San Francisco.

Right: An 1872 picture of author Bret Harte, who lived in the Tassajara Valley during the first decade after the Gold Rush. He wrote several stories reflecting his local experiences, including "An Apostle of the Tules" and "First Family of Tassajara." *Courtesy of the Museum of the San Ramon Valley.*

Below: The Bell family on the front porch of Bell's Store Post Office. Vina and David Bell (*seated*) with their children (*left to right*), Harriett, Mary, Alice, Ora and Bertha, circa 1910. *Courtesy of the Museum of the San Ramon Valley.*

James Foster was Alamo's postmaster from 1866 to 1879. He was followed by father and son John and August Henry, who bought Henry Hoffman's San Ramon Hotel and renamed it the Henry Hotel. The Henrys hosted the post office and were postmasters from 1879 to 1905. In the twentieth century, Bell family members were postmasters for a total of fifty-two years. David Crockett Bell served from 1905 to 1923, followed by son Roy D. Bell (1923–1936) and daughters Harriett Bell Hunt (1936–1944) and Bertha Bell Linhares (1947–1960).

Bertha Bell was born in 1905 and remembered the days when the Alamo population sign read "400." She recalled gatherings in the family Bell's Post Office Store in an essay called "The History of the Alamo Post Office":

The arrival of the evening mail was the signal for people to gather at the post office and visit and exchange gossip. The men sat in the post office store in winter or on the porch in warm weather. The women went into our sitting room and visited with my mother. We always heard all the news and troubles of the Alamo residents.

The post office location shifted over the years—from the Jones house, to a store and the Henry Hotel. Bell's two-story store was located on the northwest corner of the highway and North Avenue (today's Las Trampas Road). Mail arrived on the Southern Pacific Railroad, and from 1914 to 1924, it arrived on the electric railway. In July 1936, Harriett Bell Hunt constructed a small building on the southwest corner of the highway and North Avenue, creating the first building devoted entirely to the post office. It was reputed to be the smallest post office in the country.

Alamo's post office service and building were almost lost when Mrs. Hunt sold the property on North Avenue and moved away. Mail delivery out of Walnut Creek and Danville included parts of Alamo, and people weren't using the local office; regional post office administrators decided to close it. After being alerted to this possible loss, residents patronized it again. In 1944, Oscar and Imogen Cross Peterson saved the building by buying and moving it to their property near the northeastern corner of Stone Valley Road and Danville Boulevard. Alamo Community Club members stepped up, and three of their members became acting postmasters from 1944 to 1947. At that point, Bertha Bell Linhares took over the position, serving from 1947 to 1960, with her husband, Anthony, as a part-time clerk.

Linhares wrote that they helped patrons wrap their parcels: "One of the biggest items each year before Christmas were the locally grown walnuts. Tony was always willing to sack the nuts and sew up the sacks so they could be sent by parcel post. Tons of nuts were sent every fall, and by Christmas Eve, I didn't care if I ever saw another nut."

In the 1940s, the Star Route for post office service was set up to deliver mail throughout the San Ramon Valley. Leo Lynch recalled riding with his grandfather "Pop" Watson on this route, which he began by picking up mail bags from Walnut Creek that were placed in his station wagon. The first stop was Alamo's post office, then he traveled to Danville (Acree's

The post office building on the county road, near Stone Valley Road, circa 1955. Notice the Humburg house on a knoll behind the post office. *Photographer, Al Davies. Courtesy of the Museum of the San Ramon Valley.*

These San Ramon Valley Historical Society members celebrated the Alamo Post Office historical society plaque dedication in 1985. *From left to right*: Virgie V. Jones, Bertha Linhares and Ann Wiedemann Kaplan. The plaque was placed on the original Safeway building on the east side of Danville Boulevard, now the CVS store. *Courtesy of the Museum of the San Ramon Valley.*

Store), San Ramon (Bill and Lena Fereira's General Store), out to Tassajara and Blackhawk and to the back side of Diablo for their post office (in the front corner of a barn). Then they traveled back on Diablo Road to collect outgoing mail from Danville and Alamo and returned to Walnut Creek.

Neighborhood delivery service began in 1958, one year after Mrs. Linhares moved the office to the Alamo Market Plaza, next to the Alamo Pharmacy. Of course, patrons could continue to go to the post office if they chose. Bertha wrote, "I don't think we ever lost our country post office atmosphere." In October 1964, a larger post office was placed at the corner of Market Plaza and Lunada Lane. After 1998, it moved to a new site at the western edge of the enlarged Alamo Plaza Shopping Center at 160 Alamo Plaza.

DANVILLE GRANGE NO. 85, PATRONS OF HUSBANDRY

In the third decade of American settlement, after land titles had been resolved, farmers and ranchers discussed setting up a farmers' union. In 1873, at a state convention organizing meeting, W.A. Baxter of Napa touted the new national Grange movement, and the delegates founded the California Grange. This organization became the center of civic life, as it promoted improved farming practices, addressed squirrel control, hosted lectures and shared potluck suppers.

The Danville Grange No. 85, Patrons of Husbandry, was the eighty-fifth Grange in the state and the third in the county. Alamo's Albert W. Stone and Mary Ann Jones were two of the thirty Grange charter members. At first, the Grange met weekly in the Danville Grammar School and, when the numbers grew too large, builder Charles Howard of Green Valley constructed a hall that opened on November 28, 1874. The Grange Worthy Masters from Alamo were J.M. Stone in 1879; Myron Hall in 1880, 1881 and 1894; and Charles Howard in 1889 and 1890.

Grange historian Inez Butz described what this organization provided valley residents:

> It is hard for us today to understand that farmers had very little contact with the outside world. Visits to the market were few, and neighbors were often miles apart. There was no telephone, no radio, no TV, no daily mail and no newspaper. There was church on Sunday if the roads were passable. When it rained, the roads could not be used.

Grange chromolithograph. This 1874 poster was available to Granges throughout the country and was purchased by the Danville Grange No. 85 for fifty cents. It shows vignettes of farm, home, social and Grange activities. *Courtesy of the Museum of the San Ramon Valley.*

Into the routine life of the farmer and his family, the Grange brought social contacts, news of the outside world and the pleasure of laughing, talking and eating with new and old friends and neighbors. Programs were an established item in the order of business and people who had never spoken, sung or debated before an audience could now have that opportunity.

An open area on Danville's Front Street, between the Grange hall, the school and the church, was called Grange Park. In 1887, the Grange hosted a harvest festival in the park and its surrounding area, which drew 1,200 people from as far away as Oakland, Napa, San Jose and Stockton. On May 14, 1887, the *Pacific Rural Press* reported, "Four to five hundred teams were strung out along the highway, affording a very novel sight.…It was undoubtedly the largest gathering ever held in that part of Contra Costa County known as San Ramon Valley."

Over the decades, Grangers were involved in all facets of the community. They worked to get better prices for wheat and reduce railroad charges; they also set up a Grange wharf in Martinez, organized a bank, lobbied for a local railroad and, in the twentieth century, promoted road building, the construction of new public high school and the inclusion of a state park on Mount Diablo.

ALAMO WOMEN'S CLUB

Women were a force in Alamo, even before they won the vote in 1911. One native daughter, Ida Hall, exemplified just that. A longtime, well-respected teacher at several county schools, including Highland, Byron, Sycamore and San Ramon, she served on the county school board (1904–1912) and taught at the Alamo Grammar School, becoming principal in 1912. She encouraged the Alamo Mothers' Club to organize in 1916. This group of energetic women set about improving the school as well as the larger community.

Mrs. Alda Stoddard was the first president of the Alamo Mothers' Club. Its initial projects raised funds to buy a well-appreciated piano at the school and provided playground equipment. Libraries were a major club focus, and they set up a new county library branch with regular service out of the school. In 1920, they changed their name to the Alamo Community Club.

Then retired, Ida Hall became president of the club from 1921 to 1925, when it joined the Federation of Women's Clubs (1922). Evidently, the

federation had supported women's suffrage, which appealed to the club's members. In the 1930s, federation clubs were active in founding 75 percent of all U.S. public libraries. The club met at Marie Huber's home during the 1920s and installed the library there (according to the February 7, 1923 edition of the *Danville Grange Herald*). With Hall's urging, the club also became active in "local history and its perpetuation," according to a club history. Ida asked James Smith to write about his Alamo memories from the 1850s, thus creating some of the best early local histories available.

A formal portrait of teacher Ida Hall, circa 1910. *Courtesy of the Museum of the San Ramon Valley.*

The club met in several homes until it outgrew those spaces. In the 1930s, it rented the lower floor of the Henry Hotel, which had a large room and a kitchen. Again, the club and the branch library shared the space. From 1933 to 1937, the club promoted a monthly town forum at the schoolhouse, which presented educational and cultural programs.

During World War II, the Henry Hotel space became a canteen headquarters organized by club members. Sugar and coffee tickets were rationed to the club, as it hosted dances for soldiers, made garments for families, rolled bandages, organized emergency supplies and set up first aid classes. According to the club history, "When the air watch tower was built on the Alamo School grounds, members of the club and their husbands took their turns serving day and night on the tower." While in the tower, they searched the skies for enemy aircraft.

In 1952, the club's dream of its own clubhouse came true when Corwin and Ruth Henry donated property to it along the boulevard. A real community effort, Henry secured the permits and arranged a loan for the financing, and Hans Rodde, the building contractor, accepted the help of husbands to complete the building. It was dedicated with a flourish on June 14, 1952.

The next year, the club formally changed its name to the Alamo Women's Club (AWC). The club's philanthropies and service to Alamo and the larger valley are well known. It raised funds for planting pine trees in national forests and provided scholarships for high school and Diablo Valley College students, as well as other projects. The club organized an Alamo Senior Citizens Club in 1959.

Today, the seven AWC philanthropies that receive funds in kind donation and volunteer time are: Canine Companions for Independence, Friday Night Out, George Mark Children's House, Hospice Foundation of the East Bay, VESTIA and We Care Services for Children and Youth Homes. In 2020, during the COVID-19 pandemic, the club rallied the community to donate to the Food Bank of Contra Costa and Solano, the Monument Crisis Center and other groups.

AN ALAMO LIBRARY

As noted earlier, the desire for a local Alamo library bore fruit beginning in 1917, and it became another project for the new Alamo Mothers' Club. The library was announced in the weekly *Danville Journal* on February 10, 1917, with a front-page headline: "New Branch of County Library Opens." The article read:

> *A branch of the Contra Costa County Free Library is now established at the Alamo School. Arrangements have been made with County Librarian Whitbeck at Martinez by which Alamo residents can get any books they want through the Alamo School.*
>
> *Miss Kathryn Nuttall, principal of the Alamo School, will act as librarian, giving her services free. Wednesday will be regular library day. Members of the mothers' club can also get books on the alternate Fridays during their fortnightly meetings. Parents need not even go to the school for books on Wednesday but can have their children call for and return books. An order may be given for a book one Wednesday, and it will be on hand the next. The service is free.*

In April, the *Journal* reported that Miss Nuttall said the branch library was "proving very popular."

In the 1920s, the women of the Alamo Community Club set up the library in a room at the Huber home, paying a rental of five dollars a month for both club meetings and the library. Miss Hall became the librarian for a short time, coordinating volunteers who kept it open on Tuesdays and Fridays. The county librarian agreed to have a club member serve as the local librarian.

A call went out for people to donate books to add to the county volumes that were already available. In response, the Hemme sisters of Berkeley

donated over two hundred volumes of books on a variety of topics from the original Hemme Ranch. In 1937, Veda Wayne wrote that many of the Hemme books were rare volumes and covered scientific, botanical, travel, arts and music topics and included both fiction and nonfiction. Martha Bunce Mougin donated twenty-seven books to the library from the Stone family collection.

This library certainly moved around. According to the *Oakland Tribune* (February 10, 1929):

> *The Alamo branch of the county library is temporarily located in the W.A. Cross Ice Cream Stand. The old quarters are being torn down to make room for O.W. Peterson's new home. Mrs. Peterson will keep the library open Tuesday and Friday afternoons.*

Astrid Olsson Humburg recalled that librarian Annie Chase had placed the Alamo Station Library of the County Free Library in the tankhouse set inside her garden. An article in the *Martinez Herald* on April 15, 1932, reported, "The quarters have been remodeled and provide a cozy space for the library. Tea was served by Miss Chase and Mrs. Allie Coffin this week to commemorate opening of the new quarters."

The Henry Hotel in 1939. Notice the Alamo Pottery sign. This business was replaced by the Alamo Community Club and the library. *Photographer, Willis Foster. Courtesy of the Library of Congress, CA0017.*

In 1939, the Alamo Community Club rented the first floor of the historic Henry Hotel for both the library and the club. Dorothy Cooley and club members ran the library. To warm up the space, Bertha Linhares would build a fire in the room every morning. Reportedly, the old coal-and-wood stove exploded on more than one occasion and sent everyone running.

In the 1960s, the county discontinued the branch line service in Alamo because a new, freestanding San Ramon Valley Library opened in Danville in 1961. Nevertheless, the Alamo Women's Club stayed involved with library services well into the 1970s; it set up bookshelves in its clubhouse, staffed an Alamo bookmobile for most of that decade and sponsored a lending library for members and shut-ins.

ALAMO IMPROVEMENT ASSOCIATION

The Alamo Improvement Association (AIA) is a homeowners' group that has pursued keeping Alamo's rural character since it was founded in 1955. The new developments that have replaced agricultural land have been examined thoroughly. Keeping one-half-acre lots for homes and preserving a compact downtown are consistent goals that the AIA have sought in every proposed county general plan. Any Alamo resident can join and elect leaders to the AIA board. Over the years, members have met regularly with the county supervisor and testified at important county planning commission meetings.

The AIA celebrated its sixty-fifth anniversary in 2020, a remarkable achievement since so many volunteer homeowner organizations thrive for only a short time. Its involvement in development plans, incorporation efforts and traffic proposals has been significant in every decade of Alamo's modern history.

BUSINESS ORGANIZATIONS

Merchants have regularly supported a healthy business community through various organizations. Early in the twentieth century, an Alamo Improvement Club and a Danville Improvement Club began, then expanded to become the San Ramon Valley Improvement Club. In 1923, a San Ramon Valley Chamber of Commerce organized, which included Alamo and functioned

for a time. In 1948, a Danville Chamber of Commerce was created, and it later became the San Ramon Valley and Valley Chambers of Commerce. Various business and merchants' associations and chambers have always been active in the Alamo area in some form.

Political philosopher Alexis de Tocqueville of Revolutionary War fame toured the country in 1831–32 and recorded his observations in *Democracy in America*. He noted Americans' proclivity to form associations of all types, asserting that such groups extended democracy by their very existence. Alamo's organizations certainly fit that description. He wrote:

> *In the United States, as soon as several inhabitants have taken an opinion or an idea they wish to promote in society, they seek each other out and unite together once they have made contact. From that moment, they are no longer isolated but have become a power seen from afar, whose activities serve as an example and whose words are heeded.*

SCHOOLS AND CHURCHES SUSTAINED PIONEERS

Soon, we began to think about building a church. Well, we must have a camp meeting. The time and place was decided upon, and we held a meeting, and we had a good one! People came from every place in reach to attend the meeting, which lasted for ten days. There were several conversions, and we organized a church with about ten members.
—Mary Ann Jones, pioneer

From the town's earliest years, Alamo pioneers wanted education and religious training for their children. Both the Stone and Howard families hosted tutors at their homes. And through the efforts of Mary Ann and John Jones who had nine children, the San Ramon Valley's first grammar schools and an early church were established. About the school, Mrs. Jones wrote:

> *People began to come in with their families, and we began to think about having a school for our children. So, we built a schoolhouse on the Hemme Place* [near today's El Portal Road and Danville Boulevard] *and hired a teacher.*

Mary Ann also boarded the school's teacher, Richard Webster. James Smith wrote about this school which he attended as a young boy, saying that it was built with redwood lumber and had single desks and seats built along each side, with a long low table in the center. The teacher's desk was at one

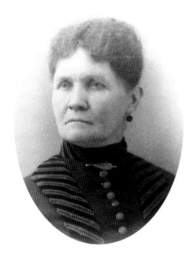

The indomitable Mary Ann Smith Jones, who founded Alamo with her husband, John M. Jones. *Courtesy of the Museum of the San Ramon Valley.*

end on a four-foot platform; it served as a pulpit when the school was used for religious services. Smith recalled that Webster was a popular teacher who kept good discipline.

THE UNION ACADEMY

The Cumberland Church promoted higher education throughout the West, and in the mid-1850s, it set up a Contra Costa County committee to locate a high school. The committee consisted of representatives from Lafayette, Alamo and Martinez. After much discussion and debate, each representative opted to locate the school in his own community. Then a new committee was created—composed of non-county representatives—and it chose the thriving central town of Pacheco as the best school site.

The high school was built, but not in that location. Alamo and Danville farmers proceeded to organize the Contra Costa Educational Association, select a board (Silas Stone, John M. Jones and Robert Love) and build a large boarding and day high school on the border of Alamo and Danville. It was the first high school in the county, and local students could attend from home. August Hemme sold three acres of his property (at a reduced price) to the school so that it could be located in the middle of the valley—although John Jones had offered land closer to Alamo. The Joneses approached Reverend David McClure to lead the school.

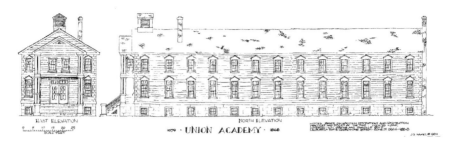

A drawing of the Union Academy, the largest building in the San Ramon Valley from 1860 to 1868. It was also used for church services and meetings. *Artist, John S. Hamel. Courtesy of the Museum of the San Ramon Valley.*

James Smith described the academy in a letter to Ida Hall:

> *The building was two stories high with a large basement that served for kitchen, dining-room and storeroom. The first floor was used for the school room. A one-storey* [sic] *building adjoining in the rear was added to accommodate the day pupils—to hang their hats, dinner pails, etc. In front, there were two halls leading into the school room—one on the north for the girls, one on the south for the boys—with an office between the two halls. That also served for the music room. It contained a piano, the first I ever saw....On the second floor, there was a partition with rooms on each side. The north side was assigned to the girls and the south to the boys that were roomers and boarders.*
>
> *Reverend David McClure did all the teaching and was the best teacher I ever had....He actually played the violin to assist our singing...And once a month, we were invited to a party, where we were permitted to dance the square dances for a couple of hours. We were then regaled with cake and candy....At the conclusion of the dancing and feasting, he would read a chapter in the Bible, have prayers, we would be dismissed about 10:00 p.m.—all very happy.*

Smith also recalled work done in 1860 to deepen a ditch south of the Union Academy that kept water away from the building. This ditch is today's Rutherford Creek, Alamo's southern boundary.

From 1860 to 1868, the Union Academy provided a high school education with an up-to-date curriculum (including music, art and calisthenics) for students. Described in detail each week by the *Contra Costa Gazette*, it was an extraordinary institution, although its "modern education" stirred some local controversy. Students even produced a newspaper, *The Waifs*. The school was the valley's educational and religious center until it burned down in 1868.

The front page of *The Waifs*, a newspaper produced by Union Academy students in March 1863. *Courtesy of the Contra Costa County Historical Society.*

Historian J.P. Munro-Fraser wrote, "It had a short life, and died a natural death; it was too far in advance of the times and the wants of the community which then resided in the beautiful San Ramon valley." When the Grange hall was built in 1874, some of the academy's nonreligious activities found a home in Danville, but it took more than fifty years for another high school to become available in the valley.

ALAMO GRAMMAR SCHOOLS

An Alamo Grammar School was built in the village, near today's northwest corner of Stone Valley Road and Danville Boulevard. In 1871, voters set up a school district and approved $1,500 to buy land and build a schoolhouse. The two-and-a-half-acre property that hosted the school was purchased for $200 from Mary Ann Jones, specifically to be used for school purposes. To the east, another school district in the Green Valley area had been established in 1865. People within the proposed grammar school district boundaries voted to tax themselves to purchase property and construct a school. The other early school districts in the San Ramon Valley were Danville, Sycamore, Tassajara and San Ramon.

Some school trustees in those early years were James M. Shuey, Joseph Thirston, Frederick Humburg, Albert W. Stone and Myron W. Hall. Kate Howard was the first Alamo schoolteacher. Improvements to the original school were made in 1893. Veda Wayne wrote:

> When repairs were being made and a new floor laid in [this] school, plans were made to hold a dance to celebrate the event. The night before the grand opening in 1893, the school burned to the ground. A report [was] given out that there were several disreputable families living in the foothills nearby who were not invited to the dance, and to get revenge, they set fire to the building.

The next Alamo Grammar School was a classic school building complete with a bell tower, probably built in 1894. Remodeled several times over forty years, the tower was removed and the bell placed in the outside yard, presumably because of concerns that the bell might fall in an earthquake. In 1904, there were sixty-one children enrolled at the school; there were sixty-eight in 1908 and fifty in 1911.

Miss Ida Hall taught at the school, serving as principal beginning in 1912. The Alamo Mothers' Club was organized in 1916 to improve the school's conditions. The club bought a piano and built a large playground apparatus with swings, a sandbox, basketball and handball courts and mapped off a baseball diamond. Astrid Olsson taught at this school and others before she married Lorenz Humburg in 1923.

By the 1920s, the school was showing its age. In a 1924 newspaper article titled "Ancient School at Alamo May Be Replaced Soon," county physician Dr. C.R. Blake talked to a meeting of Alamo Grammar School District residents:

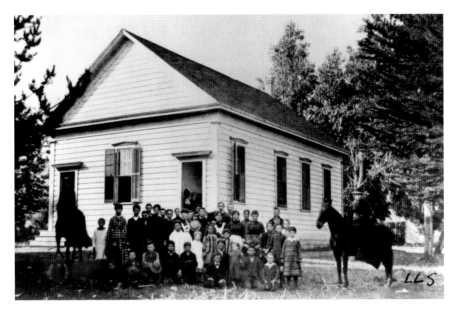

The first Alamo Grammar School teacher and students, circa 1880. *Courtesy of the Museum of the San Ramon Valley.*

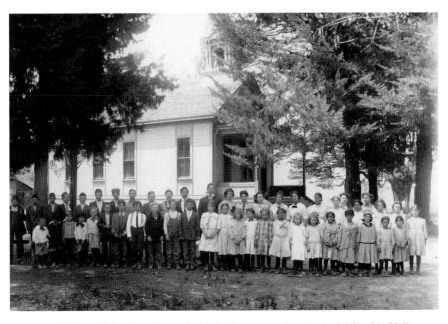

The second Alamo School and belfry in 1913. Shown are the principal, Miss Ida Hall; teacher, Miss Hannah Biggs; and some students: Alden Jones, Moiral Smith, Fred Davis, Roy Bell, Rose Silva, Stella Marengo, Lou Bell Morse, Bertha Bell, Hazel Bauer, Annie Smith, Mamie Silva and George Bunce. *Courtesy of the Museum of the San Ramon Valley.*

[He] *excoriated them for permitting their school to remain in its present condition. He told them that their school was a relic of an age now half a century gone; that it was unsanitary, an imposition on the children and a disgrace to the district. To get a drink of water, the children have to walk half a block from the dilapidated building to a 39-year-old pump, which they have to prime and struggle with its wheezy old handle before they get results. Then they drink from a rusty tomato can.*

The school was remodeled in 1924, and the porch was enclosed to create a new classroom. Several Japanese families lived around North Avenue, and nearly half of the children at Alamo School in the 1920s were Japanese Americans. In the 1930s, there were forty-eight students and two teachers at the school. In two hotly debated elections in 1931 and 1935, Alamo voters decided to stay with their local school and grammar school district and not join the Danville Union District, which offered a modern elementary school.

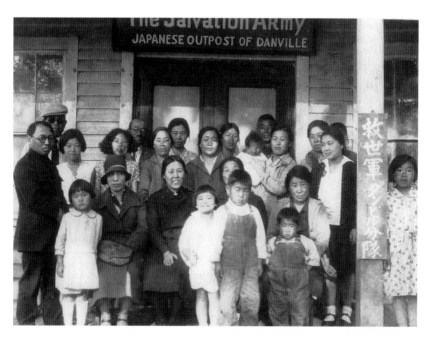

This 1929 photograph was taken in front of the Salvation Army Japanese Outpost, located in the Henry Hotel. Salvation Army captain Hirahora is on the far left, with his wife standing in the middle. Tamio "Tom" Sakata and his little brother Hiroshi "Hiro" Sakata are in front, wearing overalls. Their mother, Kiyo, is holding a baby; their father, Ichiji, is behind her; and their sister Mary is on the far right, leaning on the pillar. The Sakatas lived in Alamo. *Courtesy of the Sakata family collection.*

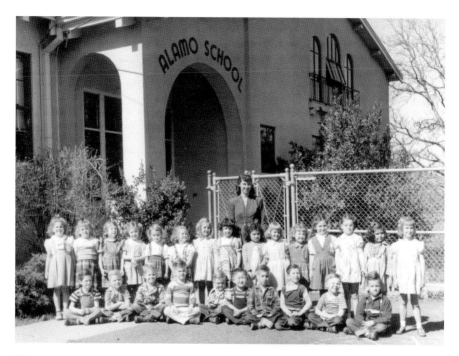

The Alamo Elementary School, 1950. Teacher Irene Mlejnik is shown with her students. *First row, from left to right:* Jimmy Morin, Michael Powell, Michael Mivelaz, Charlie Clark, Guy Wulfing, Steve Niino, Denny Putnam, Ronnie Catania, Tom Crouch and Bobby Nickerson. *Second row, from left to right:* Carla Diehl, Karen Nelson, Sue Henderson, Pattie Briggs, Susan Funk, Leslie Green, Mary Beauchamp, Charlene Havercroft, Enid Santiago, Marilyn Sherk, Cindy Gartin, Marjorie Moore, Sheryl Hendricks, Judith Romley and Mary Overcast. *Courtesy of the Museum of the San Ramon Valley.*

In 1940, a $20,000 bond issue was passed, and the third Alamo Grammar School was built near the site of the second school. Carlo Borlandelli said he finished the year in the old school and, after summer vacation, attended the new one. As with the earlier schools, the third school was an important part of the community, and for twenty-five years, it was used as a school and polling place and for social gatherings, dances and graduations.

Other schools were built in Alamo as the population grew, including Stone Valley Elementary and, later, Intermediate (1952) and Rancho Romero Elementary (1959). From 1958 to 1959, Alamo School had so many students that overflow classrooms were rented at the United Methodist Church.

Today's Alamo Elementary School at 100 Wilson Road opened in 1965. It has the original school bell in its courtyard, with a historical society plaque commemorating the history of Alamo's early education. Since 1965, Alamo's schools have been part of the San Ramon Valley Unified School District.

SAN RAMON VALLEY UNION HIGH SCHOOL

In 1910, fifty-eight years after the Union Academy burned down, a new public high school was opened. Grange members Nina McPherson Williams, Ben Boone, Will Stewart, Ida Hall and Florence Steinmetz were tasked with obtaining information on procedures to secure such a high school in the valley.

The *Contra Costa Gazette* (November 13, 1909) reported that a meeting was held in Danville to discuss the high school project. Five grammar school district boards agreed to send their students to a new high school: Alamo, Danville, Green Valley, San Ramon and Sycamore. On January 15, 1910, Grange Worthy Master Charles J. Wood announced to the public that the necessary and proper papers had been obtained. An election to create a high school union district and elect a board of trustees was scheduled.

After a successful election, the first meeting of the elected trustees of the San Ramon Valley Union School District was held on March 31, 1910. John F. Baldwin was elected president, and Will E. Stewart was elected secretary. It was moved and unanimously carried that the high school would be located in Danville. The first board of trustees consisted of John Baldwin, Will Stewart, Charles J. Wood, William Meese and Alamo's postmaster David Bell.

The trustees planned to open the school in early August with a ten-month school calendar. Harvey Eddy rented one of his houses, located two doors east of Hartz Avenue on Church Street, to the trustees. Rent was $25 a month, and Mrs. Eddy did the janitorial work for $1 a month. Theodore A. Cutting was hired as teacher and principal for $150 a month. He insisted that another teacher was needed and was instructed to make a trip to Stanford and Berkeley to find a "suitable" one. He hired Ada Maud Cornwall for $80 a month.

The trustees created a new curriculum by visiting other schools in the Bay Area. The school initially offered six courses: commercial, history, English, German, mathematics and physical geography. Chemistry and physics were added in 1912, and the Eddy house's porch was enclosed to create a science laboratory.

Thirty children attended the school in its first year in the Eddy house, and the home held the school from 1910 to 1914. As the student population grew, another location was sought. A new social and fraternal hall on Front Street had been built in 1913, freeing up the former Odd Fellows Hall upstairs in a Front Street building. In August 1914, forty-eight students and four teachers moved to the former Odd Fellows Hall, which had been

The San Ramon Valley Union High School's first graduating class in 1914. *From left to right*: Astrid Olsson, Ora Bell, Ruth Weinhauser, Viola Lynch and Alice Bell. Viola Lynch gave a valedictorian speech supporting the peace movement as the Great War began in Europe. *Courtesy of the Museum of the San Ramon Valley.*

refurbished. On May 29, 1914, the first five graduates completed all four years at the high school.

The trustees continued to look for a property on which to build a new high school, and in 1916, they found 10.7 acres of land north of Danville. Imagine the work this took as the five ranchers planned the curriculum, assessed possible school sites, purchased supplies and hired personnel, taking time out from their demanding agricultural work. The *Contra Costa Gazette*, on February 15, 1917, reported, "The trustees plan to make it a model agricultural high school."

Norman Coulter of San Francisco designed the attractive mission-styled building around a plaza, which was dedicated on March 14, 1917. That month, the students moved from the Front Street building to the new school, along with a few other students from Saranap, Lafayette and Walnut Creek. In 1920, the Tassajara and Highland Grammar School

Districts joined the union high school district. Today, the original high school district is part of a unified school district; there are now three other high schools in the San Ramon Valley.

From 1914 to 1924, some students used the Oakland, Antioch and Eastern Electric Railway to commute to school. Occasionally, large rainfalls washed out the tracks and stations. In January 1916, Ida Hall warned students to get off the North Avenue platform when it unexpectedly washed out. She lost her suitcase, lunch, purse, umbrella and books in the debacle.

The Lucille Mauzy School is another educational institution in Alamo. Located at 2964 Miranda Avenue, this school was founded in 1980 and serves students with moderate to severe developmental disabilities. Lucille Mauzy, a descendant of Alamo founders David and Eliza Glass, was a longtime county board of education member (1956–1979) with a particular interest in special needs students. The school's goal is to "allow all children to achieve the utmost of their capabilities."

ALAMO'S CAMP MEETINGS AND CHURCHES

The Joneses founded the Cumberland Presbyterian Church in south Alamo, which was received into the California Presbytery on April 5, 1851, according to church records. Once again, readers can see the determination of Mary Ann Jones when reading her autobiography, which discusses camp meetings and the church along San Ramon Creek:

> Soon, we began to think about building a church. Well, we must have a camp meeting. The time and place was decided upon, and we held a meeting, and we had a good one! People came from every place in reach to attend the meeting, which lasted for ten days. There were several conversions, and we organized a church with about ten members. That was the first Protestant church in Contra Costa County (when the county covered the whole East Bay).

This meeting and later camp meetings certainly enlivened the early pioneers' isolated lives, as James Smith recalled. "There was a large tent set up, which held 400 people at the creek, located about two miles north of Alamo. Mack Jasper did the barbeque, and neighbors brought cakes and pies." Smith said he later attended a Black camp meeting in Oakland, but he said, "The religious fervor did not compare to the ones I attended in San Ramon," which had several exhorters a day. He said the creek at that

location was wide, "The water did not flow so rapidly, and the depth was more gradual.…The converts from the yearly camp meetings were brought to be baptized, washed of their sins."

In 1856, young western writer Bret Harte tutored four boys who lived in Tassajara Valley. Their father, Abner Bryant, hired Harte because he didn't want his sons to "grow up like wild cattle." A religious man, Bryant very likely sent them all to a camp meeting. Later, Harte produced a story titled "An Apostle of the Tules," which probably reflected the Alamo camp meetings, writing that they had a "singular resemblance to a circus." He felt that the attendees of these camp meetings were brought together by an "instinct of some mutual vague appeal from the hardness of their lives." Mary Ann wrote further:

> *Then we must have a church house. Mr. Jones began to talk about it, and by this time, there was a goodly number of people in the Valley. Mr. C.W. Ish, who had a large family, was very much interested in the matter, with William Mitchell and others.…So, we built a church on the north side of the road* [today's El Portal Road], *and the Reverend Cornelius Yager had moved to the valley by this time, and he was our preacher for a few years.*

In a church history, Reverend Wesley Van Derlinder wrote that the Cumberland Presbyterian Church was organized at a camp meeting in the winter of 1850. When Reverend T.M. Johnston was the pastor, a pioneer newspaper called the *Pacific Cumberland Presbyter* was produced, which was another first for the area. The church met on the second and fourth Sundays of each month; it shared its sanctuary with the Methodists on the first Sunday and Baptists on the third.

This church moved north to Alamo's village in 1875, next to the schoolhouse on the Jones property. It remained with a diminishing membership until 1906, when it merged with the Presbyterian Church (USA). Mary Ann Jones was its final member; she then transferred to the Danville Presbyterian Church.

In 1910, the handsome St. Isidore Catholic Church was constructed in Danville; it had an extensive parish, including members from the San Ramon Valley and Walnut Creek. During the 1920s, the Japanese Outpost of the Salvation Army was housed in the Henry Hotel. Today, churches in Alamo include the San Ramon Valley United Methodist Church, New Life Church and Creekside Community Church on Danville Boulevard and the Church of Jesus Christ of Latter-day Saints on Stone Valley Road.

A drawing of the entry to the Alamo Cemetery on El Portal. The cemetery includes the grave sites of many early Alamo pioneers, including individuals from the Jones, Humburg, Stone, Bell, Hall, Howard and Stow families. *Artist, Paul Dunlap. Courtesy of the Museum of the San Ramon Valley.*

East of the original Cumberland Church, on today's El Portal Road, a cemetery was established on land donated by John B. Watson in the 1850s. While there may have been earlier burials, the first confirmed burial at the cemetery was that of six-year-old Callie Chrisman in 1856. The Alamo Cemetery hosts the burial grounds of many early Alamo and Danville pioneer families. No new burial sites are available today, only niches for cremated remains. To be eligible for niche inurnments, valley people must reside in an area based on the original nineteenth-century Alamo, Danville, Green Valley and Sycamore Grammar School Districts, with the exact boundaries established in a 1937 tax district. This peaceful pioneer cemetery is managed by the Alamo-Lafayette Cemetery District.

9

ROADS, RAILS AND TRAILS

Our goal is to beautify the boulevard by planting trees along its entire length in Alamo, from Rudgear Road, south to El Portal. Where possible, a canopy effect will be restored.
—*Alamo's* Boulevard of Trees *brochure*

Getting around was easy for Alamo folks, since all roads led to Danville Boulevard or the Southern Pacific Train, with Mount Diablo on one side and Las Trampas on the other. In later years, new roads were built, and the Iron Horse Regional Trail was established along the former railroad right-of-way.

THE MAIN ROAD: A BEAUTY

Danville Boulevard, the main county road through Alamo, which probably originally followed an Indian path, was called the Martinez to Pueblo San Jose Road after California achieved statehood. The first Alamo businesses began along this north–south road at the intersection of what was then called Diablo Road. An early path to the west led through Moraga, to the redwoods and Oakland. In 1920, the highway became one of the county's first paved streets from Walnut Creek to the Bishop Ranch in San Ramon. An experimental six-inch-high-by-fifteen-inch-wide macadam strip was

placed in the middle of the road to keep drivers in their lanes; to pass took some nerve and a clear road ahead.

Suggested alternate names for Danville Boulevard have been floated for years. Nineteenth-century street names often indicated the main destination of the road, as is the case with Martinez Road. In 1892, the roadway from the southern end of the county to Martinez was designated County Road No. 2; then it became the Memorial Highway and the Contra Costa Highway, with Danville Highway later appearing on Alamo maps. For thirty years, beginning in 1933, the road was also designated State Highway 21 throughout Contra Costa and Alameda Counties.

In 1948, a county resolution changed the name of Danville Highway to San Ramon Valley Highway. In 2007, county planning commissioner Andrew Young suggested the moniker Alamo Parkway, and Alamo Boulevard was discussed as another option. None of these names were implemented. Since 1962, Danville Boulevard has been the main thoroughfare's name, and it stretches from Hartz Avenue in Danville to Main Street in Walnut Creek.

Two of the town's original streets were North Avenue, which is now Las Trampas Road, and South Avenue, which originally extended to the boulevard. There are several streets named for pioneers, like Stone Valley Road, Miranda Avenue, Via Romero, Linhares Lane, Bolla Avenue and Hemme Avenue.

Trees by the Highway

The thoroughfare through Alamo has seen sustained civic action to preserve it as a two-lane, tree-lined highway. The effort has been a passion of many residents, with some calling the road a little El Camino Real. Any county plans to expand the road have been opposed, even though a wide right-of-way is in place and is carefully preserved by the county. Congestion on I-680 and the boulevard has generated many unsuccessful plans to widen the entire road.

The trees along the Danville Highway through Alamo have been planted for well over a century by local residents. In the 1860s, locust trees were placed along the road to adorn the entrance to Union Academy's grounds. In the next decade, August Hemme planted trees by the road on his large property. The *Contra Costa Gazette* (April 12, 1879) described Hemme's plantings:

These elm trees, photographed in 1950, handsomely framed the county highway. Planted after World War I, they were mature trees by this date. *Courtesy of the Museum of the San Ramon Valley.*

Trees about two inches in diameter have been set out on both sides of the road, about 18 feet apart. These trees are from the Sandwich Islands and are a branch of the cork family. They are about ten feet high. If they live and do well, they will form an avenue of great beauty for two miles along the garden valley of our county.

**Alamo's
Boulevard of Trees Project**

After Dutch elm disease decimated the canopy of trees along the highway, Alamo residents decided to plant new trees and create another linear parkway. The *Boulevard of Trees* brochure described the group's purposes and enlisted support for beautifying the boulevard. *Courtesy of the Boulevard of Trees Committee.*

Walnut trees had been planted by rancher Myron Hall along the road north of Alamo by the 1880s. According to his family, he placed the tree grafts high enough along the road so that they wouldn't interfere with traffic. In 1914, when the electric train traversed the highway, James Cass and Flora Jones insisted on a deed that stated: "The walnut trees growing along east side of County Road are to be left intact."

After World War I, Dutch elm trees were planted along the entire north–south thoroughfare through the county in honor of fallen veterans. To the community's dismay, Dutch elm disease had wiped them out by the mid-1970s.

In 1970, the Association for the Preservation of Danville Boulevard (APDB) was established "to preserve, protect and enhance the natural beauty" of the valley's main route, with the Alamo Improvement Association (AIA) providing support. Roy Bloss, a founder and chairman of the group, said the county proposed expanding the boulevard to four lanes. In the May 13, 1970 edition of the *Valley Pioneer*, Bloss put out an impassioned call to protect "the beauty wrought by God, over the artificiality of man." Later, he happily recalled, "We stopped the county." The Alamo Improvement Association's Scenic Highway Committee worked to establish a tree planting ordinance and resisted what it labeled a four-lane mini-freeway.

In the 1970s, an arterial road called Highway 93 was proposed by the state highway commission, which clashed with the community's desired "semi-rural" environment. Also labeled the Burton Valley to Alamo Freeway, the highway would have come east from Lafayette, over the north part of Las Trampas Ridge, to Alamo. The AIA's Highways Committee chairman John Osher successfully led the charge to organize and agitate against the

highway with letters, phone calls and large meetings. In 1973, State Senator John Nejedly's legislation (SB 1321) passed and deleted Route 93 from the State Freeway and Expressway System.

From 1987 to 2005, an energetic Boulevard of Trees Committee was founded by Alamo's R7A park committee, then chaired by Brian Thiessen. The Alamo Park Foundation managed donations, as several landscape firms produced a base and tree plan for which encroachment permits were acquired. Each dedicated tree cost $250. A grant of $2,723 was received from the California Department of Forestry, as local fundraisers and an "adopt-a-tree" program were established. Alamo resident Lillian Burns nurtured this tree-planting program for decades.

The group successfully planted 285 trees from Rudgear Road to El Portal in Alamo and made sure maintenance was provided with a funding mechanism (Zone 36) set up by the county. The group's theme was "Bring Back the Beauty." It addressed challenges presented by resistant business owners, unauthorized tree pruners and a lack of water. Bloss reported that he had happily paid for three oak trees by his house at the corner of Danville Boulevard and Laurenita Way. Today, there are a variety of species, including pistache, Wilson holly, valley oak, strawberry, maidenhair, scarlet oak, Bradford pear, Raywood ash and London plane trees, gracing the road (especially north and south of downtown).

ALAMO: A STAGE STOP

Because of its location, Alamo was an early destination for horse-drawn stages carrying passengers and freight. For example, in 1858, a new Tri-Weekly Stage, with Duncan Cameron as its proprietor, was advertised in the *Daily Alta California*. Meeting the morning ferry from San Francisco at Brooklyn (Oakland), the stage traveled into the redwoods, through Moraga Valley, Brown's Mills, Lafayette and Walnut Creek House, to Alamo. Other stage companies followed this general route in the nineteenth century. Periodically, a stage ran from Martinez to San Jose and stopped in Alamo to allow for transfers.

SOUTHERN PACIFIC RAILROAD: 1891–1978

One of Alamo's prominent residents, August Hemme, was a pivotal figure in bringing the San Ramon Branch Line of the Southern Pacific Railroad to the area in 1891. A businessman and philanthropist who was well-known in San Francisco, Hemme met with Southern Pacific president Collis P. Huntington to urge support for the branch line in 1890.

There had been interest in getting a valley railroad for decades. The county's dirt streets made it difficult to transport crops to the piers in Martinez, especially for the San Ramon Valley ranchers in the winter. In 1868, an effort to pass a bond for a Martinez and Danville Railroad went to the central county voters. The Alamo School hosted a polling place, where James Foster, Mark Anthony and John M. Jones served as judges. Alamo supported the train in a vote of 41 to1; however, communities that were not on the line opposed it, and the effort lost 522 to 391.

By the final decade of the nineteenth century, building the Avon (near Martinez) to San Ramon Railroad had gained some momentum. Southern Pacific was willing to build the line if the right-of-way was given to them for free. August Hemme shared Charles F. Crocker's promise: "If we give the right-of-way immediately, [Crocker would] blow his whistle in Danville… sixty days from signing articles."

Alamo property owners Myron Hall, D.P. Smith, A.T. Hatch, Joshua Bollinger and Hemme deeded land for the right-of-way and helped persuade others to do the same. After multiple meetings, subscriptions were raised to purchase property from recalcitrant owners. James Foster, an Alamo pioneer who then lived in Walnut Creek, chaired several committees to obtain the right-of-way.

The train's construction began in 1890, with stations planned along the line. A flag stop, the Widbero station at mile 50.6, was placed about two miles south of the Walnut Creek station at the northern end of Alamo. In two more miles, the Hemme station was built. Alamo was small, and people evidently didn't mind that Alamo's station and freight depot were south of the village on Hemme's Ranch. Initially called Hemme Station, it was renamed Alamo Station after Hemme passed away in 1904.

Alamo was featured in the *Contra Costa Gazette*'s description of the train's first public ride on June 7, 1891:

> *The first passenger train over the SRB Railroad left Martinez on Sunday morning at 9:20 o'clock…included Martinez residents and a delegation*

Right: A portrait of the enterprising August Hemme, who led the effort to bring the Southern Pacific Railroad to Alamo and the San Ramon Valley. His contacts with the leaders of the Southern Pacific were crucial to their interest in this small branch line. *Courtesy of the Museum of the San Ramon Valley.*

Below: The Alamo freight depot south of the village was placed on the Hemme Ranch. The sign reads "52.6 miles to San Francisco" and indicates a 310-foot elevation. August Hemme built a fruit packing plant nearby to prepare pears and other fruits for efficient transport. *Courtesy of the Bancroft Library.*

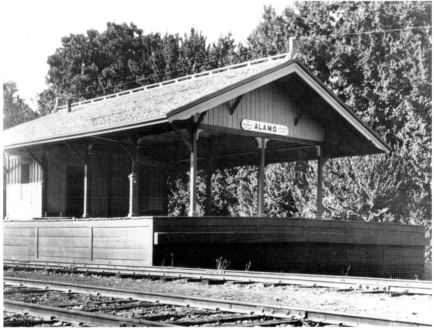

from San Francisco....The beauty of the country seemed to increase as the train sped on and reached its height as Hemme's was approached. Here, the train passes through the famous orchard of A.T. Hatch, and it is worth going a long journey to see. The trees are trimmed to a model with mathematical precision, and their luxuriant growth would attest the careful cultivation of the ground, were it not evident from ocular inspection.

To residents' delight, the train smoothly transported their farm products and cattle and allowed families to visit friends for special celebrations. Alamo's Belle Nunes Silva remembered visiting relatives in Concord's central plaza for July Fourth around 1900. The Nunes family brought a picnic with fried chicken, pickles, potato salad and cakes decorated with red-white-and-blue candy. There was a band and a parade. Each child received twenty-five cents, and they spent most of it on tiny firecrackers. They brought firecrackers home, and after their mother had sprinkled down a part of the yard, they had a firecracker party. Often, they shot them off from under a can, which would "bang off about a foot off the ground." She said, "That would be the end of a perfect day!"

AN ELECTRIC RAILWAY: 1914–1924

For a decade, from 1914 to 1924, Alamo had two transit options: the Southern Pacific and the Danville Branch of the Oakland, Antioch & Eastern Railway (OA&E). The OA&E began servicing the area in 1911 and provided a popular east–west electric transit line through the county. The main line extended west to the San Francisco ferry in Oakland, using a new Redwood Tunnel through the hills after 1913. It went east across the county to Mallard, took a barge over Suisun Bay and traveled through Solano County to Sacramento and Chico.

This Oakland, Antioch and Eastern Railway billboard, circa 1916, advertised an easy way to reach Mount Diablo and see the expansive view from the summit via an electric train. *Courtesy of the Contra Costa County Historical Society.*

These OA&E tracks are bordered by poles carrying electric power on the east side of Danville Boulevard, circa 1920. Notice the Hall Ranch walnut trees on both sides. *Photographer, Ward Hall. Courtesy of the Museum of the San Ramon Valley.*

The Danville Branch of the OA&E began in Saranap, came over the Tice Hills through Alamo, traveled south on the highway through the Hall Ranch and Alamo's village to the new public high school. Then, after going through Danville's downtown, it curved east into the new Mount Diablo Park Club in 1916.

There were several modest stations in Alamo where the train would stop; some were built as small platforms, and others were described as shelter sheds. These stops appeared at Krelling (across from Woodland Avenue), a flag stop called Romero Station, Alamo Village Station (first at North Avenue, then north at A.J. Soarer's Grocery Store), Hemme and Camille. The last two had seven-by-eight-foot shelter sheds, which cost $23.20 to construct. The Romero Station Flag Stop was installed across from the lane that led to the Jones property called Rancho Romero. Except for the village station, the other Alamo stops were placed next to orchards.

The Danville Branch Line was a sort of stepchild of the OA&E—the train itself was a recycled baggage car with an eccentric conductor. There were many endearing stories and multiple nicknames for the line. One such nickname was the "Alligator," since car no. 1051 was sixty feet long and no beauty. By 1923, it was dubbed the "Toonerville Trolley," after a popular cartoon strip created by Fontaine Fox. Paul Ogden said it took him fifteen

minutes to get from Alamo to Saranap on the "Dinky" or "Riveter" during the Great War. There, he boarded the regular electric train with four or five hundred other people who were working at the Clyde Shipyard for a commute that took about an hour. Around twenty-five men from the San Ramon Valley regularly used the train to commute to work at the World War I shipyards.

The train was also used to get to doctor appointments in Oakland, and in the reverse, teachers and students commuted on the train to the new high school in Danville. Astrid Olsson took the train to visit home when she was enrolled at San Francisco State Normal to obtain her teaching credentials. The trolley often transported both passengers and produce, such as pears and grapes.

Unfortunately, the electric train opened just as cars and trucks became popular. After ten years, the branch line closed, despite adamant opposition led by the Grange. The *Contra Costa Courier*, on February 29, 1924, commemorated the train's demise with a droll little poem by Nell Diaz:

> *Toonerville, Toonerville, we knew you well,*
> *No more you'll battle through the dell,*
> *No more your faults, to all, disclose,*
> *At last, you've earned a long repose.*

The train was replaced by a bus (nicknamed the Big Yellow Bus), which people took to reach the main electric line in Walnut Creek. In 1929, the county's railway became part of the well-regarded Sacramento Northern Railroad, which allowed patrons to ride in comfort from Oakland to Chico, a 177-mile one-way journey.

TRAILS

When the San Ramon Branch Line closed in 1978, the right-of-way's future was debated up and down the line, with dueling suggestions for a paved trail or light transit. There were multiple private and public studies done to address the possible uses. A regional trail was envisioned in the East Bay Regional Park District's 1973 master plan. When Bishop Ranch Business Park in San Ramon was opened in the 1980s, the owners wanted to be able to transport employees via rail to relieve future freeway congestion.

The Right of Way Trail Advocates (ROWTA) supported a multipurpose paved trail along the abandoned right-of-way. Here, hikers, bikers and equestrians prepare to join the July 4, 1986 Independence Day Parade in Danville. The two women on the right are League of Women Voters members Ann Macalka and Silvia Lin. *Courtesy of the Museum of the San Ramon Valley.*

Several citizen groups joined the debates. In 1983, Alamo's Roy Bloss put together a homeowner coalition to effectively voice their opinions. This coalition included the AIA, APDB, Danville Association and San Ramon Homeowners Association, and it was called the Southern Pacific Right-of-Way Study Committee (SPROW). In 1984, Bick Hooper and Beverly Lane founded an organization of diverse trail users, the Right-of-Way Trail Advocates (ROWTA), which pursued a multi-use, paved trail. Wanda Longnecker, Ann Macalka and Silvia Lin were active Alamo members of ROWTA. Beginning in 1985, Alamo's Tim Tinnes headed the Organization to Save Our Community (OSOC), which asserted that mass transit belonged on the I-680 freeway.

Contra Costa County was involved in all of the discussions and studies, as it wanted to keep the right-of-way free from development for future public use. It purchased most of the right-of-way with a state grant, using a mass transit fund, and it pursued many other funds. Prior to a final decision on the right-of-way's use, the Alamo Plaza Shopping Center developed a nine-hundred-foot section of the right-of-way as a trail in 1981. Supported by the

Regional Park District, the new Danville and San Ramon City Councils, R7A and County Supervisor Bob Schroder, the Iron Horse Regional Trail was established on the right-of-way. Today, the trail extends thirty-four miles, from Concord to Livermore. A linear parkway, it is used by walkers, runners, skaters, bikers and occasional equestrians, and it is much loved by the community.

Alamo contains two other regional trails that residents and R7 advocates supported over the years. One is Green Valley Regional Trail, which comes from Mount Diablo to Green Valley Road. And another is Las Trampas to Mount Diablo Regional Trail, which travels east–west for five miles, with fabulous views along the way. A traffic signal, supported by trail advocates John Osher and Claudia Waldron, was placed at Camille Avenue, which included an equestrian button to allow horseback riders to activate the signal. The APDB insisted that the signal should fit the "character of the boulevard."

A trail just west of Green Valley Road extends between Monte Vista High School and Diablo Road. John Osher and others from R7 worked to get a loop trail along San Ramon Creek, through Stonecastle's unique rock formation, to the Iron Horse Trail. This trail and several others were planned but never implemented because of successful neighborhood and developer opposition. There are bike paths on Miranda Avenue and trails/ sidewalks along Livorna and Stone Valley Roads, which residents pursued, as well as many informal trails that are known by local runners.

Today, the County Connection's regular and express buses provide transit services to Walnut Creek stores and BART, taking Danville Boulevard and I-680. Some people ride the buses using stops along the boulevard, but most residents prefer the flexibility of the automobile.

There are no stages or rails through Alamo, but people move freely, commute, run errands and enjoy walks. They work to keep Danville Boulevard confined to two lanes. And they travel on the beloved tree-lined boulevard, the I-680 freeway, regional and local trails, and the County Connection, using shoe leather, cars, bicycles and buses.

THE TWENTIETH CENTURY

1900 to 1950

We have often heard of the enchanted city—of the magic carpet—of the lure of the desert—of all of the wild and other sayings, but studying Alamo, as I have, I find that all who came within the boundaries of our beautiful Alamo were unable to resist her charm. All seemed to fall under her magic spell.
—Veda Wayne, Alamo Community Club historian

Twentieth-century Alamo opened up to the world as telephone service, radios, motorized vehicles and an electric railway arrived. To be sure, national events affected the community, including woman suffrage, two world wars, the Spanish flu, Prohibition and a devastating depression. Locally, a new public high school and the Mount Diablo Park Club created dramatic changes. Alamo had only a few hundred residents at the time with 258 residents in 1910; 309 in 1920; 217 in 1930; and 396 in 1940.

By 1900, a telephone trunk line with long-distance service was in place through the valley. Wires were strung down the west side of the highway from Martinez, through Alamo, to the large Bishop Ranch in San Ramon; the exchange was in Martinez. After 1910, farmer telephone lines extended out from the trunk and included between three and ten subscribers on a line. There were one hundred subscribers in the San Ramon Valley by 1920.

Longtime telephone operator Viola Scott Root recalled that farmers paid twenty-five cents a month or three dollars a year to join the farm service, and they were expected to repair their own lines. Privacy was not an expectation.

Sycamore Valley's George Wood said, "The other subscribers would come on to the line to listen, of course, because we didn't have any TV or radios at that time." Each subscriber had four numbers. For example, 5F24 stood for 5 (the line number), F (a farmer line) and 24 (which would be 2 long and 4 short rings). In the 1940s, dial phones were introduced, and the first local telephone book was distributed. No more "Alamo 4F12."

Root's office was in Danville where she kept track of people's whereabouts downtown. Sometimes, she would take messages for them. She also rang the siren behind the firehouse to let volunteers know when there was a fire.

SAN RAMON VALLEY UNION HIGH SCHOOL

Big news for Alamo—and the whole valley—centered on the creation of a public high school in 1910. After discussion and work led by the Danville Grange and Local Improvement Association, the high school opened with students from five of the valley grammar schools: Alamo, Danville, Green Valley, San Ramon and Sycamore.

Thirty students attended the school in the Eddy house on Church Street in Danville from 1910 to 1914. Then classes were housed upstairs in a Front Street building from 1914 to 1917. In March 1917, the San Ramon Valley Union High School opened in a newly constructed Mission-style building north of Danville on the highway.

THE 1911 ELECTION

An election on October 10, 1911, was significant for California and the valley. The Progressive movement and its allies had worked to decrease the dominance of railroad interests in Sacramento. New legislators were elected, and they passed the direct election powers of initiative, referendum and recall, which were ratified by voters.

Women won the right to vote in that election, making California the sixth state to approve woman suffrage. A Danville Equal Suffrage Club was formed in August 1911, with high school teacher Ada Cornwall becoming a club officer. The suffrage proposition won narrowly statewide, with Alamo men opposing it by a vote of 13–11. The women's success sent shockwaves across

This campaign poster was called the *Golden Gate Madonna*. The poster appeared in stores all over San Francisco in support of woman suffrage, which appeared on the California ballot in 1911. *Artist, Bertha Boye. Courtesy of the Museum of the San Ramon Valley.*

the country, and many of their campaign techniques were used by suffragists in the east. After Congress supported woman suffrage and thirty-six states approved, the Susan B. Anthony (Nineteenth) Amendment was added to the U.S. Constitution on August 26, 1920. Woman suffrage doubled the number of eligible voters in America.

GETTING AROUND: THE ELECTRIC RAILWAY, CARS AND HORSES

From 1914 to 1924, the Danville Branch of the Oakland, Antioch and Eastern Railway (OA&E) ran down the eastern side of the highway, providing several Alamo stops and a convenient way to get around. In 1915, visitors rode the electric railway through the Redwood Tunnel to Oakland and took the ferry to the fabulous Pan Pacific International Exposition in San Francisco. April 3 was Contra Costa County Day at the fair, and it featured special local trains and county products.

A country club opened east of Danville; it was created by entrepreneur Robert Noble Burgess, a son of Danville's Presbyterian pastor. In 1912, he bought the ten-thousand-acre Oakwood Stock Farm and other acreage, which included the summit of Mount Diablo. Called the Mount Diablo Park Club, plans were drawn for summer homes, a clubhouse, a golf course and tennis courts. With the OA&E Railway extending to its doorstep, on

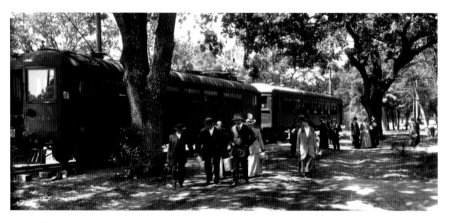

An Oakland, Antioch & Eastern two-car train arrived at the Mount Diablo Park Club Inn in 1916. It brought people from San Francisco and elsewhere to visit the new club and hike or ride to the top of Mount Diablo. *Courtesy of the Bay Area Electric Railroad Association Archives Department.*

May 14, 1916, a grand opening to sell lots brought over 1,200 people to the site. San Francisco prospects came to the club on exclusive trains that locals dubbed "Millionaire's Specials."

The electric line vied unsuccessfully with the growing popularity of new motorized vehicles, closing in 1924. Competition from the new trucks and tractors gradually reduced the need for so many work horses and large hay barns. Still, Alamo was horse country, as people enjoyed riding and horse cart racing. There was a eucalyptus-lined racetrack at the new club. August Humburg's racehorse was called Humburg Belle.

All of these cars naturally led to the need for better roads. In 1909, Danville Grange Worthy Master Will Stewart organized the first Good Roads League in the county. When a bond issue for improved roads came to the ballot in 1919, Alamo voters supported it with a vote of 65–0. One of the first paved roads in the county was built through Alamo in 1920. Gasoline stations began to dot the highway, and often, station owners became car dealers as well. Astrid Humburg's brother Oscar Olsson sold Nash products from his station in Danville.

WORLD WAR I

The Great War and the subsequent flu pandemic brought a whole raft of changes to Alamo, as its young men joined the army in 1917 when America entered the war. The 1918 high school annual, the *Valley Kernel*, listed the names of eighteen boys who were in the military. Lorenz Humburg graduated high school in 1916, attended the University of California, Davis, and went to Camp Lewis near Tacoma, Washington, for training. Then he was sent overseas to France as part of Battery C, Company 347. James Cass Jones helped sell liberty bonds, and women knitted scarves and socks for the Liberty Boys. Five valley soldiers lost their lives in the war, some from what was called the Spanish flu.

During the flu pandemic, Elwin "Rocky" Stone, the grandson of pioneer Albert W. Stone, was in the third grade at Alamo Grammar School. He ate garlic each morning before school as a strategy to prevent contagion. He said it did keep folks away from him "because no one wanted to get near me, and I ended up in the back of the room."

People who caught the flu often suffered for three to four weeks, and their deaths were reported in the newspapers. Little Manuel Camacho

A portrait of Lorenz Humburg, who trained at Camp Lewis and served in France during World War I. *Courtesy of the Humburg family collection.*

passed away in Danville. In Tassajara, Rose Ferreira's uncle died after he had tended her large flu-stricken family by bringing soup to them in milk cans every day. During November 1918, social events were canceled; every bar, school, church and lodge was closed, and masks were required. Red Cross volunteers made eight-by-five-inch gauze masks, which they sold for ten cents.

RURAL LIFE—WITH SOME ADDITIONS

Radios were a new invention that brought the world closer to Alamo. Rocky Stone remembered earning money for his first crystal radio by picking garlic at eight dollars per sack and caddying at the new country club. He and a friend put the radio together and listened to KPO. He recalled persuading his father to put on headphones and watching his astonishment. His dad said, "You can hear the weather on this thing!"

Josephine Fowler Jones remembered her first radio, too. It was a Magnavox, which they purchased to follow the 1932 national election. President Franklin D. Roosevelt was elected that year, and he used the radio to great effect. His fireside chats to his "fellow Americans" drew people to their radios throughout the 1930s and beyond.

Home deliveries were a rural practice during this period. These included fish from the "fish man," Louis Pellegrini of Martinez (especially for Catholic families' Friday dinners), and beef from Joe Lawrence's Danville Market. Other deliveries included ice cream and milk (in glass bottles to the door of your choice) from the Shuey or Williams Creameries, orange juice, baked goods, vegetables and the *Oakland Tribune* newspaper.

Celebrations and parties helped enliven community life, and they included school programs, May Day festivities and picnics, often at the schoolhouse or on a large ranch. And, of course, weddings between neighbors were big events from the beginning, including Annie Stone and August Humburg (1893); Flora May Stone and James C. Jones (1900); Astrid Olsson and Lorenz Humburg (1923); Josephine Fowler and Alden Jones (1931); and Josephine Marengo and Edward Johnsen of the Stone family (1935).

In 1928, one memorable accident marked the skies over Mount Diablo's western foothills near Alamo. Howard Hughes filmed an aerial battle at an altitude of about four thousand feet for his movie *Hell's Angels*. Two of the small vintage aircraft collided, with one pilot parachuting into a field on the Humburg Ranch, as recalled by a young Betty Humburg. Some of this film appears in a later movie on Hughes, providing glimpses of Alamo's hills in the 1920s.

THE ORPHANS' CAMP SWAIN

Each year, from 1911 to 1941, children from the San Francisco Protestant Orphanage spent the summer at Camp Swain in south Alamo, the site of today's Hap Magee Ranch Park. Their presence always brightened up the local summers. The children arrived by electric train and bus, bringing their clothes and bedding, full of energy and ready for outdoor fun in the sun. Alamo's Veda Wayne taught sewing to the girls, and Angelina Huber, who lived nearby, made cookies for them and was dubbed "Mom." Tents gave way to buildings, as they raised rabbits, hiked, played games and swam in the creek.

This brick sculpture by Rich Corrin holds a plaque commemorating the donation of Captain Isaac Swain, which made a summer camp for children from the San Francisco Protestant Orphanage possible. The original campsite is now part of the Hap Magee Ranch Park. *Photographer, Jeff Mason. Courtesy of the Museum of the San Ramon Valley.*

During the 1930s, campers let everyone know that they yearned for a proper swimming pool. They would march to McDonald's Drugstore in Danville for ice cream singing this song:

> *We are the kids from Camp Swain*
> *You hear so much about!*
> *The people stop and stare at us*
> *Whenever we go out.*
>
> *We're here to have a real good time,*
> *So come and help us out,*
> *By giving us a swimming pool*
> *So we can swim about!*

Their earnest campaign prompted the construction of a pool.

THE 1930S

The Great Depression in the 1930s left ranchers with very little cash, as itinerant families and workers came into the valley, looking for jobs. In the Danville Fire District minutes from 1933, Ed Wiester wrote, "Lot of talk about hard times, but as we could do nothing about it, we adjourned."

But not all was doom and gloom. On April 26, 1931, the new 1,400-acre Mount Diablo State Park was opened to the public with a parade led by the flamboyant Sheriff Richard R. Veale. Attendees stopped at Diablo Country Club to wait out a huge thunderstorm where they enjoyed the club's hospitality. Finally, Governor James Rolph Jr. made the dedication honors, although he was a little unsteady on his feet. Tart-tongued Rose Ferreira said he was "drunker than a skunk." Active support for the park came from the Danville Grange, Alamo Community Club, Danville Women's Club, George and Waldo Wood, the Mount Diablo State Park League and the Sierra Club.

New bridges and tunnels generated some grand openings, like the Bay Bridge opening in 1936. In 1937, the new Broadway Low Level Tunnel (later called the Caldecott), from Contra Costa County to Oakland, replaced the tiny Contra Costa Tunnel, built in 1903. County Supervisor Oscar Olsson had worked hard to get the new passage in place. On December 5, 1937, the San Ramon Valley High School band played, and young women representing each Contra Costa community attended the five-hour dedication ceremonies. Army airplanes circled overhead, pigeons were released and Governor Frank F. Merriam pushed a button that set off an explosion, demolishing a papier-mâché barrier to open the tunnel. This was an event no attendees ever forgot.

During the mid-1930s, several talented high school athletes made a name for the valley, although the high school had only 110 students, with over half of them being girls. In 1933, Lee Fereira won the junior pentathlon in Berkeley; Ted Main won it the next year. Eldred Ramos placed first in the pole vault (12 feet and 10.5 inches with a bamboo pole) at a state track meet. Young Bob Frick ran the one-hundred-yard dash in 9.6 seconds, breaking the 1935 state meet record.

In an interview, Fereira said, "Heck, our starting backfield in football was also our relay team....When we had a home game on Friday afternoons, everyone closed up their business to come and watch us play." In 1935, the San Ramon Valley Union High School football team had an 8–0 record against much larger schools in the county.

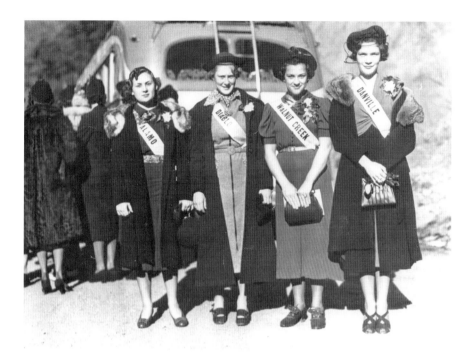

In 1937, when the Caldecott Tunnel opened, there were exciting celebrations. These young women enjoyed the day. *From left to right:* Joanne Miles (Alamo), Barbara Conklin (Diablo), Florence Symmons (Walnut Creek) and Mildred Lewis (Danville). *Courtesy of the Museum of the San Ramon Valley.*

Lewis Tromp was the high school's longtime athletic coach. Each spring, he would get H.T. Wing or Chester Love to plow the high school football field; then he and some students would work the field down with a modified Model T Ford and a disk-harrow. Next, they leveled the field with a homemade clod-masher constructed of planks. Later, Coach Bob Vincent said, "Needless to say, every school dreaded playing San Ramon Valley on its home field. Coach Tromp's teams were always tough on their opponents and so was San Ramon's football field."

Regular Saturday night dances featured live bands at the Legion Hall in Danville, Livermore and the San Ramon Hall. In Danville, the American Legion Auxiliary would provide big "feeds" at these events, which lasted well into the night. In 1939–40 the Treasure Island Fair was a huge draw, with people going every weekend. Accessible by the new Bay Bridge, it featured an Acquacade (water ballet), the Gayway Amusement Area and a daily Cavalcade of America, to say nothing of Sally Rand's Nude Ranch for those over the age of eighteen.

This decade also marked some new utilities for homes. On April 16, 1931, the California Water Service Corporation began pumping water into the mains for Walnut Creek, Alamo, Danville and Diablo, although many homes continued to use well water. At that time, butane or propane fuel was used with tanks in residents' front yards for ease of service. Furnaces were oil-operated. Some houses subscribed to the Coast Counties Gas Company, even after Pacific Gas and Electric (called "The P.G.&E." in the *Valley Kernel* 1937 annual) began delivering gas to the valley with a four-inch line in 1931.

THE VILLAGE

THE
RANCHO
EL RIO

IN THE VALLEY
OF THE
SAN RAMON

Dodge-ver Mehr Co.
AGENTS
BERKELEY - CALIFORNIA

BERKELEY PRESS 217 ADDISON ST.

An early development in Alamo and Danville was called Rancho El Rio. This sales brochure, circa 1910, featured the "picturesque" San Ramon Creek and encouraged new residents to become farmers on small properties. *Courtesy of the Museum of the San Ramon Valley.*

In Alamo's small village, the retail footprint stayed very much the same with just a few stores. Walnut Creek was the residents' main shopping and entertainment destination. They saw movies at the Ramona Theatre in the 1920s and, after 1937, they went to the El Rey Theatre, which advertised: "Perfect Sound—Good Pictures—Air Conditioning." Then young people went across the street to Bradley's for ice cream and singing around their piano.

Since 1866, the western side of the county road, near the school, had belonged to the Jones family; they called their ranch Rancho Romero. On the eastern side, Frederick Humburg bought 160 acres during the nineteenth century, and he later sold it to John O. Reis, who raised racehorses and placed a track east of the knoll. August Humburg repurchased the land from Reis and built a home on the knoll around 1919.

Various stores and the post office were located south of the Jones and Humburg properties along the highway. After 1922, Walter and Mary Ellen Cross managed Alamo's first gas station on the west side of the highway, an area that was called Alamo Maples. They eventually built the first public swimming pool, an open-air dance pavilion and a roller-skating rink in that area.

In 1910, the Rancho El Rio development offered property for sale east of San Ramon Creek, in an area that stretched from Alamo to Danville. Advertised as a subdivision offering tracts of any size, the promoters invited people to buy and build a "rural homesite," a model orchard or farm that would support them in comfort. The El Rio brochure touted the "picturesque San Ramon Creek, and the highly productive cherry, peach, walnut and other orchards" which provided the perfect setting for a small farm.

Several miles south of Alamo's village, the Shady Way Inn was built by Lorenzo Zunino in 1929, beginning its evolution as a destination along Highway 21 at the corner of Hemme Avenue. In 1933, it was called the Shady Way Fountain Service. On the site, there was a long fruit and vegetable stand, a fountain for ice cream treats and sodas, a small grocery store, a bar for thirsty adults and a three-pump Standard Oil gas station by 1936. Pete and Grace Elissondo bought the property in 1937 and added a small restaurant. A railroad shed to the west hosted Saturday night dances with a jukebox and the occasional live jazz band in the late 1930s. Under Maud Wagner's ownership, beginning in 1944, it was a popular party spot.

Outside of the small downtown area, the first housing subdivision was started at Alamo Oaks off Stone Valley Road in the mid-1930s. In 1947, the Wayne development was built west of the highway and, in 1948, homes off Camille Avenue were offered as Jones Walnut Acres.

WORLD WAR II

World War II impacted Alamo, and again, the historic Henry Hotel building became an important gathering place. The Alamo Community Club set up a canteen in the hotel, offering refreshments and providing dances for soldiers from Camp San Ramon, Camp Parks and Camp Stoneman. On Sundays, busloads of soldiers from the camps would arrive at the hotel, and local families would invite them over for home-cooked meals.

The rationing of food and gasoline affected everyone, as they never knew what might or might not be available when they went to the grocery store. People put maps on their walls and followed the various battles in Europe and in the Pacific. And, of course, Victory Gardens were planted everywhere.

In May 1942, Japanese nationals and their Japanese American children from the San Ramon Valley were forced to leave their homes on short

Here, Lucille Glass Mauzy and her daughters Claudia and Kay tend their Victory Garden at home on Ramona Way in Alamo. *Courtesy of the Museum of the San Ramon Valley.*

notice. They and all ninety-three thousand of their fellow Californians were deemed security risks by the federal government and sent to several internment camps. After a stay at the Turlock Fairgrounds, Japanese families from the valley were sent to a camp at the Gila River Reservation in Arizona. From this camp, Tom Sakata, Katsumi Hikido and Ace Handa joined the army and fought with the decorated 442nd Infantry Regimental Combat Team.

A three-story air watch tower was built behind Alamo Grammar School, with a twenty-four-hour schedule set up to spot enemy airplanes. The tower's construction was accomplished using a version of an old-fashioned barn raising. According to the *Oakland Tribune*, on June 5, 1942, "Donations of material and money were obtained, and then, at a huge community gathering and picnic, the residents pooled their efforts and built the tower."

It was not unusual to see soldiers walking down the highway, since they rarely had cars. On Christmas Day in 1943, sisters Doris and Alice Jackson saw two officers walking between Alamo and Walnut Creek and pulled over to invite them to dinner. The men were teachers at Camp San Ramon, a base east of Danville on Tassajara Road. This led to two soldier/local girl romances and weddings. Doris married Fred Kjelland in 1946, and her sister Alice married Kenneth Hasbrouck in 1948.

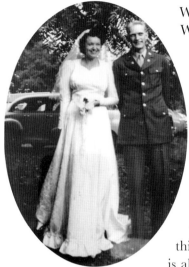

Doris Jackson and Fred Kjelland met when she invited the young officer to her home for a Christmas dinner. They married in 1946. *Courtesy of the Kjelland family collection.*

With a shortage of farm workers during World War II, the high school would close for two weeks in the fall so that students could help harvest walnuts. Stained hands were evidence that a person had actually hulled the valuable nuts.

World War II's end was celebrated with great enthusiasm with victory in Europe on May 8 and victory in Japan on August 15, 1945. A huge Danville July Fourth event was planned in 1946. The *Valley Pioneer* (July 4, 1946) wrote that, after the war's end, they should all think beyond the picnics and fireworks: "It is also a time for giving earnest consideration to the tasks ahead and to the measure that will be necessary to preserve our freedom for the rising generations and for generations yet unborn."

Little did they foresee that California and the valley would become the destination for a new crop of immigrants from around the country, drawn by job opportunities and the many attractions of the Golden State.

A 1960s TRANSFORMATION

Leaders of this unincorporated town plant trees, save old Victorians and dress cellular-phone antennas as pine trees, all to save Alamo's rural character.
—*San Ramon Valley Times, 1999*

*I*n the decade of the sixties, Alamo was transformed in dramatic ways. After World War II, people flowed into California. Many had seen its beauty and appreciated its weather during their military travels to the Pacific. The new aerospace industry required a variety of workers throughout the state, and the Bay Area grew exponentially. As people moved to California, they spilled eastward from Oakland and found the bucolic valleys surrounding Mount Diablo. Alamo's large lots and lovely boulevard of trees were enticing. Its downtown area expanded, Danville Boulevard was widened and new retail areas opened, as orchards continued to line the boulevard in both directions from the center. Alamo's population swelled from 1,791 in 1960 to an estimated 6,120 in 1970. Then it rose from 8,505 (1980), to 12,277 (1990) and 15,625 (2000).

New residents looked for more police protection and wanted parks for their children. But how was the community to manage this influx of residents and their new demands? There were no sewer pipes, inadequate water supplies and insufficient road capacity. Bumper-to-bumper traffic filled Danville Boulevard, as local cars could barely escape the side streets to get on the highway. In response, the county began to widen streets and set up county service areas for police, parks and landscaping.

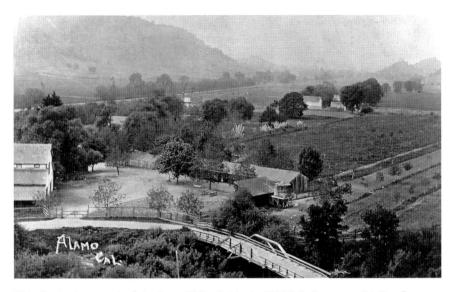

This classic photograph of the Stone Valley bridge in 1910 is facing west, with San Ramon Creek at the bottom, the Humburg Ranch in the foreground and Las Trampas in the distance. Few changes to this scene occurred until the 1960s. *Courtesy of the Museum of the San Ramon Valley.*

Alamo's changes in the 1960s shaped its story through the rest of the twentieth century. In 1964 alone, the freeway opened, voters approved a unified school district and annexed the county to the East Bay Regional Park District and Black baseball star Curt Flood put Alamo on the map. The Jones and Jackson families, dealing with new assessments and much higher tax rates, sold land for retail development. Round Hill Country Club was opened in 1961.

The 1960s were tumultuous for the entire country, as young people questioned long-held traditions, protested against the Vietnam War and discovered the birth control pill. The decade also saw the assassinations of the Kennedy brothers, Martin Luther King Jr. and Malcolm X. Woodstock resonated as a symbol of the 1960s, and the successful American moon landing was unforgettable. Television newsman Walter Cronkite became everyone's favorite uncle.

THE ALAMO IMPROVEMENT ASSOCIATION SPEAKS UP

Founded in 1955, the Alamo Improvement Association (AIA) is a nonprofit 501(c)(3) homeowner's group with this purpose: "To preserve and foster

Alamo Improvement Association FOR

P. O. BOX 271 • ALAMO, CALIFORNIA

FINE COUNTRY LIVING

Letters from the Alamo Improvement Association were frequently sent to the county, promoting country living and Alamo's distinctive character. *Courtesy of the Museum of the San Ramon Valley.*

the established character and quality of Alamo as a semi-rural, low-density residential area."

The AIA has pursued keeping one-half-acre home zoning, protecting ridgelines, restricting Danville Boulevard to two lanes, preserving trees and many other issues. New subdivision proposals drew its attention. The group faithfully attended planning meetings and organized letter-writing campaigns in an effort to influence county development decisions.

For decades, the AIA was involved in every planning issue in Alamo, as community activists gravitated to the association. In one example from the 1960s, the AIA opposed retail shops on the east side of Danville Boulevard, asserting that the new Alamo Market Plaza on the west side provided sufficient retail stores for residents. County Supervisor James E. Moriarty supported the opposition and said Alamo people "simply do not want more commercial areas, because there are plenty already."

Residents opposed commercial and other development extending down the boulevard, with some success. This included the construction of churches, as the Assembly of God church discovered when it proposed the construction of a sanctuary and classrooms in the 1980s. Critics thought the classrooms would become a full-time school with the increased traffic. Virgie V. Jones wrote a letter on February 20, 1983, to the *Valley Pioneer* editor, saying the church would be "the ruination of Danville Boulevard." In 1994, a Jiffy Lube location that had been proposed for a downtown street was pronounced "too intense for the site."

Another debate focused on an appropriate location for a central GTE cell tower, with the AIA stating that such a tower would hurt Alamo's rural ambiance. Finally, the company proposed using an artificial pine tree for the tower and, in 1996, the AIA reluctantly approved its location west of the I-680/Stone Valley Road off-ramp. The AIA's president said in the *San Ramon Valley Times* (July 13, 1996), "We think it's a big improvement, but it's still an artificial tree." Writer Bruce Marhenke declared it was "standing guard over" the intersection in the *Alamo Magazine*.

While there were calm meetings, sometimes, debates got heated. In 1992, one county-bashing AIA newsletter wrote that there may have been a "nefarious county scheme to build out Alamo's remaining hillsides, ridgelines and open space." When the AIA president stated that, because of Alamo's complaints, the "powers that be will split the community by annexing half to Danville and half to Walnut Creek," County Supervisor Robert Schroder shot back: "That's ridiculous," (*Tri Valley Herald*, February 7, 1992).

Round Hill Country Club

Over four hundred acres of undulating hills and farmland a mile and a half east of Alamo came on the market in the 1950s. The three Mott sisters owned 270 acres, and the Squier Ranch covered 140 acres. Realtor Harlan Geldermann obtained the listing when developers proposed a housing subdivision with one-third-acre lots. Opposed by the AIA for the lot size and traffic impacts, the proposal fell through.

Geldermann was the descendant of early San Ramon pioneers and a visionary real estate land developer. He brokered the land for the huge suburban development in Dublin and South San Ramon and promoted a "new city" in north Livermore called Las Positas. He had vacationed at an upscale country club in Jamaica called Round Hill Resort and envisioned the Alamo land as a championship golf course and country club with luxury residences. The entrepreneur enlisted these venture capitalists to create such a club: John Sparrowk, Joseph Dwilla, Paul Spagnoli, Stanley Burroughs and Milton Bloom. They worked this project successfully through the County Board of Supervisors and the AIA. Geldermann's idea to combine country charm and elegant buildings won the day.

Round Hill Country Club opened with a dinner dance and champagne reception on June 1, 1961. The club featured a club house, golf course, swimming pool and tennis courts, all surrounded by custom homes. Insurance man Bill Hockins bought one of the first Round Hill homes and recalled sheep grazing around the property to control grass on the golf course rough. A small crop duster spread grass seed and fertilizer on the course, making the news on Channel 2 KTVU. Rural life, indeed.

Designed by Lawrence Hughes, the golf course hosted the best women golfers in the world when it held LPGA tournaments from 1969 to 1973 and again in 1977 and 1978. Round Hill tennis produced several elite

A photograph of John Sparrowk (developer), Lawrence Hughes (golf course designer) and Harlan Geldermann (developer) looking at the Round Hill Golf Course layout in 1959. *Courtesy of the Round Hill Country Club.*

men's tournaments beginning in 1972, with a televised Davis Cup match in 1973. Renowned tennis players including Arthur Ashe, Bjorn Borg and John Newcombe performed, stayed with club residents and put the club on the tennis map.

Not all was sweetness and light, however, as the country club was seen by some as an enclave that focused on its own area and didn't care about parks or schools in the way other residents did. In 1972, County Service Area P-5 taxed country club residents for extra police patrols inside the club.

THE I-680 FREEWAY

Then came the interstate highway. People joked that the freeway changed everything, but it was no joke. Beginning in 1956, freeways were constructed throughout the country. Lively San Ramon Valley meetings focused on the freeway alignment, as everyone agreed it was needed. The main highway was so congested that people joked about drivers pulling alongside one another and catching up on the gossip—without leaving their cars.

The I-680 freeway was planned, graded and built, making changes in San Ramon Creek's alignment and shifting Stone Valley Road north from its original intersection with Danville Boulevard. A sturdy new bridge was installed. Today, the original Stone Valley Road is called Alamo Square Drive. The Henry Hotel, which had stood on the southeast corner of Stone Valley Road for one hundred years, was razed in 1955 to make way for a Flying A Service Station. Farther south, the freeway cut through the Magee Ranch, where several original Camp Swain buildings disappeared beneath the pavement. La Gonda Way continued under I-680, allowing an east–west regional trail to cross the valley.

People loved the new freeway, which extended for 6.4 miles from the Rudgear Exit in Walnut Creek to Danville's Sycamore Valley Road. They celebrated its opening on November 1, 1964, with a parade from Alamo to Danville. The honorary grand marshal was pioneer descendant Claude Glass, who was touted as the oldest man in the valley.

In 1979, a hillside facing the freeway at Stone Valley Road gave Alamo a cachet that no one could have anticipated. Artist Will Ashford planned a "geoglyph" for the hill and produced a *Mona Lisa* image in the grasses, which freeway drivers could see as they drove south. He convinced Hap Magee to keep cattle off the hill, marked off the drawing and enlisted sturdy friends to spread fertilizer in its direction. Kim Komenich spent $400 to hire a helicopter to take a photograph of Ashford on the hill, and the picture appeared in *Life* magazine's Just One More section, for which Komenich was paid $400. Over coffee at the Alamo Café, Ashford carefully sounded

© 1978 California Department of Transportation

Opposite: Everyone welcomed the I-680 freeway when it opened in 1964 by celebrating "Frontier I-680" and wearing these commemorative ribbons. The parade from Alamo to Danville along Danville Boulevard featured vintage cars, a ribbon cutting and speeches. *Courtesy of the Museum of the San Ramon Valley.*

Above: A huge grassy "geoglyph" of *Mona Lisa* greeted drivers going south on the I-680 freeway in 1979. It put Alamo on the map. *Courtesy of the CalTrans archives.*

out some California Highway Patrol (CHP) officers about the drawing. They said the CHP used it to direct officers to incidents "north or south of the *Mona Lisa*," so he told them he was the artist.

A NEW DOWNTOWN

The Alamo Café had been a popular place since 1947, but it was soon eclipsed by new retail stores and restaurants that were built to serve the growing population. Modern malls began to draw residents and, in 1967,

the new Sun Valley Mall in Concord was the largest shopping center in Northern California. The Alamo Grammar School closed and moved to a Wilson Road location in 1965, leaving its former building behind for years.

The Alamo Market Plaza was built on the Jones family's former walnut orchard west of the boulevard. It had a grand three-day opening from November 29 to December 1, 1956, and it brought fifty thousand square feet of retail space to the village. Designed by Arne Kartwold, the Market Plaza had a Spanish look, with tile roofs and wood elements. Pete Peterson's Union 76 Gas Station opened early (in 1954), although he had to change his proposed shiny white modern design to a more rustic look. In 1961, Louis Store (a chain grocery store) opened. Ruth Farrell's children's store, the Golden Closet, drew families, and Kemp's Hardware Store became another go-to place to shop.

Looking for more room, Postmaster Bertha Linhares moved the Alamo Post Office from its small twenty-year old building across the highway to a store in the Market Plaza's southeast corner in 1957. In October 1964, another larger post office was built not far away, facing Lunada Lane, which at that time exited onto the boulevard. The small former post office building, in turn, became a real estate office, the American House Antiques and Indian Jewelry Store and, finally, a shoe repair store.

In 1980, John Bellandi put a fiberglass horse topper on the store's roof, saying that the horse was a real eye-catcher. Bellandi's adjacent Alamo Hay and Grain Store sold chickens, pets and pet and horse feed, making it the last feed store in the San Ramon Valley.

Across from the Market Plaza, on the east side of the highway, Friederiche Humburg Jackson sold some of her family's ranch for development. For over fifty years, the Humburg Ranch had included the east side of Danville Boulevard, from the original Stone Valley Road to today's Jackson Way. When the knoll and house were razed in 1967, it was revealed that the "knoll" was actually an Indian mound.

After lively local opposition, the construction of a Safeway Store was approved on the former Humburg Ranch. *The Valley Pioneer*, on August 3, 1966, wrote an editorial titled "We Get Stabbed Again…And Again and Etc.," which stated:

> *The action of the board of supervisors on July 6, in approving the request of Safeway Stores, Inc., for retail business zoning in Alamo, is the highest example yet of the board's total disregard for the wishes of people in the San Ramon Valley.*

In 1980, a full-sized fiberglass horse appeared on the shoe repair store near the corner of Danville Boulevard and Stone Valley Road, placed there by owner John Bellandi. It became a symbol of Alamo's rural aspirations. *Photographer, Jeff Mason. Courtesy of the Museum of the San Ramon Valley.*

On the other hand, there were articulate proponents who considered a new Safeway to be a good thing. They pointed out that Alamo was modernizing and meeting new residents' needs.

Fifteen years later, in 1980, the west side's Market Plaza expanded and became the Alamo Plaza Shopping Center. The Alamo Plaza was the largest shopping center in the county at that time, covering 19.5 acres and 190,000 square feet. It hosted a new 42,000-square-foot Safeway Superstore. Richard and Terri Delfosse moved their popular Richard's Arts and Crafts store to a 12,000-square-foot new building, which anchored the southeast end of the plaza. Alamo Plaza developer Fred Redman was everywhere and loved tooting around in his red Cadillac convertible.

ALAMO MAPLES

Just south of the new Alamo Plaza, the Alamo Maples area had provided a variety of stores built by Walter Cross over several decades. After Lloyd "Matt" Matthews and his wife, Camille, bought and developed some of the

Maples land in the mid-1940s, Virgie Jones wrote, "Mrs. Winchester, of Winchester House fame, had nothing on Matt!"

The Matthews gradually purchased additional property, providing a hamburger stand (very popular with soldiers) with some slot machines in back. The old Cross home became Alamo Gardens Restaurant, which had a bar. In 1947, the Alamo Gardens Dance Pavilion was set up on Saturday nights and featured a live band. From 1951 to 1961, the restaurant was called Thelma's. Next, Matthews built the seventeen-unit Alamo Gardens Motel (remembered as the "no-tell-motel"), which lasted from 1953 to the 1980s.

According to Virgie V. Jones, in 1961, the old former Cross buildings were demolished, and a new restaurant was constructed by builder Vern Ryan,

Left: The Elegant Bib became the place to go for a fine dinner out, drawing customers from miles away. A patron kept this bib and gave it to the Museum of the San Ramon Valley. *Courtesy of the Museum of the San Ramon Valley.*

Below: For over forty years, George Parmakos ran this store at the corner of Livorna Road and the county road (also known as State Highway 21). Its formal name was Mt. Diablo Grocery, but everyone called it George's Groceries. *Courtesy of the Museum of the San Ramon Valley.*

adding a banquet room in 1964. In 1969, the Elegant Bib took over the restaurant space. This popular upscale restaurant was leased and run by Mickey and Lea Adza. In an era when eating out was not something people did frequently, it became the place to go for special birthday or anniversary dinners. It featured specialty cocktails, holiday-themed meals and salads tossed tableside (which was very new). A stuffed baked potato was popular, and one *Chicago Tribune* article gave the Elegant Bib credit for starting the craze for these potatoes. The gregarious Adza made everyone feel welcome; he presented red lollipops to guests who wore red, provided patrons with "Elegant Bib" bibs and gave hugs to repeat customers. People came for meals from Walnut Creek, the San Ramon Valley and beyond. The Elegant Bib closed in 1984, but it definitely was not forgotten.

North of Alamo's downtown, at the intersection of Livorna Road and the boulevard, there was George's Groceries, a cash store that sold groceries from the 1920s to 1967. In the early 1940s, young Claudia and Kay Mauzy lived nearby on Ramona Way; Claudia recalls being sent to the store to get milk and bread (and delicious Eskimo Pies) from owner George Parmakos. For years, a sign at the corner said, "Alamo: Pop. 950."

South of downtown, at the corner of Hemme Avenue and the highway, the Shady Way Inn evolved from a fruit stand in 1929 to a corner gas station, a store, a café and, finally, a popular watering hole. In the 1960s, owner Charley Diaz briefly added a "Go-Go Dancer's Night" with a topless bar. A tagline on an August 21, 1964 *Oakland Tribune* advertisement read, "North Beach Comes to Alamo!" These stores were retail exceptions, since there were homes and orchards between them and downtown.

EXPANSION AND CHANGE

In 1966, Monte Vista High School opened on Stone Valley Road—the first new high school since San Ramon Valley Union High School was completed in 1917. The school was unique in its design, with modules scattered on the campus that were assigned different disciplines, such as science, foreign language and home economics. The large library initially hosted classes, since all of the buildings and the gymnasium were not yet complete. Principal Ray Roberts greeted the first class, which was entirely composed of ninth graders.

Not long after the school opened, the town's first traffic signal appeared at the intersection of Stone Valley Road and Danville Boulevard in 1972, an addition welcomed by drivers.

Several clubs supported community improvements and civic discourse. In 1948, the Diablo Tuesday Morning Club was founded by several people to bring "cultural events to residents on the Contra Costa side of the tunnel." The club met at the Diablo Country Club for decades, then met at the Alamo Women's Club from 1975 to 1997, providing a total of 239 enriching programs over the years.

In the 1970s, the Civic Arts League met monthly in the Alamo Women's Club to provide programs, study topics and plan local trips. The Alamo Dads' Club (1952–1964), the Alamo Rotary Club (established in 1971), the Alamo/Danville Soroptimists (established in 1984) and young Jay Cees supported community projects. In 1982, a successful Alamo Music and Wine Festival started, which featured bands and performances from local schools.

As suburban housing expanded, many of the developments included restrictive covenants designed to keep minorities out. This situation flared in 1964, when Black baseball star Curt Flood leased an Alamo house on La Serena Avenue, shortly after winning a World Series title with the St. Louis Cardinals. A representative of the owner threatened Flood with a shotgun, saying "no n———rs are going to move in here!" The ensuing publicity revealed the dilemma that Black Americans faced throughout California. Flood, with his wife, Beverly, and their four children were warmly welcomed by the other neighbors, but life in the predominantly White community was not easy.

In the late 1950s, urban utilities arrived in Alamo, beginning with water. In 1958, the San Ramon Valley County Water District was annexed into East Bay Municipal Utility District (EBMUD), and water from the Sierras replaced local ground water supplies, although some residents stayed with well water. Twenty thousand new water customers in sixteen square miles were added to the district, making it the largest single EBMUD expansion since the company began in the 1920s.

Voters had opposed annexing the valley to the new Central Sanitary District in an attempt to limit growth. Nevertheless, in 1955, a thirty-inch sewer line was installed from Walnut Creek, through Alamo, into Danville and Diablo. This happened because, shortly after the new Cameo Acres homes off Green Valley Road were built, the sewer plant that served the development failed. Responding to an emergency recommendation from the county health officer, the Board of Supervisors passed a Resolution of Necessity that approved the new pipe.

ALAMO PROUD: SPEAKS UP FOR ITSELF

Alamo residents worked with the county supervisor to provide services for the burgeoning population. Supervisors created advisory committees and special service areas that advised the county on development, public safety, beautification, parks and traffic. The clarion call for many residents continued to be: "Keep Alamo's rural way of life." Citizens actively opposed suburban sidewalks and streetlights, especially on the west side, and looked askance at model home developments.

There were plenty of debates as Alamo grew beyond a population of fifteen thousand people by 2000. The school district proposed closing the Alamo Elementary School, located at 100 Wilson Road, in order to send students south to the Rancho Romero and Stone Valley Schools. Parents successfully opposed the closure, pointing out that numerous pre-school children from new home developments would soon enter elementary schools.

During the 1960s and 1970s, there were several votes to create a city in the San Ramon Valley (with Alamo included). The Alamo Improvement Association was deeply involved in each. An Alamo-Danville incorporation effort nearly succeeded in 1964, losing by only 128 votes. A descendant of Alamo pioneers David and Eliza Glass, Claudia Mauzy Nemir, was the top vote-getter in the cityhood elections of the 1970s. She stepped up to run for the state assembly in 1974 but lost to a powerful incumbent.

In 1974, after coming in first in the January 1973 valley-wide incorporation election, Claudia Mauzy Nemir ran for the assembly using this campaign brochure. She was one of the dynamic young women who stepped up to run for office in the 1960s. *Courtesy of the Museum of the San Ramon Valley.*

In 1977, a San Ramon Valley Regional Planning Commission was approved by the Board of Supervisors by a 3–2 vote, and early agendas were full of valley development proposals. The group met at the education center in Danville, which allowed activists to avoid driving to Martinez. The state policy of assessing land for its highest and best use in the 1960s meant large ranch properties were reassessed as potential housing developments. Longtime owners could not afford the new taxes and sold their land for development.

On December 23, 1985, the *Herald* newspaper reported a study that showed Alamo incomes were second in the Bay Area, with an average annual household income of $80,000 after taxes. At the top was Ross in Marin County, with an average income of $89,000. Wanda Longnecker of the parks committee said that people of means were attracted to Alamo's "park-like setting." AIA's Larry Regan explained in the article, "We have been successful, so far, in keeping it a relatively rural community. Then you throw in the charm of living in a valley." Consistently, AIA newsletters and a broad consensus of residents assert their desire to preserve and enhance the distinctive nature of Alamo and make the community a great place to live.

ALAMO GOVERNANCE

The valley had better be prepared to shoulder its own responsibilities and render local decisions on our own affairs or expect to have what we have zealously sought to maintain, carelessly drawn and quartered, and served up to private interests on a silver platter.
—The Valley Pioneer, *August 3, 1966*

After California achieved statehood in 1850, the new legislature created new government agencies and entities. It set up twenty-seven counties, including Contra Costa County, with Martinez as the county seat. In 1853, Alameda County was carved primarily out of Contra Costa County, with politicians initiating the change and making Oakland the county seat. These two counties became the San Francisco East Bay.

The county formed townships from which officials were elected and addressed law enforcement and road needs. Townships, including Alamo, often changed numbers and boundaries, making accurate nineteenth-century community population counts a challenge. County history books list elected officials from local to state levels. For example, Nathaniel Jones of Lafayette was elected the first County Sheriff in 1850. Alamo officials included his brother John M. Jones, who served as assessor and school superintendent in the 1850s; County Supervisor Carroll W. Ish (1853–1854); and Silas Stone, who was elected justice of the peace in 1854.

The logo for Contra Costa County features the diversity of this East Bay county. It shows Mount Diablo, deep-water ports, industrial buildings and orchards. Contra Costa was one of California's original twenty-seven counties when the new state was established in 1850. *Courtesy of the Museum of the San Ramon Valley.*

Managing roads was an important county function, so road districts and road masters were set up. In 1850, the first road district covered the county from Martinez to the farm of Francisco Garcia in Alamo. Later, Alamo's main road was designated County Road No. 2. Able-bodied men between the ages of eighteen and forty-five were required to work five days a year to maintain county roads.

Early on, the only voter-approved governmental boundaries in the county were school districts. Alamo's school district was created in 1871, and Green Valley's was created in 1865. When the first official fire district was organized in 1921, it included four school districts, Alamo, Green Valley, Danville and Sycamore, in an area of about fifty square miles. Called the Danville Fire Protection District, its first chief was Oscar Olsson. Alamo's James Cass Jones was elected as a fire commissioner on the initial board in 1922.

Olsson became county supervisor in 1923 and, since he was Astrid Humburg's brother, family gatherings meant that people could talk directly to the area's leader. He served on the County Board of Supervisors until 1932.

The county government managed roads, creeks, drainage, planning, justice, library and welfare systems. It established the court system and law enforcement, including a county jail. Locally, there were justices of the peace and constables. Neighborhood jails were usually small holding tanks for drunks. Eventually, separate special districts provided schools, water, sewers, resource conservation, mosquito abatement, regional parks and fire protection. For over a century, Contra Costa County provided part of the Bay Area's agricultural perimeter, with a few industries established along the shoreline.

COUNTY GENERAL PLANS GUIDED CHANGE

After World War II, new homes and retail businesses were proposed and built, and Alamo residents were concerned about these changes. In 1940,

only 386 people lived in Alamo, but by 1960, the town had 1,791 residents. County general plans were established to guide future development. The first *General Plan for the San Ramon Valley*, in 1955, described Alamo this way: "The northern section of the valley to Danville is presently developed in a low-density rural residential manner. Numerous orchards provide a semi-agricultural character."

The *General Plan for Alamo-Danville* was adopted in 1968, and it zoned Alamo primarily with half-acre lots. In 1977, a general plan for the entire valley was adopted, which confined commercial development to Alamo's downtown area. County planner Jim Cutler pointed out in 1985, "Alamo will be Alamo forever....It hasn't really changed in years. This is the way the people want it," (*The Valley Pioneer* January 30, 1985). With urging from the Alamo Improvement Association (AIA) and others, the 1990 general plan prohibited rezoning Alamo properties to less than R-20 (about one-half acre) and limited downtown commercial development to local-serving, nonregional uses.

Although the several general plans were consistent, residents criticized many of the county's specific development decisions, as ranches were replaced with homes. They believed that the county planning commission,

Alamo was orchard country in the twentieth century, with walnuts and fruit trees like this plum orchard covering the valley floor. Mount Diablo can be seen in the background. After the I-680 freeway opened in 1964, many of these orchards were replaced by developments. *Courtesy of the Museum of the San Ramon Valley.*

which met in Martinez, did not appreciate Alamo residents' desire to retain a rural character. At the same time, longtime residents benefited when they sold their orchards along Danville Boulevard and elsewhere for new development. Having nearby hardware and grocery stores, restaurants and bars to serve the growing population had widespread appeal.

The county supervisor representing Alamo and south county took the lead in decisions about services and development for the burgeoning population. The supervisor usually accommodated Alamo's advocates and supported them when controversial projects were proposed. However, with five supervisors in total, they could be outvoted. For example, in 1966, Supervisor James Moriarty called the other four supervisors short-sighted, saying the remainder of the board was not concerned with the problems of the San Ramon Valley:

> *Time and time again, they have flaunted reasonable, considered requests by groups and individuals, and have either voted on sheer whim or have given in to pressure groups, offering either political or material inducements. (The Valley Pioneer, August 3, 1966)*

New people moved in, bringing new ideas and a willingness to speak up and volunteer. In one Alamo household during the 1970s, Ed and Linda Best served on three of the San Ramon Valley's main decision-making bodies: the San Ramon Valley Unified School District Board, the R7 Park and Recreation Advisory Committee and the San Ramon Valley Regional Planning Commission. Efforts to create a new city covering the entirety of San Ramon Valley reached the ballot box three times in the 1960s and 1970s, with longtime and new residents competing for the prospective city councils. All efforts were rejected by the voters.

Over the years, supervisors appointed citizen committees, such as the Alamo Area Council or Scenic Highways Committee, to facilitate local participation. Beginning in 1955, the Alamo Improvement Association regularly advised the county on Alamo planning issues. They held local meetings to hear from citizens and carried significant clout with the county. The chamber of commerce–based San Ramon Valley Planning Committee represented business and homeowner interests and made recommendations to the county.

COUNTY SERVICE AREAS

By the late twentieth century, the county set up county service areas (CSA) for police and parks, usually with advisory committees. At the urging of the local Jay Cees group, CSA P2 was created in 1970 to provide additional law enforcement in much of the San Ramon Valley. It is still in place and charges $18 annually per parcel. Round Hill's police CSA P5 began in 1972 and now assesses club residents $470 per parcel each year for additional police service.

Residents began to look for ways to obtain public parks, since the county didn't provide them. Some in Alamo argued that, with half-acre lots, regional parks and Mount Diablo State Park nearby, no public parks were needed at all. A park vote in 1972 was rejected. In 1974, promoted with the theme "Parks Are Forever," voters in Alamo, Danville and part of San Ramon supported a tax (twenty-five cents per one hundred dollars) and created the R7 County Service Area. Such a county service area could purchase, plan and develop local parks. In 1984, Alamo's Claudia Waldron searched unsuccessfully for a T-ball program and a local ball field for her son; she attended a park CSA meeting and promptly became a member. Until Proposition 13 reduced its income in 1978, the R7 Committee was able to purchase land in several locations, including the large Oak Hill Park on Stone Valley Road.

On June 4, 1974, voters throughout the valley agreed with park advocates and supported new parks. This brochure reminded voters that "Parks Are Forever." *Courtesy of the Museum of the San Ramon Valley.*

After Danville and San Ramon incorporated in the early 1980s, R7A took over Alamo's park planning. In 1985, David and Linda Gates produced a plan called the "Alamo Park, Open Space, Conservation and Recreation Plan" for R7A when Wanda Longnecker was chair. In the following decades, the committee planned and completed these parks: Livorna Park, Hap Magee Ranch Park (with Danville) and Andrew H. Young Park. It collaborated to renovate fields at Rancho Romero, Stone Valley and Alamo Schools; raised funds for the pool at Monte Vista

High School; and provided programs from the YMCA to serve residents for several years. Hemme Station Park opened in 2017.

Zone 36, an Alamo-wide landscape and lighting district, was created in 1990 in cooperation with an Alamo Beautification Committee, with Andrew Young in the lead. It addressed the general appearance of Alamo's four principal roadways: Danville Boulevard, Stone Valley Road, Miranda Avenue and Livorna Road. Funds were spent on trash pickup, landscaping, street sweeping, tree care and watering the trees and shrubs on county property. The committee also conducted general policing of the county sign ordinance along these arterials. In 2000, Zone 36 chairperson John Moeller stated, "Our purpose is to attempt to keep Alamo looking rural and well-kept, a place we can all be proud to call home!" From the beginning, this service has cost $9.36 per parcel each year.

INCORPORATION EFFORTS STIR THE GOVERNANCE POT

Alamo voters weighed in on potential San Ramon Valley–wide cities several times after World War II. Each time, residents chose to stay with county government. The first serious discussions about creating a city occurred in 1956 and 1961, and they were initiated by the Alamo Improvement Association. The AIA was concerned that Walnut Creek might annex parts of Alamo and was unhappy with several county planning decisions. They saw incorporation as a way to retain local control over planning and ensure taxes would be spent in Alamo. An AIA study in 1956 examined the potential income for a city, but leaders decided not to pursue incorporation at that time. By 1960, Alamo's population had grown to 1,791, with its southern neighbor Danville numbering 3,585 residents.

One Alamo-only effort nearly got to the ballot in 1961, but it was squelched by its opponents' shenanigans. People who owned a majority of the assessed property in Alamo needed to sign a petition to schedule a "new city" election. Proponents collected and turned in election-supporters' names each day. The opposition went to the assessor's office, took down the petition's signatories and made house calls on the signers. In a history of incorporations, Eleanor Rusley wrote, "With evangelistic fervor, they persuaded many of the original 70% who had signed [to reverse their positions and took those lists to the county]." Realtor William F. Anderson and attorney Gordon Turner led

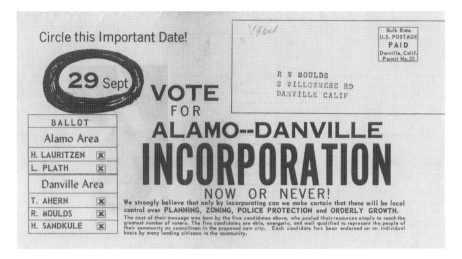

In 1964, this campaign piece went to voters in Alamo and Danville. Five candidates were endorsed. The unsuccessful campaign for cityhood touted the need for local control over planning, police, roads and parks. *Courtesy of the Museum of the San Ramon Valley.*

the Committee Against Incorporation of San Ramon Valley in this effort. Incorporation proponents prepared for a July 11 election date that was set by the Board of Supervisors (who had accepted the original petition), only to lose a court case that challenged the petitions and canceled the election.

An actual vote on incorporation, which included Alamo and Danville, narrowly failed on September 29, 1964, with 2,086 against and 1,958 in favor. The council would have been T. James Ahern, Herman Sandkuhle, Max Lauritzen (Alamo), Richard Moulds and John Hartwell. Round Hill Country Club had just opened and opposed the effort, since the owners still needed government approvals and did not want to gamble on a new council. The opponents charged that Alamo would be "gobbled up by Danville" and taxes would inevitably rise.

Complicating any new city efforts, a state-established commission, the Local Agency Formation Commission (LAFCo), was created in 1963 and was charged with examining prospective new special districts or proposed new cities. The commission worked to prevent the creation of government entities that were not economically or politically viable. From then on, when cityhood proposals came from south county, LAFCo insisted that the boundary must encompass the entire San Ramon Valley.

On December 19, 1967, a San Ramon Valley–wide vote went was defeated 2,796 to 1,830. Alamo and Danville pro-city advocates had begun the effort. However, when representatives of San Ramon Homeowners asked to be

included, LAFCo chose to attach that area with a two-hundred-foot-wide strip next to the still-agricultural Bishop Ranch. This weird boundary was derided as a "cherry-stem" incorporation. The five elected to the potential council were Roy Anderson, Byron Athan, Francis Driscoll, George Filice and John May.

CITYHOOD ELECTIONS IN THE SEVENTIES

Proponents tried to incorporate a San Ramon Valley–wide city twice, once in 1973 and again in 1976, when the 1970 census listed Alamo and Danville with a combined population of 14,059 people. The valley's population grew from 28,000 in 1970 to 57,307 in 1980. The freeway was finished to Danville in 1964, and it was completed to Dublin in 1966. Some proponents of incorporation felt that it was almost too late for local people to affect the valley's rapid development, which was controlled by the county. Large volunteer efforts were mounted in both elections.

Beginning in 1971, the Taxpayers for Incorporation touted the need for local control, which would retain the rural nature of the valley and resist hillside development. The group noted that only 64 percent of local tax dollars were being spent inside the valley and put together an extensive grassroots organization.

The opposition group, Valley Residents for Non-Incorporation, asserted that Alamo and Danville would lose their special identity and taxes would surely go up if a city were created. Western Electric had just purchased the Bishop Ranch in San Ramon and did not want to deal with an unknown council, so it helped fund the opposition. Those in favor spent $7,109, while those opposed spent $11,864.

The supporters were optimistic that, this time, success would be theirs. But on January 23, 1973, cityhood was defeated with a 58 percent valley-wide voter turnout, 5,623 against, 5,178 in favor. Alamo voters rejected cityhood by 59.1 percent, voting 2,136 against to 1,484 in favor. The council would have been Claudia Nemir, Roy Bloss and Brian Thiessen from Alamo and Danville's Eric Hasseltine and Dick Kennett.

That February, Nemir, Kennett, Thiessen, Hasseltine and Bloss met with County Supervisor Edmund Linscheid to propose that a San Ramon Valley–wide Municipal Advisory Council (MAC) with planning powers be created by the county. They wanted the seven-member council empowered

This 1972 portrait shows Roy Bloss, an activist, historian and candidate for the San Ramon Valley City Council, in January 1973. He promoted a tree-lined Danville Boulevard, local government leadership and knowledge about Alamo's history. *Courtesy of the Museum of the San Ramon Valley.*

to allocate park dedication funds, approve all zoning, and advise the supervisors on matters affecting public safety, public health, welfare and public works. "They had two main objectives: to develop stronger community participation in planning and to retain green areas and establish parks," (*The Valley Pioneer*, February 21, 1973). "Those of us working on this proposal," said top vote-getter, Claudia Nemir, "represent most of the community organizations in the valley. We'll solicit input and support from these groups."

This proposal was ambitious and was taken seriously by the county. A March 1973 report from Planning Director Anthony Dehaesus pointed out that the county didn't recommend Municipal Advisory Councils but indicated that a regional planning commission might be possible. Unwilling to wait, the advocates created an all-volunteer Valley Action Forum in July, which represented a coalition of San Ramon Valley homeowners, to review planning proposals and other matters; Eric Hasseltine became the group's first president.

By 1975, the valley was growing so quickly that a special census was taken. The whole valley had a population of 41,095 people; Danville had 19,453 residents, and Alamo counted 7,500. Soon after this census, a fresh attempt at a valley-wide incorporation came to the ballot on November 2, 1976. The Taxpayers for Local Control through Incorporation (TLC) organized throughout the valley, again with an all-volunteer campaign. It called for better police, local planning and parks. One advertisement proclaimed, "Bring Government Home—YES on K—TOWN NOW!"

Opponents put up signs urging "Work Against Increased Taxes" or WAIT. Developer Broadmoor Homes, just opening the Crow Canyon Country Club, did not want a new council deciding on its development permits and underwrote the WAIT campaign. The opposition sued the county over the new California Environmental Quality Act, which failed but delayed the election. One anti-incorporation brochure announced, "If you want to live in a city, move to Concord!" The potential City of San Ramon Valley lost by a vote of 10,426–7,846. The new council would have been Claudia Nemir (Alamo), Don Sledge, Norm Roberts, Bob Bush (Alamo) and Gene Rolandelli.

Alamo voters opposed each of these incorporation efforts. People were satisfied with county government, were convinced taxes would rise, opposed "another layer of government," accused candidates of political ambition or power-grabs and asserted that "the time is not ripe." Finally, they charged that Alamo would lose its identity and rural ambiance within a city that included entire San Ramon Valley.

The following year, after a vigorous supervisorial debate (with a 3–2 vote), a new San Ramon Valley Regional Planning Commission was created, covering 112 square miles. Seven county-appointed members reviewed subdivision maps, rezoning and general plan amendments, and they met locally at the education center in Danville. By then, Hasseltine had been elected County Supervisor and worked hard to get this commission in place.

Initial commission appointments included all valley communities: Dick Kennett, Juanita Burrow, John Olander, John Meakin, Nelson Wright and Linda Best (from Alamo). Citizens could readily come to planning commission meetings, many of which lasted well into the night. One memorable commission decision prevented a movie theater from being placed at the back of the Alamo Plaza. The commission discussed the proposed expansion of Alamo Plaza Shopping Center at length in 1979–80.

Periodically, county staff would recommend sunsetting this planning commission. After Danville and San Ramon had incorporated and appointed their own planning commissions, there were further debates about keeping the Regional Commission. On March 22, 1983, the *San Ramon Valley Herald* editorialized that the Regional Commission was "a necessary tool for the citizens of this area…if the people of the valley are to have a voice in what is to happen in the future."

THE EIGHTIES AND NINETIES

In the meantime, other small communities successfully incorporated, including Moraga (1974) and Orinda (1985). To the south, Dublin incorporated in 1981, Danville in 1982 and San Ramon in 1983. By 1980, the valley's population had grown to 57,307, with Danville counting 26,446 and Alamo at 8,505.

Alamo advocates investigated a town including only Alamo citizens and boundaries after the others cities' successes. In the mid-1980s, the controversial Bogue Ranch development at the eastern end of Livorna Road fueled opposition when multi-floor clustered condominiums were proposed. Residents who lived

near the site organized a group called "Remember the Alamo" that density. Eventually, a gated single-family residential development called Stonegate was built, and 310 acres of open space were donated for public use. Remember the Alamo and AIA activists worried that the Bogue Ranch proposal was just the tip of the iceberg; they worried that county decision-makers would approve many more high-rise, dense developments.

Beginning in 1983, an incorporation committee (ACTION or Alamo Citizens to Incorporate Our Neighborhoods) prepared a fiscal analysis, proposed boundaries and applied to have an Alamo-only incorporation on the ballot. John Osher spearheaded the effort. Many felt that this incorporation effort had a very good chance of succeeding.

At LAFCo, the commissioners cited concerns about loss of county revenue. County Administrator Phil Batchelor took the unusual step of writing a report, which indicated that if Alamo incorporated, the county would have to lay off staff. This assertion had not surfaced when the Danville, San Ramon and Orinda incorporation proposals were before LAFCo, leaving Alamo's advocates flummoxed and angry. In 1986, the commissioners turned them down by a 4–1 vote.

A 1989 survey showed that residents favored incorporation 2–1, but advocate Larry Kaye said, "The problem is that everybody is for [incorporation], but nobody comes out of the house." Of those surveyed, 92 percent said the Alamo of the future should be the same as Alamo today, as reported in the *San Ramon Valley Times* on October 6, 1989.

Discussions about an Alamo-only incorporation or some change in governance surfaced again in 1989, 1993, 1998, 2004 and 2009. The possibility of a Municipal Advisory Council came up again in 1996. Claudia Waldron, a member of the R7A Parks and Recreation Committee said, "I think we're at a window of time where we should be looking at forming a municipal advisory council." She wanted an elected council. John Osher opined, "There's no central body overlooking the interests of Alamo....The MAC would be able to focus on the whole community." On the other hand, the AIA's Mike Gibson asserted that the six-hundred-member organization had an independence that a MAC would lack.

Issues of police coverage, tax spending, traffic management, tree preservation, dense development proposals and governance are regular topics of public debate, since Alamo remains an unincorporated enclave between Danville and Walnut Creek. In 2009, the first Alamo-only incorporation election finally came to the ballot, an important event in the twenty-first century.

MODERN TIMES

The Twenty-First Century

If you love Alamo and want to preserve its friendly small-town atmosphere, we know you'll want to support incorporation with your vote.
—*"Yes On A," Aim For Incorporation*

For decades, Alamo stayed remarkably the same size, with a population of 12,277 people in 1990 and 14,570 in 2010. The *San Ramon Valley Times*, in 1999, wrote that Alamo's growth from 1990 to 1999 had been 2.7 percent, with a current population estimate of 12,000 and a median home value of $560,000. In the twenty-first century, the county provided government services, an Alamo-only cityhood effort was rejected and a Municipal Advisory Council (MAC) was created. The Alamo Improvement Association (AIA) continued to promote the rural character of the community.

The *Alamo Today* newspaper provides a monthly community forum, with a regular AIA column and local feature articles. In 1993 the paper was founded by upbeat educator Bruce Marhenke as the *Alamo Magazine*, and it provided a venue for nearby news from many authors. He called his propensity for exclamation points "slammers." After a break, in 2000, he published the periodical again as *Alamo Today*. His goal: to "bring you the best of the news about our neat little hamlet of Alamo!" Alisa Corstorphine has edited *Alamo Today* since 2004, even as a pervasive social media presence threatens such local newspapers.

As much as the AIA weighed in and often criticized various developments, sometimes, unexpected things happen. When the Alamo Trails development

This image displays part of the inaugural front page of a monthly newspaper, *Alamo Today!* in May 2000. The picture featured a cell tower disguised as a tree, which was placed near Stone Valley Road and I-680. Bruce Marhenke was the editor, followed by Alisa Corstorphine. *Courtesy of the Museum of the San Ramon Valley.*

on Livorna Road was finally approved, developer Bruce Kittess paid tribute to local leaders, whom he called "living pioneers," and he put their names on streets throughout the development. Now, the names Gibson, Evelyn, Osher, Ensley, Young, Neely and other volunteers appear on local maps.

THE DOWNTOWN: KEEPING IT LOCAL

The community clearly valued Danville Boulevard as a quiet two-lane road with trees softening the edges, even as traffic signals were installed at Livorna and Stone Valley Roads and Hemme and Camille Avenues. People also definitely wanted a compact commercial area, and they weren't shy about saying so. Business owners promoted a healthy business community through an Alamo Merchant Association or chamber of commerce.

In 1996, the expansion of the small used car lot in downtown was opposed by the AIA, which stated that more cars would make the business look cluttered. The AIA planning chair John Henderson said, "I think some of the things he's proposing depart from the semi-rural atmosphere of Alamo" (*San Ramon Valley Times*, May 17, 1996).

In 2005, Home Depot purchased Alamo's funky and familiar Yardbirds, and fans of the store were upset. After renovations, Home Depot Yardbirds opened, only to close again in early 2009. Later that year, Alamo Ace

Hardware was introduced with a combination of old and new products and familiar employees. A separate kitchen section with high-quality merchandise attracts a large fan base today.

Traffic congestion was the topic that everyone talked about. All new developments had traffic studies that were read avidly by AIA committees and Alamo Road Committees. When new projects, such as churches and housing developments on former ranches or the large YMCA facility, were proposed, traffic counts were thoroughly analyzed. Residents wanted to have primarily local drivers on the boulevard.

Advocates discussed the size of the central Stone Valley Road and Danville Boulevard intersection, which was often gridlocked and had scary collision statistics. How were they to solve these problems? Should they add more turn lanes to widen the corners, new green turn arrows, an expansion of the bridge over San Ramon Creek? Resisting what was called the "ultimate configuration" in 2004, people wanted to keep the intersection modest in size. The May 2008 issue of *Alamo Today* stated, "The AIA opposes the ultimate configuration because it would serve freeway traffic at a great expense to local pedestrians, drivers, and residents." Two south left-turn lanes from Danville Boulevard onto Stone Valley Road were implemented (instead of the "ultimate" plan), which greatly improved the congestion and conflicts.

Traffic controls at the north end of downtown focused on a mishmash of fifteen driveways, none of which led straight across the boulevard. A signal was proposed and a roundabout suggested in an effort to pulse traffic both ways. Beginning in 1995, these choices were debated ad nauseum until many people quit paying attention. Residents on the west side were the most likely to care. Finally, a roundabout was selected to be an iconic northern entry that would slow—not stop—the traffic. This roundabout, just south of Andrew Young Park, is due to be installed in 2022, a change that will, no doubt, provoke more comments.

Susan Rock, the Alamo MAC chair in 2019, pointed out, "People are truly invested in the community. Nothing is done without controversy."

DISCUSSIONS AND DEBATES

When county supervisorial districts were reapportioned in 2000, the San Ramon Valley and East Contra Costa Districts were placed together, with Mary Piepho of Discovery Bay as the Supervisor. It wasn't a smooth

transition. The AIA asserted that the "once-symbiotic" relationship between the volunteers and the county had changed significantly with the redistricting.

In 2005, Supervisor Piepho questioned how the various advisory committees had functioned and then disbanded the Alamo Parks and Recreation and Zone 36 Advisory Committees—thirteen people in total. She then set up a new application process to appoint different representatives. The Alamo Roads Committee was changed so that groups no longer appointed their own representatives; this would then be done by the supervisor. Piepho also proposed that a Municipal Advisory Council (MAC) be established for Alamo. By then, these MACs were in place throughout Alameda and Contra Costa Counties, either directly elected or appointed by the Supervisor. All were asked to provide a local voice for their unincorporated communities. Piepho was not a fan of the grassroots Alamo Improvement Association.

Not unexpectedly, the AIA was none too pleased with the prospect of a MAC, pointing out that residents could join the AIA, be elected to its board and provide a voice free from county control. With broad responsibilities, such as the administration of justice, public health, the library system and social services, Alamo's nuanced expectations were not always welcomed by county staff. In turn, AIA representatives could be harsh in their testimony and criticisms of the county.

When a new YMCA facility was proposed north of Magee Park with access via Danville Boulevard in late 1999, debates were hearty and long lasting. Opponents charged the project would ruin the community's bucolic environment and increase non-Alamo traffic. The YMCA planned a 40,000-square-foot cluster of buildings on 12.4 acres, pools and an open air gymnasium, with all vehicles coming over a new San Ramon Creek Bridge at Lewis Lane. Ultimately, financing became too onerous to proceed with the project and, today, the span has been dubbed "the bridge to nowhere."

Another controversy ignited when David and Cheryl Duffield wanted to build a "mega-mansion" of 72,000 square feet on a 22-acre site in Bryan Ranch at the end of Stone Valley Road. One 2004 article pointed out that Hearst Castle was only 60,645 square feet. Save Mount Diablo challenged the project, and the Bryan Ranch homeowners passed a restriction limiting house sizes in the area. Three and a half years later, the estate was finally built in a smaller form, with an 18,067-square-foot house and a conservation easement on most of the property.

The Ball estate homes development was a significant project that came before the community with much input from the AIA and adjacent neighbors, taking six years to go through the process. Residents were concerned about

drainage, grading, visual impacts, density and construction traffic on Camille Avenue. Selecting a location for a Las Trampas to Mount Diablo Regional Trail staging area was another challenge, as neighbors wanted to move trail-user cars off the avenue. Thirty-five lots for homes were approved in 2019.

ALAMO VOTES ON ITS OWN TOWN

Proposals for an Alamo-only incorporation vote had been argued about for decades. Finally, fifty years after the AIA first discussed the option, such an opportunity appeared on the ballot for the first time in 2009. This election was the major public event of the twenty-first century in Alamo.

Advocates for incorporation witnessed fewer half-acre lots being proposed and remembered the Bogue Ranch development's original stacked condominium attempt. They charged that the county did not listen to them and were convinced that locally elected residents could do a better job of governing Alamo. The county was again debating whether or not to continue the regional area planning commission, which met locally and had been in place since 1977. In addition to clashes with Supervisor Piepho, residents were concerned about the county's fiscal situation and convinced that Alamo tax revenues were not being spent in Alamo. In 2005, Vicki Koc contacted Sharon Burke and Kent Strazza, who shared coffee and talked about the fiscal issues and the county's unsatisfactory responses to Alamo's priorities.

It had been thirty years since the last Alamo city effort went to the Local Agency Formation Commission (LAFCo), the agency that controlled such elections. In 2007, a proposal to incorporate Alamo was formally initiated by seven residents: Steve Goodman, Vicki Koc, Sharon Burke, Randy Nahas, Mike Gibson, David Bowlby and Steve Mick. The group paid for an initial fiscal analysis from Walter Keiser's Economic and Planning Systems. The report examined the feasibility of Alamo as an independent, limited-services town and found that it had the resources to incorporate.

An Alamo Incorporation Committee Inc. was organized, with Vicki Koc as president. Alamo Inc. had ten directors: Sharon Burke, David Bowlby, Randy Nahas, Kent Strazza, Steve Goodman, Mike Gibson, Vicki Koc, Steve Mick, Nancy Kaplan and Chris Kenber. In 2008, Alamo Inc. submitted an incorporation application to LAFCo, with Vicki Koc, Sharon Burke and Steve Mick as signatories.

The LAFCo process was complex and demanding. The commission required another comprehensive feasibility study, which was prepared by Winzler and Kelly, led by Gary Thompson. The study produced positive results, indicating that a limited services town was feasible. Incorporation advocates were required to pay for a survey of Alamo's metes and bounds, which created precise Alamo boundaries for the first time. Alamo's population was listed as 16,683 (verified by the state department of finance), which was larger than the 2010 census figure of 14,570. In 2008, a variety of county service areas had been established to provide funding for enhanced services. These included: R-7A (parks and recreation), P-2/Zone B, P-5, P-6 (public safety), EM-1 (emergency medical services), L-100 (street lighting) and M-30 (Alamo Springs enhancements). There were also lighting and landscape benefit zones 36, 45 and 54.

The city advocates, the "Alamo Incorporation Movement" (AIM), met constantly and tried to answer all of the questions that were thrown at them by critics, as they campaigned vigorously for incorporation. An Alamo Community Foundation raised and distributed funds for the fiscal study and candidates' forum, which was headed by Claudia Waldron. A website was set up, www.alamoinc.org, something far more modern than earlier efforts. Sharon Burke wrote monthly columns titled "I ♥ Alamo! Incorporate Alamo Now" to support the effort. Several local activists signed the arguments for Measure A in the Voter Information Pamphlet: Claudia Waldron, Richard Delfosse, Kirk Doberenz, Frank Lockwood, Chris Kenber, Michael Gibson, David Dolter, Jeanne Tate and William Bassett

There were months of deliberations over the proposed Town of Alamo, which was placed on the ballot in March 2009 as Measure A. Dinner parties inevitably had lively arguments on the topic. Coffee klatches could talk of nothing else. Brochures from both sides went into people's mailboxes.

One of many promotional pieces produced by the 2009 Alamo Incorporation Movement; this was a pro-incorporation bumper strip. *Courtesy of the Museum of the San Ramon Valley.*

The monthly *Alamo Today* newspaper featured newspaper articles, debates, letters to the editor, as well as advertisements from the candidates and pro and con sides.

Alamo Café habitué and local realtor Bob Myhre drove his truck around with a large sign that said, "I ♥ ALAMO, INCORPORATION—NO, A MAC—YES." Several Alamo leaders who had supported past valley-wide incorporations were actively opposed, including Ed and Linda Best and Carolyn and Brian Thiessen. Longtime resident Virgie V. Jones, who had opposed all valley incorporation efforts, stated, "We just can't afford it."

One group against incorporation organized, calling itself "We R Alamo, Vote No on Incorporation," and setting up a website at www. AlamoSpotlight.com. Others coalesced as "Alamo Against A." They analyzed the LAFCo's feasibility study's assumptions, argued that the assumptions were flawed and asserted that the town costs were clearly underestimated. Involved in this group were the Bests, Mike and Sandra McDonald, Larry Rodrigue, Mark Holmstedt, Joe Bologna and David and Cecily Barclay.

In addition to disputing the financial information, anti-incorporation advertisements and letters predicted that onerous regional housing requirements would be applied if Alamo incorporated. Rumors about the political ambitions of candidates were expressed. Some voters were adamantly anti-regional government and worried over another layer of government. Opposition to the "citification" of Alamo appeared in one letter.

A major economic recession started in 2008 and, when Home Depot closed early in 2009, critics pointed out the important city revenues that would be lost by the closure. One letter to the editor said, "Simply put—the commercial tax base for Alamo is miniscule." In the *Voter Information Pamphlet*, four people signed the opposition arguments: Denise Padovani, Jean Taylor, Anthony Carnemolla and Stephen Heafey. Their opinions were listed under the

The anti-incorporation group Alamo Against A produced this *NO on Measure A* brochure, showing the iconic horse on the shoe repair store along Danville Boulevard. *Courtesy of the Museum of the San Ramon Valley.*

A Candidate Faire was held on January 22, 2009. Shown here are fifteen of the candidates for the Alamo Town Council. *First row, left to right*: John Morrow, Bob Connelly, Vish More, Diane Barley, Vicki Koc, Grace Schmidt, Karl Niyati and Joe Rubay. *Back row, left to right*: Kevin Morrow, Brad Waite, Roger Smith, Steve Mick, Randy Nahas, Karen McPherson and Dennis Johnson. *Courtesy of Alisa Corstorphine.*

title "The Incorporation of Alamo Would Be Toxic to Our Community." On the March 3, 2009 ballot, Alamo residents could vote yes or no on Measure A and select five people to serve as the new town council. Many predicted the decision would be a close one.

Arguments for an independent town simply did not resonate with Alamo voters. Measure A was defeated by nearly two-thirds, 2,468 to 4,456 (35.64 percent to 64.36 percent). The turnout was impressive—62.27 percent— as 6,924 out of 10,508 eligible voters went to the polls. From a field of sixteen potential council members, these five were the top vote-getters: Grace Schmidt, 2,076 (10.38 percent); Vicki Koc, 1,978 (9.89 percent); Steve Mick, 1,935 (9.67 percent); Randy Nahas, 1,875 (9.37 percent); and Bob Connelly, 1,842 (9.21 percent). As Steve Mick later said, they were a "council without portfolio."

The night of the election, at the Alamo Women's Club, incorporation advocate Chris Kenber said, "At one level, it's sort of emotional, and at another level, I wouldn't have done anything differently." Opponent Tony Carnemolla asserted that the county was simply "doing right by Alamo," so people just voted no.

ALAMO'S MUNICIPAL ADVISORY COUNCIL

After the 2009 Alamo incorporation effort defeat, Supervisor Piepho established Alamo's first Municipal Advisory Council. It became the twelfth MAC in the county. The adopted county board resolution (July 30, 2009) stated that a MAC provides an "opportunity for a focused voice and input from an unincorporated area to the district supervisor." The Alamo MAC's responsibilities include park and recreation, lighting and landscaping, land use and code enforcement, public safety, transportation and other county services. These responsibilities are extensive and broader than those of most county MACs.

In creating the MAC, Piepho tried to balance opinions about cityhood in her first seven appointments. Steve Mick, David Bowlby and Nancy Dommes were prominent incorporation supporters, while Ed Best, Mike McDonald and David Barclay were vocal opponents. Janet Miller Evans was pro-incorporation but not active in the campaign. An alternate and a youth representative also served on the MAC, though without a vote.

Whether or not to establish an Alamo MAC had been discussed for decades. AIA representatives opposed it as unnecessary. Some anti-incorporation advocates had loudly supported an appointed MAC in their campaign materials. By this time, the community saw it as a logical step after the failure of incorporation. Most of the various county service area advisory committees have been amalgamated under the MAC, although there are still separate police services advisory committees. A MAC park and recreation subcommittee pursues new park possibilities and recommends programs like the annual summer concerts at Livorna Park. The AIA sponsors various events like the farmers' market and annual car show.

Ed Best said that, at first, the county staff probably listened to the AIA positions more than those coming from the MAC, since staff knew the association representatives. The MAC carefully considers AIA advice on projects, acknowledging the group's extensive planning experience. Currently, both groups advise the local Supervisor, county staff and, sometimes, the Board of Supervisors. When they bring joint recommendations, it can be very effective. The MAC is required to observe the Brown Act (primarily, no private meetings of a majority), and their comments go to the local Supervisor. Speaking individually as a MAC member is not permitted.

The Alamo Improvement Association continues to have resident support and makes recommendations to the MAC and the county on development

An Alamo Municipal Advisory Council had been initially proposed in 1973. This 2009 photograph shows the first Alamo MAC appointed by the County Board of Supervisors. *From left to right*: David Bowlby, David Barclay, Mike McDonald, County Supervisor Mary Piepho, Steve Mick, County Clerk Steve Weir, Nancy Dommes, Janet Miller Evans and Ed Best. *Courtesy of Supervisor Candace Andersen.*

proposals and other issues. They lobby decision-makers and are careful to protect their credibility. Their comments on the county general plan update, "Envision 2040," support current county policies to protect the "character of the community." Observers say that the combination of MAC discussions and AIA planning expertise represent "a uniquely Alamo solution" to governance.

In 2017, two park projects in Alamo were completed. The MAC and County Supervisor Candace Andersen spearheaded Hemme Station Park with a railroad theme at the corner of Hemme Avenue and Danville Boulevard, next to the Iron Horse Trail. The other project was privately initiated. The San Ramon Valley United Methodist Church weathered criticism and built an activity and recreation center (ARC), which provides a community gymnasium for the public on Danville Boulevard in Alamo.

An early order of the day for the MAC was the adoption of an Alamo logo. This project had been initiated by Vicki Koc during a 2005 contest

The Alamo Municipal Advisory Council selected an Alamo logo in 2010. This version of the logo appears at Hemme Station Park on the corner of Hemme Avenue and Danville Boulevard. *Photographer, Jeff Mason. Courtesy of the Museum of the San Ramon Valley.*

that was won by Ginnie Anderson. MAC member Janet Miller Evans pressed to establish a graphic symbol for Alamo, and the council adopted a version of the logo in 2010. Another version appeared on the Hemme Station Park signs.

It seems unlikely that another incorporation effort will be initiated. Alamo residents have voted against every city proposal when given the chance. In 2020, Supervisor Andersen has an office in Danville, not far away from Alamo, and a sheriff's station is set up in the Alamo Plaza. The Supervisor's monthly Alamo liaison meeting is open to all. It provides an opportunity for Alamo residents, providers of public services (the sheriff, California Highway Patrol, San Ramon Valley Fire Protection District, San Ramon Valley Unified School District), volunteer groups and business organizations to meet in an informal setting. With the 2020 pandemic restrictions, these meetings were conducted over Zoom.

In modern Alamo, the median price of a home is $1.639 million; the population is 15,646; and the median household income is an impressive $226,540 annually, as calculated by the Census Bureau's American Community Survey for 2018.

Alamo, as a community, has many people devoted to it. They enjoy its beautiful physical setting, Mediterranean climate, large lots and small-town, sometimes rural, character. There are twenty-four equestrian properties in Alamo, and many families keep chickens. AIA board member Valerie Schooley described this as not "gold country rural" but "sophisticated rural." Residents have access to trails and open space with shopping opportunities not far away, all set in the renowned San Francisco Bay Area. At nearly 270 years old, Alamo is a microcosm of old and new California.

APPENDICES

Historical Plaques in Alamo

San Ramon Valley Historical Society Plaques

- Alamo Grammar School, at the northwest corner of Stone Valley Road and Danville Boulevard
- School bell, at Alamo Elementary School at 100 Wilson Road
- Jones home and post office, on the wall of CVS on Danville Boulevard
- Alamo Cemetery, on El Portal
- Howard home in Whitegate on Shandelin Court

Plaques from Other Groups

- Stone Family plaque by E. Clampus Vitus, at Stone Valley Center
- The Blue Star Memorial Highway sign by California Garden Clubs Inc., on Stone Valley Road, northeast of I-680

PARK PLAQUES

- Hemme Station Park interpretive signs by Municipal Advisory Council, R7
- Andrew H. Young plaque by Municipal Advisory Council, R7
- Hap Magee Ranch Park by R7A and the Town of Danville
 - Tatcan Indian plaque, adjacent to San Ramon Creek and the small dog park
 - Captain Isaac Swain plaque, between the Cottage and the playground

ALAMO POSTMASTERS: 1852 TO 2020

NAME	TITLE	DATE APPOINTED
John M. Jones	Postmaster	May 18, 1852
William Carmichael	Postmaster	November 12, 1861
Simon Wolf	Postmaster	November 13, 1862
Samuel H. Ball	Postmaster	December 22, 1863
James Foster	Postmaster	October 2, 1866
John B. Henry	Postmaster	April 3, 1879
August J. Henry	Postmaster	March 15, 1900
David C. Bell	Postmaster	May 9, 1905
Roy D. Bell	Acting Postmaster	February 24, 1923
Roy D. Bell	Postmaster	April 24, 1923
Harriett Hunt	Acting Postmaster	July 1, 1936
Harriett Hunt	Postmaster	October 15, 1936
Mildred B. Ulrich	Acting Postmaster	May 1, 1944
Hazel C. Hetherwick	Acting Postmaster	October 1, 1944
Eleanor C. Stokes	Acting Postmaster	April 30, 1945
Bertha V. Linhares	Acting Postmaster	February 15, 1947
Bertha V. Linhares	Postmaster	July 2, 1947
Horace L. Green	Acting Postmaster	November 8, 1960

Mary Ellen Gwynne	Acting Postmaster	September 27, 1961
Mary Ellen Gwynne	Postmaster	September 4, 1962
Lester M. Houston	Officer-In-Charge	August 27, 1971
Lester M. Houston	Postmaster	November 27, 1971
Vivian L. Lemke	Officer-In-Charge	December 31, 1974
Peter G. Mennen	Officer-In-Charge	September 5, 1975
Joseph J. Coppa	Postmaster	January 3, 1976
Jacqueline A. B. Sue	Officer-In-Charge	August 15, 1977
Jesse Castro	Officer-In-Charge	February 17, 1978
Mary J. Bufton	Postmaster	March 25, 1978
Myrtle Beasley	Officer-In-Charge	May 3, 1984
Theodore A. Knapp Jr.	Postmaster	October 27, 1984
Myrtle Beasley	Officer-In-Charge	June 27, 1986
Ruben A. Romero	Postmaster	August 30, 1986
Ruby Lowe-Kirk	Officer-In-Charge	October 3, 1992
Russell M. Teves	Postmaster	January 9, 1993
Janell Olsen	Officer-In-Charge	July 8, 2000
Chris T. Casey	Officer-In-Charge	August 11, 2000
Chris T. Casey	Postmaster	February 24, 2001
Judy Corbett	Officer-In-Charge	November 26, 2001
Anne Marie I. Mcclure	Officer-In-Charge	March 2, 2002
Anne Marie I. Mcclure	Postmaster	December 13, 2003
Janeth L. Johnson	Postmaster	March 31, 2018

COUNTY SUPERVISORS REPRESENTING ALAMO FROM 1850 TO 2020

1852: At Large

Samuel H. Robinson, Victor Castro, Robert Farrelly, William Patten, T.J. Keefer

1853: At Large
Samuel H. Robinson, Cummings Lund, E.D. Winn, William Patten,
 T.J. Keefer

1854: At Large
A.W. Genung, Joseph Martin, Carroll W. Ish (Alamo), Isaac Hunsaker,
 J.C. McMaster

1855: District 2 (The county was reorganized into three districts, and each
 district had two supervisors for one year)
L.E. Morgan, Nathaniel Jones

1856–1861	Ira J. True	1933–1956	H.L. Cummings
1862–1864	J.R.L. Smith	1957–1964	Mel F. Nielsen
1865–1876	D.N. Sherburne	1964–1972	James E. Moriarty
1877–1879	Walter Renwick	1973–1976	Edmund A. Linscheid
1880–1881	D.N. Sherburne	1977–1980	Eric Hasseltine
1882–1885	T.E. Middleton	1981–1992	Robert Schroder
1886–1887	J. Kelley	1993–1997	Gayle Bishop
1888–1892	James M. Stow	1998–2003	Donna Gerber
1893–1900	William Hemme	2003–2004	Millie Greenberg
1901–1904	James M. Stow	2005–2011	Mary N. Piepho
1905–1908	Ralph Harrison	2011–2012	Gayle B. Uilkema
1909–1923	J.P. Casey	2012–present	Candace Andersen
1923–1932	Oscar Olsson		

PARKS IN AND AROUND ALAMO

Alamo Parks

Alamo School sport fields and batting cages
Andrew H. Young Park
Livorna Park
Hap Magee Ranch Park (with Danville)
Hemme Station Park
Oak Hill Park (borders Alamo, created by R7)
Rancho Romero Sport Fields and Park
Stonecastle Creek Overlook Park

Regional Trails in Alamo

Green Valley Regional Trail
Iron Horse Regional Trail
Las Trampas to Mount Diablo Regional Trail

Nearby Parks

Diablo Foothills Regional Park
Eugene O'Neill National Historic Site
Las Trampas Wilderness Regional Park
Mount Diablo State Park
Shell Ridge Open Space in Walnut Creek
Sugarloaf Open Space in Walnut Creek

INCORPORATION EFFORTS IN THE SAN RAMON VALLEY: 1964-2009

Councilmembers Elected

Alamo (Only), Near Election in 1961: Scheduled for July 11, 1961
Insufficient assessed valuation, petition signatures prevented a vote.

Alamo–Danville: September 29, 1964, Lost 2,086 to 1,958
Council would have been T. James Ahern, Herman Sandkuhle, Max
 Lauritzen, Richard Moulds and John Hartwell.

San Ramon Valley: December 19, 1967, Lost 2,796 to 1,830
Council would have been Roy Anderson, Byron Athan, Francis Driscoll,
 George Filice and John May.

San Ramon Valley: January 23, 1973, Lost 5,623 to 5,178
Council would have been Roy Bloss, Eric Hasseltine, Dick Kennett,
 Claudia Nemir and Brian Thiessen.

San Ramon Valley: November 2, 1976, Lost 10,426 to 7,846
Council would have been Bob Bush, Claudia Nemir, Norm Roberts, Gene
 Rolandelli and Don Sledge.

Danville: June 8, 1982, Won 5,809 to 4,952
Council sworn in on July 1, 1982: John May, Beverly Lane, Dick McNeely,
 Doug Offenhartz and Susanna Schlendorf.

San Ramon: March 8, 1983, Won 3,825 to 1,254
Council sworn in July 1, 1983: Diane Schinnerer, Rick Harmon, Mary Lou
 Oliver, Wayne Bennett and Jerry Ajlouny.

Alamo: March 3, 2009, Lost 4,456 to 2,468
Council would have been Grace Schmidt, Steve Mick, Vicki Koc, Randy
 Nahas and Bob Connelly.

SOME ALAMO STREET NAMES: MEANINGS AND ORIGINS

Geographical Street Names

Danala Farms. Located on the Danville-Alamo border, hence *Danala*.

Danville Boulevard. Beginning as a Native trail and an 1850s stagecoach
 route, it has been called State Highway 21, Memorial Boulevard and the
 Contra Costa Highway. The Alamo portion has been known as Danville
 Boulevard since 1962.

Green Valley Road. Named for one of the earliest settled valleys in the
 area east of Alamo.

Las Quebradas Lane. Means "broken cliffs" in Spanish. It was named by
 early Spanish settlers for an unusual rock outcropping, which is still visible.

Las Trampas Road. Originally named North Avenue, the street leads
 to Las Trampas Ridge. It means "the traps" and is named for dead-end
 valleys where Natives trapped elk and deer.

Litina Drive. Litina Homestead Ranch was owned by early settlers David
 and Mary Smith, and it covered a large portion of westside Alamo, from
 Ridgewood Road to Livorna Road.

Orchard Court. The site of one of the Humburg homes, early Alamo
 pioneers. It was surrounded by orchards for many years.

CORRECTED HISTORY OF LAS QUEBRADAS LANE

Las Quebradas Lane was built and named by Louis and Marie Stroever, Art and Louise Bisset and Artie and Grace Clements, who purchased 64 acres in the hills above Miranda Avenue in the late 1940's. Using an old surplus road grader, Art Bisset spent months building the mile long road beginning at Miranda Avenue for the full length of modern day Las Quebradas. Artie and Grace Clements had been involved in mining in Columbia, and their knowledge of Spanish led them to name the road Las Quebradas Lane, "a break in the cliff".

ADDITIONS

Cindy Lane is named for lifelong Alamo resident Cindy Grabel Leonard, daughter of Alamo real estate broker and developer Lee Grabel, who developed the street.

Lunada Lane was originally a short dirt road accessed off Hillgrade Avenue. When early resident Rose Magnesi moved there in the late 1940s she named it Lunada Lane after she was inspired by a beautiful clear moonlit night she saw from her house. Lunada Lane in modern days has three unconnected parts. When the other two streets named Lunada Lane were developed, the County required them all to have the same name because there was a plan to connect all three streets as a bypass for the congested Highway 21 (Danville Boulevard). This plan had universal opposition from Alamo residents and was never implemented.

Round Hill. Round Hill Country Club opened in 1961 and was named by developer Harlan Geldermann for the posh Round Hill Resort in Jamaica, which he visited.

South Avenue. One of two original named streets that led off Alamo's main highway.

Stonecastle Drive. Named for two "stone castle" homes located on this street that were built in 1941 and 1952 in the Storybook architectural style by master architect Carr Jones of Berkeley.

Streets Named for Alamo Pioneers and Residents

Ashford Court. Property owners David and Carola Ashford lived on Camille Avenue, and their subdivided property used this street name in the early 1970s.

Austin Lane. Named for "Commander" Frank Austin and wife Leonore, who bought the circa 1870 Albert and Martha Stone Victorian house.

Bolla Avenue. Farmers Joseph and Catherine Bolla emigrated from Italy and farmed on Stone Valley Road in the 1920s and 1930s. Their ranch became Bolla Avenue, Angela Avenue (named for Joseph's mother) and Catherine Court.

Britain Court and Lurmann Court. Named for Charles and Marjorie Britain Lurmann, the property owners. Charles was the brewmaster at the Burgermeister Brewing Company of San Francisco. They retired to Alamo and raised chinchillas and walnut trees on eleven acres, which received these names.

Bunce Meadows Place. Martha and Edward Bunce were farmers on this property for more than seventy years. Martha was the daughter of Alamo pioneers Albert and Martha Stone.

Camille Avenue. Named for Camille Grosjean, a French immigrant to America who was a landowner in this area of Alamo in the early 1900s.

Corrie Place. Named for Sid Corrie, the developer of Alamo Springs.

Corwin Drive. Corwin and Ruth Henry owned this property in the 1950s.

Davey Crockett Court. Named for the Tennessee frontiersman who died at the Battle of the Alamo in Texas. The developer, Centex Homes, made the Texas connection.

David Drive and Ina Court. Named for property owners David and Ina Gerlach, who subdivided this property in the 1960s.

Dorris Place. Named for the Dorris family, the founders of Dorris Eaton School.

Elliott Court. Named for Alamo Improvement Association board member Bob Elliott.

Ensley Court. Named for Clark Ensley, an Alamo Improvement Association board member.

Erselia Trail. Named for Erselia Miranda, the youngest daughter of Santos Miranda, a pioneer rancher in the 1860s.

Evelyn Court. Named for Evelyn (Eve) Auch, a longtime president of the Alamo Improvement Association.

Finley Lane. Named for Dr. Anna Reis Finley, a local physician and property owner.

Gary Way. Named for Gary Jones, the son of property owners Alfred and Virgie Jones who subdivided this property as Jones Walnut Acres in 1948.

Gibson Court. Named for Alamo Improvement Association board member Mike Gibson.

Harrington Court. Named for Alamo schoolteacher Jacqueline Harrington

Hemme Avenue. August and Minerva Hemme were prominent Alamo citizens who owned a two-thousand-acre ranch on the west side of Alamo and Danville in the late nineteenth century.

Jackson Way. Named for Richard and Friederiche Jackson. Friederiche was the granddaughter of Alamo pioneers Albert and Martha Stone and Frederick and Maria Humburg.

James Bowie Court. Named by the developer for Kentucky frontiersman James Bowie, who perished at the Battle of the Alamo in Texas.

Kirk Court and Kirkcrest Road. Named for Kirk Ashford, the son of property owners John and Carola Ashford, who subdivided the property in the 1970s.

Laurenita Way. A combination of the two developers' wives' names, Laura and Anita.

Linhares Lane. Named for Bertha and Anthony Linhares, who owned this property in the 1930s and 1940s. Bertha Bell Linhares was the Alamo postmaster from 1947 to 1960.

Massoni Court. Corrinne and William Massoni were poultry producers and vegetable growers who operated a produce stand at the corner of Massoni Court and the highway for many years.

Mathews Place and Sara Lane. C.C. and Sara Mathews were walnut farmers who subdivided their property in 1947.

Medlyn Lane. Named for Danville restaurateur Valentine "Vally" Medlyn, the owner of Vally Medlyn's Restaurant on Hartz Avenue in Danville who lived here in the 1940s.

Miranda Avenue. Named for Santos Miranda, a pioneer rancher in the 1860s.

Mott Drive. Named for the Mott Family, who farmed this area that later became part of Round Hill Country Club.

Neely Court. Named for AIA board member Sherry Neely.

Osher Court. Named for AIA board member and park advocate John Osher, a Livermore Lab scientist.

Pangburn Lane. Named for Charles and Ida Pangburn, the original landowners of the area. Charles was the president of the Contra Costa Walnut Growers Cooperative (Diamond Brand).

Ranger Court. Named for Jim and Yvonne Ranger, whose Jim-Yve Stables were located here in the 1960s.

Romero Circle and Via Romero. Named for Rancho Romero, the ill-fated Mexican land grant of Jose and Inocencio Romero. The grant included most of present-day Alamo but was never confirmed. John and Mary Ann Jones named their property Rancho Romero, and the family lived there.

Scripps Haven Lane. Named for the wealthy Scripps newspaper family, whose Alamo vacation home was named "Scripps Haven." Built in 1940, the home still exists, and when the acreage was subdivided in the 1980s, the street was named after the home.

Silva Dale Road. Named for the Silva family, farmers, dairymen and immigrants from the Azores who settled in this area in the early 1900s.

Smith Road. Named for Lawrence Smith, who homesteaded this property in 1871. His family lived there until the Alamo Oaks subdivision was built in 1937. This was the first subdivision in Alamo after Rancho El Rio in 1910.

Squire Court. Named for the farmers Grover Cleveland and Mary Margaret Squier, who farmed this area in the twentieth century; it later became part of the Round Hill Country Club. The spelling was a typographical error by the developers.

St. Alicia Court, St. Alphonsus Way and St. Paul Drive. Named by devout Catholics and Italian immigrants Catherine and Joseph Bolla, who owned the land that became these streets.

Stone Valley Road. Named for the Stone family who were pioneer settlers of Alamo in the 1850s. The Stones eventually owned most of the land from Livorna Road to Stone Valley Road.

Tracy Court. Named for Tracy Geldermann, the daughter of Round Hill developer Harlan Geldermann.

Turner Court. Named for Jeff Turner, an AIA board member.

Wayne Avenue. Named John and Veda Wayne, prominent Alamo citizens. The Waynes were famous for their extensive gardens and their many garden parties for the Alamo Community Club. They developed property on the west side of the boulevard and created Wayne Avenue in the 1940s.

Young Court. Named for Andrew Young, the "dean" of Alamo and Alamo Citizen of the Year.

Animal and Horse Street Names

Byerley Court. Named for seventeenth-century Arabian horse Byerley Turk, said to be one of three Arabian horses from which all Thoroughbred horses are descended. The street is part of the Stonebridge Estates development, which was John Rogers's Arabian Horses Ranch for many years.

Carmalita Place. Named for the Arabian horse Carmalita, a daughter of Arabian champion Serafix, who was bred and raised by Sherman Ranch Arabians in Alamo.

Childers Court. Named for eighteenth-century Arabian horse Flying Childers, who was considered the first truly great Thoroughbred racehorse.

Guess Court. Champion Arabian stallion Winning Guess, the son of Carmalita and descendant of Serafix, was bred and raised on this property, which was owned by Sherman Ranch Arabians.

Livorna Road. Livorna Farm, a large Leghorn chicken ranch owned by Harry and Marie Hunter from 1910 to 1920 was located at the northwest corner of Livorna Road and Danville Boulevard. *Livorno* is Italian for Leghorn chicken.

Matchem Court. Named for the eighteenth-century Arabian stallion Matchem, the ancestor of today's Thoroughbred horses.

Mystic Place. Named for the champion Arabian horse Mystic Bey.

Serafix Road. Named for the famous champion Arabian stallion Serafix, who was imported from England in 1954 by John Rogers of Rogers Arabians, an Arabian stud farm located at the east end of Livorna Road during the 1950s and 1960s.

CHAPTER NOTES

1. Alamo's Setting

Brewer, William H. *Up and Down California in 1860–1864*. Edited by Francis P. Farquha. Berkeley: University of California Press, 1974, 184–85, 203.

Crane, Ron, and Kevin. *Geology of the San Ramon Valley, A Personal Account of the Present Geological Knowledge of the Area*. N.p.: self-published, 2002.

Daily Alta California. "Earthquake Report." October 22, 1868.

Hoffman, Ogden. *Reports of Land Cases Determined in the U.S. District Court for the Northern District of California*. Vol. 1. June 1853 term to June 1858 term. San Francisco: Sumner Whitney, 1862. Land Case 322, 1855. (San Ramon Valley).

Lane, Beverly. "Mount Diablo: The History of Its Name." Valley Vignettes, *Valley Pioneer*, July 15, 1987.

Mount Diablo Interpretive Association. *The Mount Diablo Guide*. Berkeley, CA: Berkeley Hills Books, 2000. www.imdia.org/geology.

Newsletter of the University of California Museum of Paleontology. "The Discovery of the Blackhawk Quarry." December 1998, 1, 3.

San Ramon Valley Times. "Valley Residents Cook Meal for Santa Cruz Quake Victims." October 26, 1989.

Smith, James Dale. *Recollections, Early Life in the San Ramon Valley*. Edited by G.B. Drummond. Livermore, CA: GRT Book Printing, 1995. ("Letter to Ida Hall, Aug. 7, 1925").

Wood, Charlotte. *Rambling Reminiscences of the Charles Wood Family and Their "Woodside Farm" Home*. Monograph, 1950. (Cynthia Wood's earthquake memories).

2. The First People

Bancroft, Hubert Howe. *History of California*. Vol. 1, 1542–1800. Santa Barbara, CA: Wallace Hebberd, 1963, 556, 708–9. (Indian resistance).

Heizer, Robert F., ed. *Handbook of North American Indians, California*. Vol. 8. Washington, D.C.: Smithsonian Institution, 1978, 44. (CCo-229).

Hoffman, Ogden. *Reports of Land Cases Determined in the U.S. District Court for the Northern District of California*. Vol. 1. June 1853 term to June 1858 term. San Francisco: Sumner Whitney, 1862. Land Case 322, 1855 (San Ramon Valley).

Milliken, Randall. "Central Contra Costa Indians, An Ethnographic Study of the Clayton Area." CEQA document, 1982, 9.

———. *A Time of Little Choice: The Disintegration of Tribal Culture in the San Francisco Bay Area, 1769–1810*. Novato, CA: Ballena Press Publishers' Service, 1995, 156–57.

Ortiz, Beverly. "Bay Miwok Sacred Geography, C. Hart Merriam, 1910 (N. Miwok fire story)." Monograph provided for the Bay Miwok Conference, 2003.

———. "Ohlone Curriculum, 2015." www.ebparks.org.

3. The Hispanic Era in Alamo

Bancroft, Hubert Howe. *History of California*. Vol. 6, 1948–1859. Santa Barbara, CA: Wallace Hebberd, 1963, 557.

Contra Costa Gazette. "The San Ramon Rancho." August 27, 1864.

Fink, Leonora Galindo. "The Rancho San Ramon of Bartolome Pacheco and Mariano Castro." Monograph, March 7, 1963, 6.

Hoffman, Ogden. *Reports of Land Cases Determined in the U.S. District Court for the Northern District of California*. Vol. 1. June 1853 term to June 1858 term. San Francisco: Numa Hubert Publisher, 1862. (June term 1857, Romero, 219–227), LC 73 (Castro/Pacheco), LC 221 (Romero), LC 227 (Romero), LC 322 (Romero), May 15, 1864, Victor Castro quote and Romeros and Garcias "lose equally," LC 304 (Romero).

Milliken, Randall. *A Time of Little Choice: The Disintegration of Tribal Culture in the San Francisco Bay Area, 1769–1810*. Novato, CA: Ballena Press Publishers' Service, 1995, 1.

Morrison, Father Harry. "Mexican Grants and Colonization Law." Monograph, 1993–1994.

Royce, Josiah. *California. A Study of American Character*. New York: Alfred A. Knopf, 1948, 378–82.

4. Pioneer Daughters Narrate Alamo History

Jones, Flora May Stone. "Monographs on Valley History." N.d.
Jones, Mary A. "San Ramon Valley." In *The History of Contra Costa County*. Berkeley: Elms Publishing Co., 1917, 77.
Munro-Fraser, J.P. *History of Contra Costa County California*. San Francisco: W.A. Slocum and Co., 1882, 430–33.

5. Alamo's American Beginnings: 1850s and 1860s

Bancroft, Hubert Howe. *The History of California*. Vol. 6, San Francisco: History Company, 1890, 576–81.
Churchill, Frank. "History of the Glass Family." Monograph, May 30, 1897.
Fink, Leonora Galindo. "The San Ramon Valley." *Contra Costa Chronicles*, Spring 1966, 17–27.
Hall, B. Fred. "Recollecting Pioneer History of Contra Costa County." Essay, n.d.
Illustrations of Contra Costa Co. California with Historical Sketch. Oakland, CA: Smith and Elliott, 1879, 23. (James Foster quotation).
Jones, Mary Ann (Smith). "The Story of My Life." In *Remembering Alamo… And Other Things Along the Way*. Alamo CA: Morris-Burt Press, 1975, 45–61.
Langlois, Barbara Hall. *The Hall Book*. Lafayette, CA: Self-published, 1990, 64.
Munro-Fraser, J.P. *History of Contra Costa County*. San Francisco: W.C. Slocum & Co., 1882, 430–33.
Purcell, Edna Fisher. *History of Contra Costa*. Berkeley, CA: Gillick Press, 1940, 194.
Smith, James D. *Recollections, Early Life in the San Ramon Valley, As Related by Prof. James Dale Smith Headmaster, Livermore College*. Edited by G.B. Drummond. Oakland, CA: GRT Book Printing, 1995. ("Letter to Ida Hall, Aug. 7, 1925").
Van Delinder, H.W. "The Alamo Cumberland Presbyterian Church." Monograph, 1959 (April 1851 church founded; author thinks the Jones family arrived in late 1850).

6. Agriculture Supported Alamo for a Century

Anderson, Arthur. Interview with the author, 2020.

Borlandelli, Carlo. Interview with the author, 2019 and 2020.

Brewer, William H. *Up and Down California in 1860–1864*, Berkeley: University of California Press, 1966, 242–43.

Contra Costa Gazette, January 18, 1890. (1862 floods).

————. "Almonds and Pears: The Orchards of Judge Cope and August Hemme." April 16, 1887.

————. "San Ramon Valley: A Pen Picture of that Pretty Part of the County." May 7, 1892.

Cozine, Ralph. "Agriculture, For a Century, the Business of the Valley." Monograph, 2002.

Dotson, Irma M. "Hemme: A Big Man in a Small Valley." San Ramon Valley Historical Society Talk, June 8, 1972.

————. "The Impact of August Hemme on Nineteenth Century Agriculture and Cattle Raising with an Analysis of His Economic Failure." MA thesis, San Jose State College, 1972, 19.

Dunlap, Betty Humburg. Interview with the author, 2019 and 2020.

Illustrations of Contra Costa Co. California with Historical Sketch. Oakland, CA: Smith and Elliott, 1879, 25. (Hemme Ranch).

Jones, Virgie V. *Historical Persons and Places…In San Ramon Valley*. Alamo, CA: Morris-Burt Press, 1977, 109.

————. *Remembering Alamo…And Other Things Along the Way*. Alamo, CA: Morris-Burt Press, 1975, 84, 90, 108.

Knoles, George H., ed. *Essays and Assays: California History Reappraised*. Stanford, CA: Stanford University, Institute of American History, 1973. 41–42.

Langlois, Barbara Hall. *The Hall Book*. Lafayette, CA: Self-published, 1990, 30, 65, 75–78, 80. (The Hall's Mother Tree was cut down on January 14, 1982 when a heavy rain affected its roots and it began to tilt into street wires.)

Muir, Joseph, and George McNeely. "History of the Cattle Industry in Contra Costa and Alameda Counties." *California Cattleman*, March 1966, 26–32.

Rego, Nilda. "Ranch Bride Juggled Farming with Alamo Civic Activities." Days Gone By, *Contra Costa Times*, November 20 and 27, 1994.

Root, Viola Scott. "History of Danville." Monograph, 1972, 2.

Rutherford, Richard. "Agriculture in the San Ramon Valley." *Valley Pioneer* (Centennial Issue), September 1958.

Smith, James Dale. *Recollections, Early Life in the San Ramon Valley, As Related by Prof. James Dale Smith Headmaster, Livermore College.* Edited by G.B. Drummond. Oakland, CA: GRT Book Printing, 1995,11.

Wildenradt, Margaret Baldwin. Interview with the author, 1991.

Wood, Donald. Interview with the author, 2020.

———. "Random Recollections of Things I've Seen or Been Told (valley agriculture)." Monograph, 2002, 3, 6.

7. Civic Engagement

Butz, Inez. "The History of Danville Grange #85." Monograph, 1984.

Danville Grange Herald, February 7, 1923. (Library in Alamo).

DeTocqueville, Alexis. *Democracy in America, English Edition.* Edited by Eduardo Nolla. Translated from French by James T. Schleifer. Indianapolis: Liberty Fund, 2012.

Dunlap, Betty Humburg. Interview with the author. 2020.

Gibson, Mike. Interview with the author, 2020.

Jones, Virgie V. *Remembering Alamo…And Other Things Along the Way.* Alamo, CA: Morris-Burt Press, 1975, 53.

Koc, Vicki. Interview with the author, 2020.

Linhares, Bertha Bell. "The History of the Alamo Post Office." Monograph, 1965.

Lynch, Leo. "Mail Delivery in the San Ramon Valley in the Early 1940's." San Ramon Valley Historical Society Talk, May 1998.

Smith, Ross. *History of the Danville Grange, Patrons of Husbandry.* Danville, CA: Ashford Publications, 2008.

Various authors. "Alamo Women's Club History." www.alamowomensclub.com.

Wayne, Veda. "History of Alamo and the San Ramon Valley." Monograph, 1937.

8. Schools and Churches Sustained Pioneers

Contra Costa County History Center. School notebooks, newspaper clippings categorized by school.

Contra Costa Gazette, 1871; 1880; March 18, 1893; August 12, 1911; December 23, 1921; May 19, 1924; March 7, 1935; June 27, 1935; March 25, 1936. (Articles on schools and churches).

Dotson, Irma M. *Danville Branch Line of the Oakland Antioch & Eastern Railway*. Danville, CA: Museum of the San Ramon Valley, 1996, 118.

Harte, Bret. "An Apostle of the Tules." In *The Writings of Bret Harte*, vol. 4. New York: Houghton, Mifflin & Co., 1895, 306–34.

Jones, Flora May. "Notes on the Union Academy. Typewritten pages, n.d.

Jones, Virgie V. *Remembering Alamo…And Other Things Along the Way*. Alamo, CA: Morris-Burt Press, 1975, 25, 52–53, 185*ff*.

Lane, Beverly. "Schooling in the Valley, A History of Education in the San Ramon Valley." Monograph including a school history by Inez Butz, 2006.

Munro-Fraser, J.P. *History of Contra Costa County*. San Francisco: Slocum, 1882, 434.

Overholtzer (Dunlap), Betty. Interview with Irma Dotson, 1998.

Smith, James Dale. *Recollections, Early Life in the San Ramon Valley*. Edited by G.B. Drummond. Livermore, CA: GRT Book Printing, 1995. ("Letter to Ida Hall, Aug. 7, 1925").

Van Delinder, Reverend H. Wesley. "History of the Alamo Cumberland Presbyterian Church." Manuscript, 1959.

Wayne, Veda. "History of Alamo and the San Ramon Valley." Monograph, n.d.

9. Roads, Rails and Trails

Association for the Preservation of Danville Boulevard. "Proposed Master Tree Plan." 1971.

Burns, Lillian. "History of the Boulevard of Trees." Monograph, 2019.

Daily Alta California. "Tri-Weekly Stage Line." May 6, 1858.

Dotson, Irma M. *Danville Branch of the Oakland Antioch & Eastern Railway*. Danville, CA: Museum of the San Ramon Valley, 1996, 29, 77–78, 118, 122.

———. "The Impact of August Hemme on Nineteenth Century Agriculture and Cattle Ranching with an Analysis of His Economic Failure." Research paper for MA, Department of Librarianship, San Jose State College, June 1972.

———. *San Ramon Branch of the Southern Pacific*. Danville, CA: Museum of the San Ramon Valley, 1991, 3–4, 13, 210.

Lane, Beverly. *Before BART: Electric Train Link Contra Costa County*. Danville, CA: Museum of the San Ramon Valley, 2012.

Langlois, Barbara Hall. *The Hall Book*. Lafayette, CA: self-published, 1990, 78.

Mercurio, John, and Steve Minniear. *HIGHWAY 21: The Farm Road That Became an Interstate in the San Ramon and Amador Valleys*. Pleasanton, CA: Provided for attendees of a Conference of California Historical Societies, 2016.

Nunes, Belle Silva. Diablo Valley College interview. 1960.

Ogden, Paul. Interview by Andrew Young at the Contra Costa County History Center. 1987.

San Ramon Valley Times. "Boulevard of Trees Beautifies Alamo." October 2, 1991.

———. "Danville Boulevard Plantings Continue." August 8, 1992.

10. The Twentieth Century: 1900 to 1950

Dunlap, Betty Humburg. Interview with the author, 2020.

Hanson, Tom. Interview with the author, 2020.

Jones, Virgie V. *Remembering Alamo…And Other Things Along the Way*. Alamo, CA: Morris-Burt Press, 1975, 111–12, 123–24.

Kaye, Ann, and Larry Kaye. Interview with the author, 2020.

Rego, Nilda. "Ranch Bride Juggled Farming with Alamo Civic Activities." Days Gone By, *Contra Costa Times*, November 20 and 27, 1994.

Root, Viola Scott. "History of Danville." Monograph, 1972.

Stone, Rocky. Interview with the author, 1996.

Vincent, Bob. Interview with the author, 2005.

Walnut Kernel. "Legion Hall Dances." 1941.

Wood, George. Rotary video interview, 1984.

11. A 1960s Transformation

Besse, Janet. *Golden Anniversary, Round Hill Country Club*. Oakland, CA: Stories to Last, 2010.

Central Contra Costa Sanitary District. "Board minutes." September 27, 1954.

Ciardelli, Dolores. "Growing Mona Lisa." *Danville Weekly*, January 11, 2008.

Delfosse, Richard, and Terri Delfosse. Interview with Sharon Burke, 2020.

Dunlap, Betty Humburg. Interview with the author, 2020.

Hockins, Bill. Interview with the author, 1997.

Jones, Virgie V. *Remembering Alamo…And Other Things Along the Way*. Alamo, CA: Morris-Burt Press, 1975, 125 89*ff*.

Noble, John Wesley. *Its Name Was M.U.D.* Oakland, CA: EBMUD, 1970.

Oakland Tribune. "Alamo Loses Shopping Center Fight." August 11, 1967.

San Ramon Valley Times. "Alamo Group OKs Tree-Like Cell Tower." July 13, 1996.

———. "Elegant Bib 'Family' Continues to Meet Long After Doors Shut." November 6, 2014.

———. "Horse on Store." September 19, 1994.

Thiessen, Brian. Interview with the author, 2020.

Valley Pioneer, October 27, 1964. (Curt Flood in Alamo).

Waldron, Claudia. Interview with the author, 2020.

12. Alamo Governance

Alamo Today, May 2000. (Alamo Area Council).

Best, Ed, and Linda Best. Interview with the author, 2020.

Burke, Sharon. Interview with the author, 2020.

Contra Costa County. *General Plan for the San Ramon Valley*. Martinez, CA: n.p., July 15, 1958, 10, map.

Danville Weekly. "Keep Local Planning Voice." August 24, 2007.

Jones, Virgie V., *Remembering Alamo…and Other Things Along the Way*, Alamo: Morris-Burt Press, 1975.

Kaye, Larry. Interview with the author, 2020.

Koc, Vicki. Interview with the author, 2020.

Lane, Beverly. "Who's in Charge? Home Rule in the San Ramon Valley." Presenting the Past, *Danville Weekly*, 2007.

Munro-Fraser, J.P. *History of Contra Costa County*. San Francisco: W.A. Slocum & Co., 1882, 205, 240*ff*.

Nemir, Claudia. Interview with the author, 2020.

Rusley, Eleanor. "The History of Incorporation Movements in the San Ramon Valley." Monograph, 1966.

San Ramon Valley Times. "Alamo Favors Incorporation, Survey Reveals." October 6, 1989.

Valley Pioneer. "Alamo Voters Defeat Cityhood." January 26, 1973.

———. "Area Planning Body Proposed." February 21, 1973.

———. "New Construction Changes the Face of Alamo." January 30, 1985.
Waldron, Claudia. Interview with the author, 2020.

13. Modern Times: The Twenty-First Century

Alamo Today. May 2000 (incorporation), November 2008 (incorporation), January 2009 (incorporation), May 2009 (incorporation).

Best, Ed, and Linda Best. Interview with the author, 2020.

Burke, Sharon. Interview with the author, 2020.

Collins, Cameron. Interview with the author, 2020.

Contra Costa County Local Agency Formation Commission. "Executive Officer's Report: Proposed Incorporation of the Town of Alamo." September 18, 2008.

Danville Weekly. August 19, 2005 (logo); February 10, 2006 ("sophisticated rural"); March 6, 2009 (election night quotes).

Gibson, Mike. Interview with the author, 2020.

Koc, Vicki. Interview with the author, 2020.

McDonald, Mike. Interview with Sharon Burke, 2020.

Mick, Steve. Interview with the author, 2020.

Rock, Susan. Interview with the author, 2020.

San Ramon Valley Times. October 26, 1997 (Alamo Trails street names); May 6, 1999 (Alamo description).

Thiessen, Carolyn. Interview with the author, 2020.

Waldron, Claudia. Interview with the author, 2020.

INDEX

ABOUT THE AUTHORS

*B*everly Lane and Sharon Burke produced this history book about Alamo together. Beverly graduated from Occidental College in Los Angeles, a setting where California history has been a major academic focus for decades. After doing extensive research on local history, she has written many newspaper columns and three books about this area: *San Ramon Valley: Alamo, Danville, San Ramon* (an Arcadia Images of America book), *Vintage Danville, 150 Years of Memories* and *San Ramon Chronicles: Stories of Bygone Days.* She has been a teacher, a lecturer, a community organizer, an elected official and a historian. Beverly was elected to the first Danville Town Council and served as Mayor three times. Currently, she represents the central part of Contra Costa County as a Director for the East Bay Regional Park District. She and her family have lived in Danville for over forty-five years.

Sharon brought a love of Alamo, a devotion to research and great enthusiasm to this book. She and her family are longtime Alamo residents. A graduate in communication arts from the University of San Francisco, she worked for the California Canning Peach Association and the California Christmas Tree Growers Association; served on the boards of the League of Women Voters and the Diablo Valley National Charity League; and worked with many appointed committees, including the Local Agency Formation Commission, as an alternate public member. A cofounder of the Alamo Incorporation Movement from 2005 to 2009, she became interested in Alamo history during the incorporation movement, and she became more interested when she started giving downtown tours and researching Alamo street names. She was fascinated to find how many streets were named after distinctive Alamo characteristics: early settlers, horses, trees, saints' names, Spanish names. The history of Alamo is told in its street names.